IMAGES
*of America*

# LOCKE AND THE SACRAMENTO DELTA CHINATOWNS

IMAGES
*of America*

# LOCKE AND THE SACRAMENTO DELTA CHINATOWNS

Lawrence Tom, Brian Tom, and the Chinese
American Museum of Northern California

ARCADIA
PUBLISHING

Published by Arcadia Publishing
Charleston, South Carolina

Library of Congress Control Number: 2012949185

For all general information, please contact Arcadia Publishing:
Telephone 843-853-2070
Fax 843-853-0044
E-mail sales@arcadiapublishing.com
For customer service and orders:
Toll-Free 1-888-313-2665

Visit us on the Internet at www.arcadiapublishing.com

*This book is dedicated to the Chinese pioneers who settled in the
Sacramento River delta, who did not let injustice and other barriers
stand in their path but believed in themselves and followed their
dreams to attain a better life for their children while teaching them the
importance of cultural preservation, identity, and the meaning of family.*

# CONTENTS

# ACKNOWLEDGMENTS

The authors owe a great debt of gratitude to the descendants of the pioneer Chinese families of the Sacramento River delta who made this book possible. During our research, we have made many new friends and have learned a lot of the history of the Chinese in the Sacramento River delta. Our research gave us a greater appreciation for the effort that the Chinese experienced in trying to survive and succeed in the delta.

Recognition is given to the following for their contributions and assistance to this book: Chester Chan, Don and Gigi Chan, Gene Chan, Sonya Chan, Wallace and Debbie Chan, Chester Cheung, Kern Chew, Roger Chin, Ron Chong, Clarence Chu, Lawrence Chu, Ed and Mary Ann Chun, John Chun, Morrison Chun, Betty Fong, Eva Fong, George Fong, Robert Fong, Sharon Wong Fong, William Fong, Henry Go, Tom Herzog, Leonard Hom, Hong Kong Chow Family, Rogena Hoyer, Isleton Brannan-Andrus Historical Society (IBAHS), Helen Jang, Nolan Jang, Ruth Jang, Wave Jang, Virginia Johns, Robin King, Ester Koopman, Clifford Lee, Jeff Lee, Ping Lee, Donovan Lee, Edna and Herbert Leong, Eileen Leung, Paulette Liang, Wilkie Liang, Locke Foundation, Frank Lum, Arthur Mark, National Archives Pacific Region San Francisco (NAPRSF), National Park Service (NPS), James Owyang, Robert Owyang, Wally Owyang, Alfred Owyoung, Kathy Owyoung, Sacramento River Delta Historical Society (SRDHS), Harry Sen, Mary Tom, Debbie Tom, Raymond Tom, University of California Davis Health System (UCDHS), Elizabeth "Bett" Wong, Fan Yee, Nytee and Robert Young, and Elsie Owyoung Yun.

We especially want to recognize Elsie Owyoung Yun and Sharon Wong Fong. Elsie was the editor of the 1999 *Delta Reunion* book. She assisted us greatly in reviewing this book to ensure that the information is correct both grammatically and factually. Sharon is an officer of the Isleton Brannan-Andrus Historical Society and the tour director for the Isleton Museum. She was a great resource person who contacted many of the contributors for this book.

Unless otherwise noted, the images in this book are courtesy of the Chinese American Museum of Northern California.

# INTRODUCTION

The Sacramento River delta, once a large wasteland of swamps and marshes, has become one of the most productive agricultural areas in the world. Located a short hour's drive from the San Francisco Bay Area, and a shorter drive from the state capital, Sacramento, the delta remains relatively unknown—even to most Californians. Though the delta is close to the state capital and the Bay Area, it seems isolated because none of the state's major freeways run through the area, and no large cities are found there. The Chinese town of Locke and the Chinatowns of Isleton, Walnut Grove, and Courtland are located near the Sacramento River.

A drive through the delta transports visitors back to what California must have been like 100 years ago. The pace of life moves slower here, and drivers instinctively slow their cars to adjust to the narrow roads, many built on the tops of levees. There is greenery everywhere with huge oak and eucalyptus trees that pop up unexpectedly. Small country lanes, waterways, and bridges connect the small towns and farms. Two vintage ferries, still in operation, are the remnants of a large ferry fleet that formerly served this area.

The delta's rich farmland is visible from State Route 160. Rows of wine grapes, asparagus, blueberries, strawberries, potatoes, and alfalfa and large orchards of pears and apples stretch out in an endless panorama of nature's bounty. The rich soil of the delta virtually guarantees a productive harvest every year.

The historic Old Town of Isleton is a good place to learn about the significant role Chinese Americans played in the early farming history of California. The Isleton Museum, located on Main Street, has devoted many of its exhibits to the history of the Chinese in the area. Artifacts include the original banner that welcomed Gen. Tsai Ting Kai to the delta in 1934. Next door to the museum is the old Bing Kung Tong building, an important meeting place for the Chinese in Isleton. Ten miles north of Isleton is the town of Walnut Grove, where another Bing Kung Tong building is a reminder that the Chinese once had a vibrant community here.

A mile north of Walnut Grove is Locke, perhaps one of the most interesting towns in California. Locke is a Chinese town—the only surviving Chinese town in America—built for and by the Chinese. The Boarding House Museum and the Joe Soong Chinese School are both located on Main Street, but the town itself is the major attraction. Most visitors seeing Locke for the first time realize how little they know about the history of the Chinese in California.

The history of the Chinese in the delta is linked to that of modern China. From the time the Chinese were defeated by the British in the Opium War (1839–1842), China has been transitioning from a traditional society to a modern society, a change that is still going on today.

From the 16th century (when the West first started trading with China by sea) to the mid-19th century (when England defeated China in the Opium War), China was the richest and most powerful country in the world. For 200 years, China was strong enough to dictate the terms of trade with the West. Then England became modernized as a result of the Industrial Revolution, placing demands on China to change its trading system. When China refused, England declared

war and defeated China. After the war, Chinese people realized that the ruling Qing Dynasty had lost the mandate of heaven, and change was needed.

Chinese leaders frantically searched for a way for China to modernize and defend itself against the European powers, America, Japan, and Russia. Was it possible to modernize, using only western technology and keeping Chinese cultural values? Was the proper model of government that of England, the United States, or Japan?

The Chinese in the delta followed events in China intently. As residents of the most technologically advanced nation in the world, they felt a special responsibility to "save China." The large number of Chinese living in the delta made it one of the mandatory destinations for Chinese leaders seeking to modernize China. Kang Yuwei and Liang Qichao, well known reformers, visited the delta around the turn of the 20th century.

Perhaps the most important visitor was Dr. Sun Yat-sen, the first president of China. Like many of the Chinese in the delta, Dr. Sun was a native of Chungshan County in Guangdong province, thus he was always warmly welcomed. Many residents of the delta have family stories of the times when Dr. Sun visited and stayed in their homes.

A resident of Courtland (a delta town seven miles north of Locke), Chauncey Chew had been appointed by Dr. Sun to be the purchasing agent for China's air force in the early part of the 20th century. Chew bought a number of surplus World War I planes and arranged to have young Chinese American men trained as pilots and mechanics in Courtland. As related by Jack Chew, Chew's son, to Prof. Peter Leung in *One Day, One Dollar*, "They trained on the ranch for several months, living in camps set up there for them. . . . My father stored the planes and kept them ready for shipment when they would be needed. He was waiting for the command to transport them, but the planes never reached China because someone set a fire (around 1929/30) purposely destroying them all." While the fire proved to be a setback at the time, later, many of these same Chinese Americans who were trained as pilots and mechanics served in China in the war against Japan.

Gen. Tsai Ting Kai, another native of Chungshan and the hero of the first Battle of Shanghai (1932), received a tremendous welcome to the delta in 1934. While the battle for Shanghai was ultimately won by the Japanese, General Tsai, as commander of the 19th Route Army, put up a fierce resistance to a better equipped and trained Japanese invasion force. The Chinese of the delta constructed a new building for the general's reception. Even today, old-timers remember the welcome they accorded the general.

Driving through the dusty hamlets of Courtland, Walnut Grove, Locke, and Isleton today, it is hard to imagine that the Chinese residents were once involved in historic events half a world away.

Almost from the date of California statehood in 1850, California's leaders recognized the potential to develop the delta into rich farmland. The obstacle was how to reclaim marshlands and swamps and make them productive. The State of California wanted the swampland developed because of its potential and the impact that development would have on California's overall economy. After acquiring the land from the federal government for free in the mid-19th century, California sold the land to farmers and land speculators on credit at low prices with minimal down payments. As an incentive to develop the land, the state agreed to waive repayment of the loans if landowners reclaimed the land. This system encouraged land speculators and corporations to acquire large tracts of land.

In the early decades of California statehood, the agricultural industry concentrated on production of grain. Eager to increase the value of their holdings, farmers and landowners wanted to transition from growing grain to growing fruit, vegetables, and other, more lucrative crops. The delta became a leading area for this transition. The first step was the reclamation of the land, which meant the building of levees. For this work, the landowners and land speculators soon discovered they only had one solution: hiring Chinese contractors and farmworkers.

Almost all of the Chinese immigrants had come from the Pearl River delta in Guangdong province, an area with similar geographical conditions to the Sacramento delta. Farming in the

Pearl River delta required the building of levees, a task that, over the course of centuries, the Chinese had become very skilled at performing.

Much of the contribution of Chinese workers to the development of agriculture in California has been muddled by the cheap labor issue. Chinese farmworkers accepted a wage of $1 a day or a contracted piece rate that worked out to roughly that amount. They did so because, through a system of both governmental and private discrimination, alternatives were limited. In those days, federal, state, and local governments passed a series of anti-Chinese laws that limited their employment prospects. Private companies and unions further limited their possibilities. At the same time, the Chinese were paid a wage in California that was 4 to 10 times more than what they could have earned in China, thus making $1 a day seemed reasonable. Still, the Chinese knew they had valuable land reclamation and farming skills so they never worked for less than $1 a day. Chinese contractors and workers agreed on that minimum, and they refused any offers that paid less.

For the capitalist farmer and land speculator, the system that evolved had many benefits. Any capitalist who tries to start a new business realizes how difficult it is to locate a staff, establish a record-keeping system, hire a workforce, supervise the workforce, and handle payroll. This was especially true in reclaiming the delta, for which crews of hundreds of men were required. By using the labor-contracting system, these problems were solved by passing them on to a Chinese contractor. This system freed up landowner's time, which was used for other activities such as land speculation and investing.

The California government land policy adopted for the delta worked. Land was sold cheaply by the state. The development of the land increased its value enormously, and the state gained greater tax revenues, justifying the low initial sales price. For the landowner and speculator, the policy also paid off. As Prof. Sucheng Chan has written, though there were risks, profits could be very high. Citing the experience of one landowner, land could be purchased for $1 to $4 an acre, reclaimed for $6 to $12 an acre, and resold for $20 to $100 an acre, resulting in profits of $4 to $93 per acre. As an alternative, landowners could rent the land to Chinese farmers for $8 to $10 a year and thus recapture their investment in one or two years. The system provided a major boost to the California economy. Once unusable swampland became highly productive farmland, providing funds to develop other parts of the California economy.

But the system was not fair to the Chinese. From the beginning, there were informal restrictions against Chinese landowners. So unlike European Americans, Chinese Americans could not purchase swampland at cut-rate prices. These informal restrictions were later codified into the Alien Land Laws that forbade "aliens ineligible for citizenship" from purchasing agricultural land. At that time in American history, Europeans were eligible for citizenship—Asians were not. The result was that almost all the landowners in the delta were European Americans.

The Chinese played an important part in the development of the California agricultural industry. By 1870, some historians estimate that the Chinese made up as much as 90 percent of the agricultural workers in California. Most Californians would be surprised hear this figure as few memorials exist in present-day California that acknowledge how important Chinese were in helping build this industry.

During the anti-Chinese movement, which started in the 1870s, Chinese farmworkers in the agricultural parts of California were driven out of their homes and farms. It was a period of violence and terror—systemic and institutionalized racism—a failure of our democratic safeguards to protect Chinese immigrants.

The Chinese were driven out of most rural parts of California with one exception: Locke and the Chinatowns of the delta. In the delta, the Chinese refused to leave. In time, European American and Chinese American communities learned to live with each other.

While the elementary schools were segregated, the high schools were not. Over the years, all Chinese children had a chance at an equal education. The prohibition against the Chinese owning land lasted for decades, but a new generation of American-born Chinese started buying farmland, and the European American monopoly on land ownership was broken. By the turn of

9

the 20th century, a number of Chinese in the delta had breached the old system of discrimination and found prosperity. Lincoln Chan, the "Pear King," and Thomas Chew, the "Asparagus King," are only two examples of Chinese Americans who found success in the delta.

Perhaps even more important than the big success stories are the stories of the average person. A number of Chinese residents and former residents of the delta were interviewed for this book. Almost all had fond memories of growing up in Locke, Walnut Grove, Courtland, and Isleton. For those old enough to remember the Great Depression, many mentioned how difficult those years were. But even during those hard times, no one went hungry. Living in one of the most productive agricultural areas in the United States, they always had food on the table. Families had their own vegetable gardens and fruit trees. Most raised chickens and ducks. Others were hunters for duck or pheasants. And there were always the rivers, where striped bass, catfish, and perch were plentiful.

The interviewees described life in the 1920s and 1930s often in an idyllic way—the long, slow summer days, fishing and swimming in the river, the abundant wildlife, and the peaceful spring days. Many had worked during high school. While they acknowledged the work in the packing sheds or fields had been tough, no one looking back saw it as a hardship. In fact, many credit their work experience as an asset for their later success in life. Most born in the delta left the area for greater opportunities elsewhere, often for service in the military, followed by college on the GI Bill. Chinese American history has often been told through the perspective of the driving out, as if that were the complete story. For a time, it was. In 1920, when the full impact of the anti-Chinese movement took effect, the Chinese population in America had been reduced to 60,000 from 110,000 in 1890. Chinese Americans were the only immigrant group to come to America and see their numbers decline. For a while, it seemed that the racists won. But the story did not end there.

Chinese Americans stayed, built homes, and welcomed their families and compatriots from China. Today, those who stayed and those who joined them have created a community of over 3.5 million Chinese Americans. The true story of the Chinese in the delta, of all Chinese Americans, is the story of an immigrant group that came to America seeking freedom, faced discrimination, fought to stay, and become part of the greater American story.

# One

# CHINESE IMMIGRATION
# TO AMERICA

Soon after gold was discovered in 1848 in California, the Chinese started to arrive. Most of the Chinese who came to California in search of gold were from three adjoining districts near the provincial capital of Guangzhou in Southern China—Chungshan (Heungshan), Sam Yup (San Yi), and Sze Yup (Si Yi). However, the Chinese that settled in the Sacramento River delta region were primarily from only two of these districts, Chungshan and Sze Yup. The Sze Yup people were from four counties—Taishan (Toishan), Kaiping (Hoiping), Enping (Yanping), and Xinwui (Sunwui)—and the Chungshan people were from one county. Both of these districts were close to the port of Hong Kong, which was a major port for trade with the western world; it was easy for the people here to get news from outside China. In addition, the Chinese could also embark on ships to other places. Though there was an emperor's decree that anyone leaving China would be beheaded when returning, the people in this part of China were more adventurous and rebellious. Thousands of Chinese joined the California Gold Rush, and by 1852, it was estimated that 20,000 arrived in San Francisco. The voyage to America was only the beginning of a very difficult journey. Passengers were at the mercy of the weather and the ship's captain, whose objective was to transport as many people as possible at the lowest cost possible. After arrival, the Chinese were initially processed for entry in San Francisco until 1910, when Angel Island was established. This became a bitter chapter for the Chinese immigrants. The immigrants where held here for weeks, and in some cases, two or three years. Though there were various reports on the filth and unfit conditions for habitation at Angel Island, the facility operated until 1940, when it was closed and operations were transferred back to San Francisco.

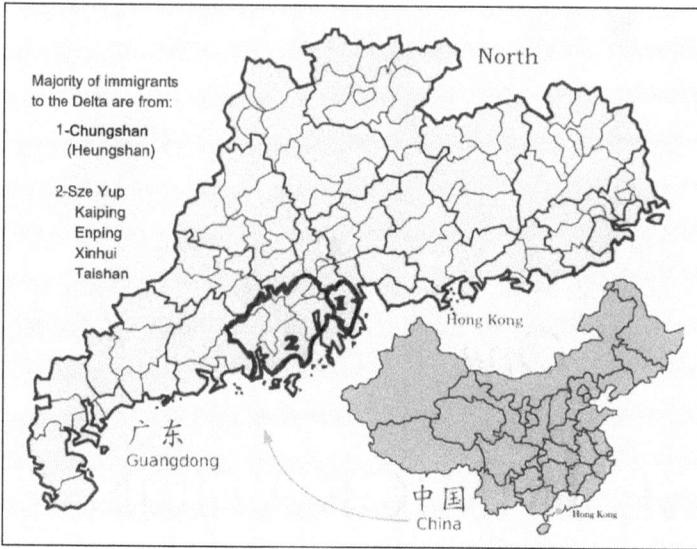

Prior to the mid-1900s, most of the immigrants who settled in the Sacramento River delta were Cantonese from two distinct districts in the Guangdong province in Southern China. This distinction was based on the local dialect spoken in the counties, Sze Yup (four counties) and Chungshan (one county). The occupations for many of the immigrants were in farming and fishing, which blended right in with the delta's geography.

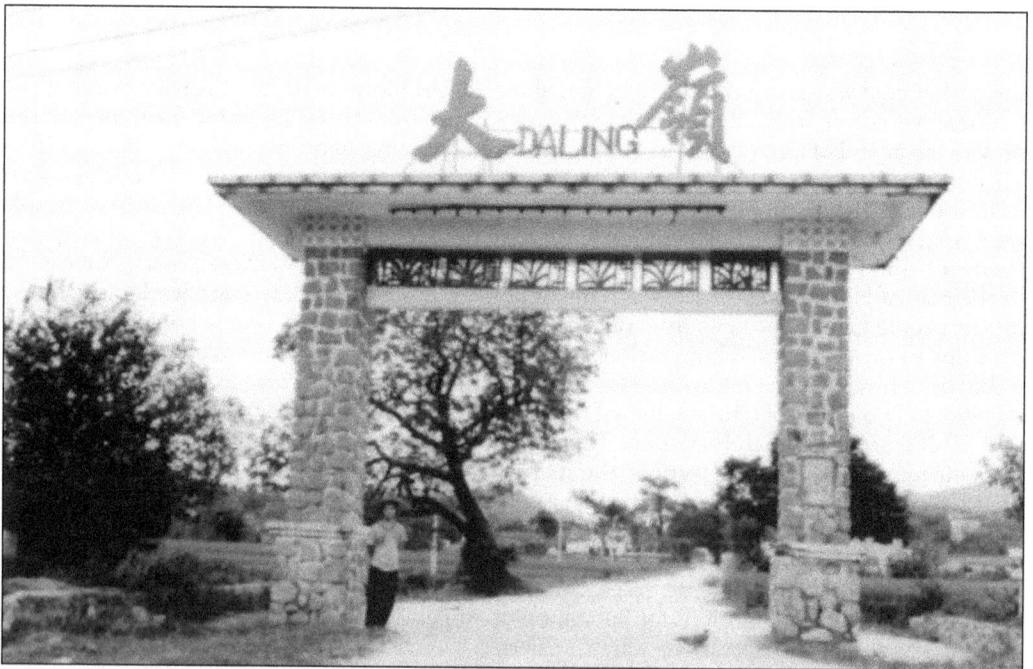

This is the archway into the Dai Liang Village (aka Tai Ling). The village is located in the county of Chungshan in the Guangdong province in Southern China. Many of the immigrants who settled in the Sacramento River delta were farmers from the county of Chungshan. (Courtesy James Owyang.)

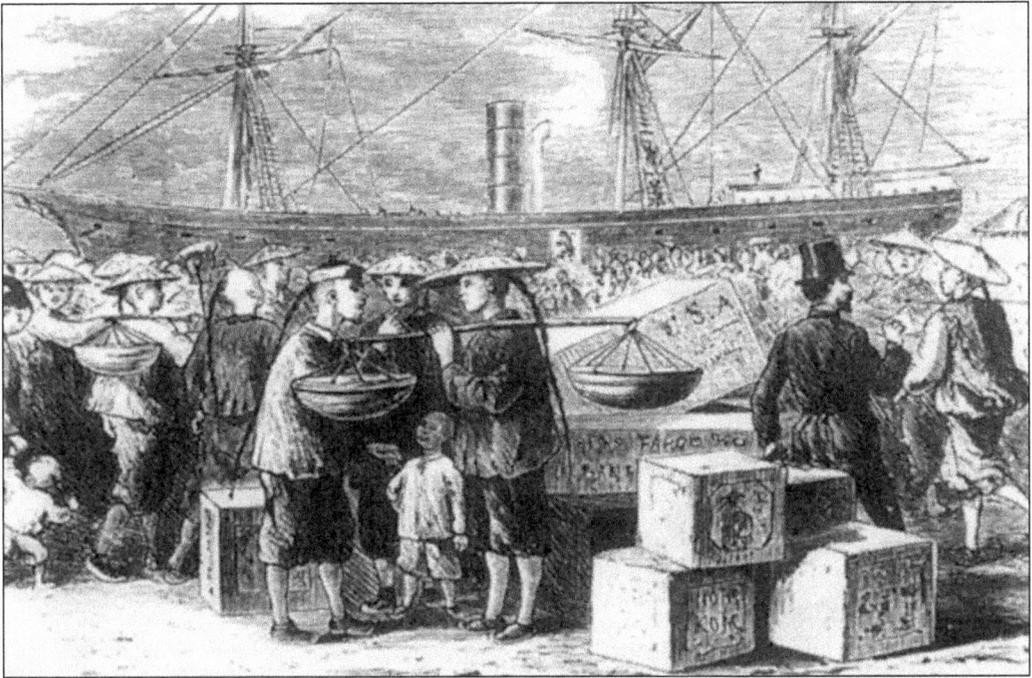

Decrees by the Qing Dynasty forbade emigration and were intended to prevent supporters of the Ming Dynasty from establishing bases overseas. Since the British colony of Hong Kong was one of the few ports open for trade with the western world, it was easy for anyone who wanted to leave the country to obtain passage here on a foreign ship. Most of the Chinese embarked from here on their transpacific voyages.

The Immigration Act of 1882 levied a head tax of 50¢ on each immigrant. By 1907, the tax was $4 to enter the United States. Lum Shee Yin was required to pay the $4 tax when she applied for admission into the United States in 1916. In 1917, the tax was doubled to $8. (Courtesy Nytee Chan Young.)

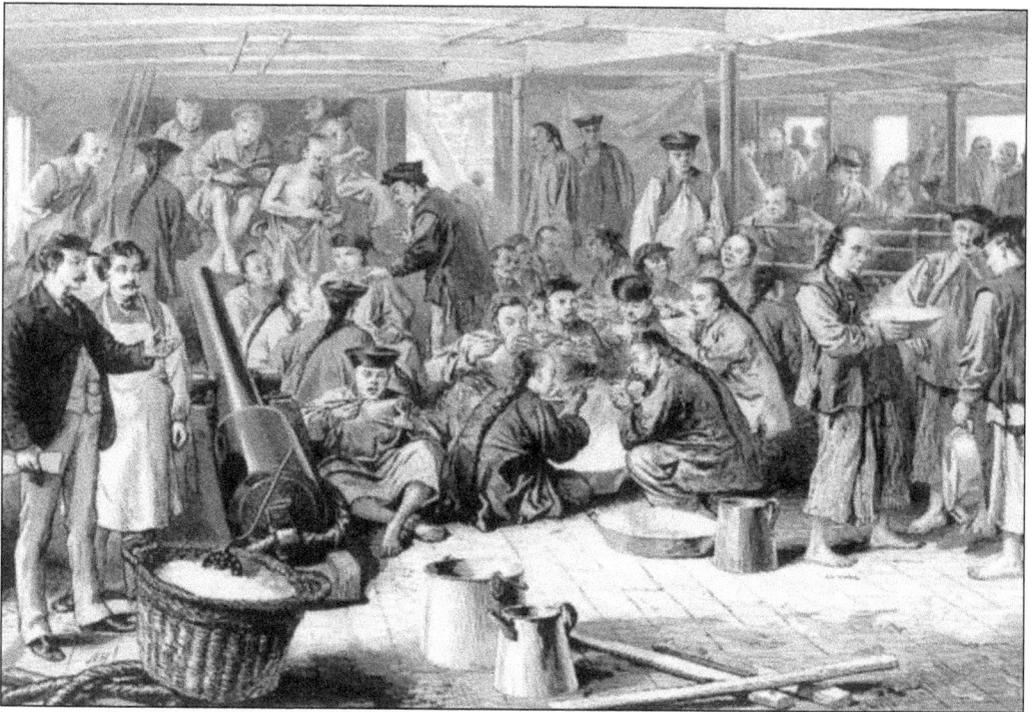

The journey to America was not an easy trip for many of the Chinese who purchased steerage accommodations. The travelers were packed into the hold of the ship and were often crowded into minimal space. Health and safety was not a concern of the ship owners or the captain, and fatalities were frequent.

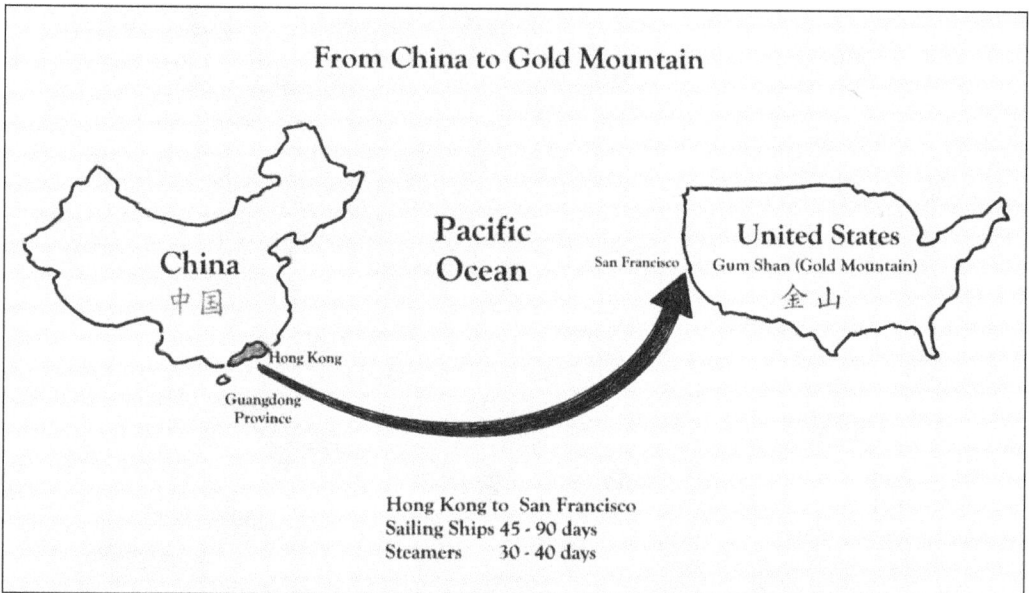

**From China to Gold Mountain**

China
中国

Pacific
Ocean

San Francisco

United States
Gum Shan (Gold Mountain)
金 山

Hong Kong

Guangdong
Province

Hong Kong to San Francisco
Sailing Ships 45 - 90 days
Steamers    30 - 40 days

The voyage from Hong Kong to the Port of San Francisco on sailing ships was from 45 to 90 days depending on weather conditions. As steamers (less dependent on the weather) replaced the sailing ships, the voyage was shortened to between 30 and 40 days. (Courtesy Lawrence Tom.)

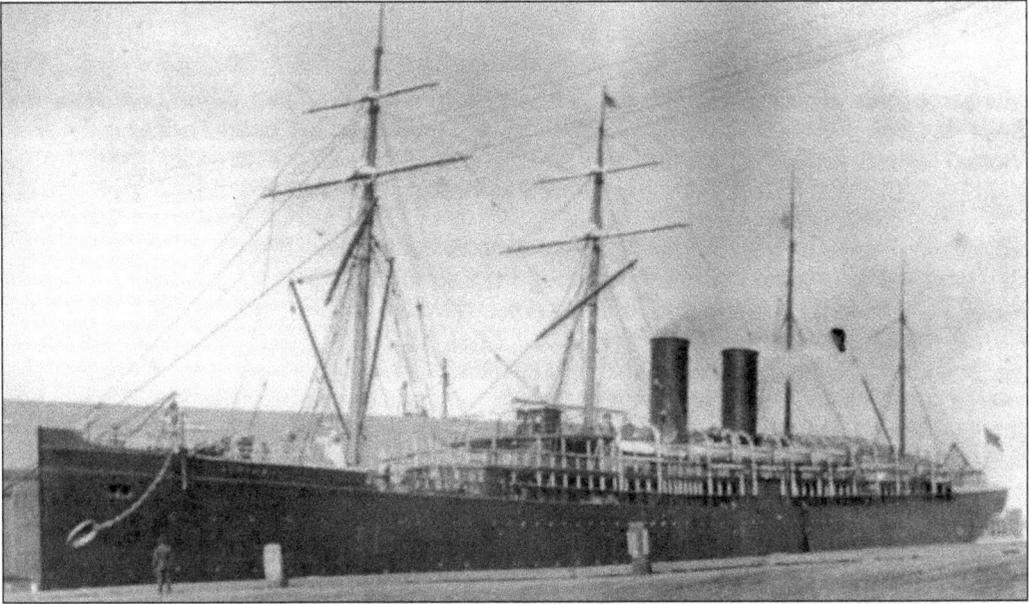

The steamship *China* was built in 1889 for the Pacific Mail Steamship Company. This ship was used to transport passenger from Hong Kong to San Francisco via Yokahama and Honolulu. In October 8, 1919, *China* arrived in San Francisco from Hong Kong in 27 days, 4 hours, and 41 minutes, breaking its own record. There were 674 passengers on board. (Courtesy Raymond Tom.)

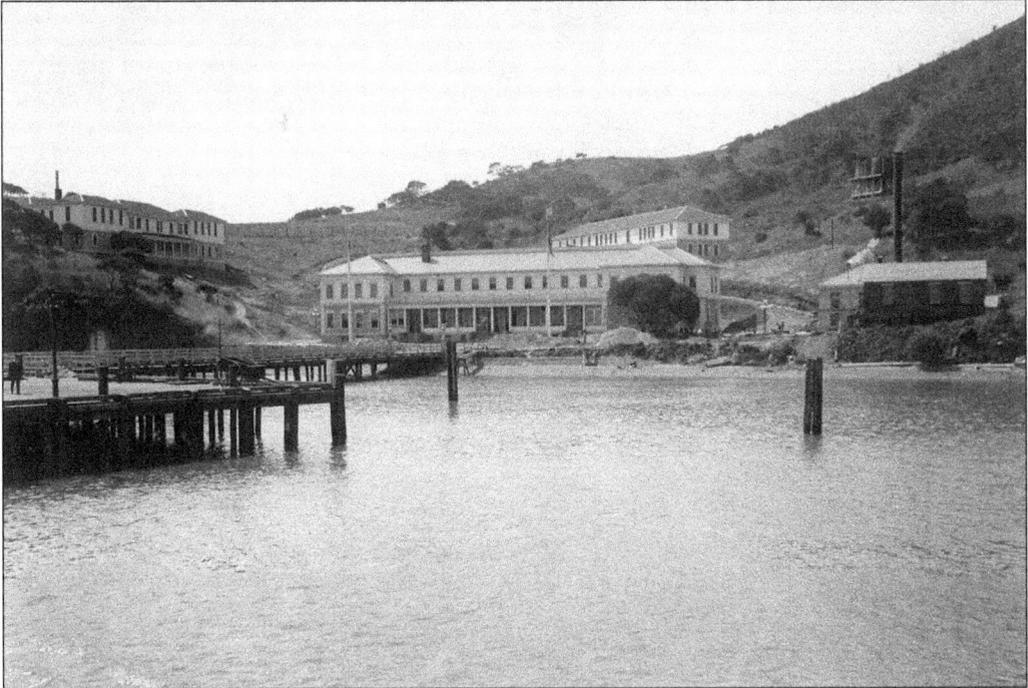

Angel Island in the San Francisco Bay was the first stop for the Chinese immigrants arriving from China from 1910 to 1940. It was here that the immigrants were processed to determine eligibility for entry into the United States. After disembarking at the pier, they were processed at the administration building. (Courtesy NAPRSF.)

No. 23991     THE UNITED STATES OF AMERICA     ORIGINAL

CERTIFICATE OF IDENTITY

ISSUED IN CONFORMITY WITH RULE 19 OF THE CHINESE RULES OF THE BUREAU OF IMMIGRATION, DEPARTMENT OF LABOR.

*This is to certify that the person named and described on the reverse side hereof has been regularly admitted to the United States, as of the status indicated, whereof satisfactory proof has been submitted. This certificate is not transferable, and is granted solely for the identification and protection of said Chinese person so long as his status remains unchanged; to insure the attainment of which object an accurate description of said person is written on the reverse side hereof, and his photographic likeness is attached, with his name written partly across, and the official seal of the United States Immigration officer signing this certificate, impressed partly over said photograph.*

Upon arrival at the Port of San Francisco on September 12, 1916, Lum Shee passed inspection and was issued this certificate of identity on September 30, 1916. She was the wife of Chan Sun Hing in the town of Locke, California. Chan Sun operated a soda fountain and restaurant in Locke called the Happy Café. (Courtesy Nytee Chan Young.)

Lum Shee, wife of Lee Bing, entered the Port of San Francisco on November 30, 1913, and was issued the certificate of identity on December 30, 1913, as the merchant wife of Lee Bing. Lee Bing was the owner of the Hing Lee Company, a dry goods and drug store in the town of Walnut Grove. (Courtesy Ping Lee.)

16

# Two

# CHINESE PRESENCE IN THE SACRAMENTO DELTA

The Sacramento River delta stretches from the town of Freeport in the north to Rio Vista in the south. Chinese were already settled in the delta by the 1860s. After the completion of the transcontinental railroad, Chinese railroad workers returned to the cities or settled in the Sacramento River delta to build the levee system that would reclaim the swampland. Building the levees was difficult and dangerous work. There were many early attempts to reclaim the swampland, but early, primitive levees were routinely destroyed by floods. It was not until the Chinese were recruited in large numbers for construction of the levees that progress was made. The Chinese were very creative. In the construction of the levees, they developed the tule shoe, an oversized horseshoe wired to horses' hooves for packing and leveling dirt. The idea was to disperse the weight of the horse, similar to the way a snowshoe works, over the soft, marshy soil. It was successful, allowing for the reclamation of land that would otherwise be unusable. It was estimated that 250,000 acres of land were reclaimed by Chinese laborers. After the levee system was complete, many of the Chinese stayed and continued to work as farm laborers or tenant farmers. By the latter part of the 1800s, there were several thousand Chinese farmers and workers in the delta. Due to the large number of Chinese and the demand for goods and services, Chinatowns were established from Freeport to the town of Rio Vista. The Chinatowns started to abate in the 1930s and 1940s after the next generation of children continued their educations and sought job opportunities elsewhere. Today, only four towns in the Sacramento River delta—Courtland, Locke, Walnut Grove, and Isleton—show remnants of their Chinatowns.

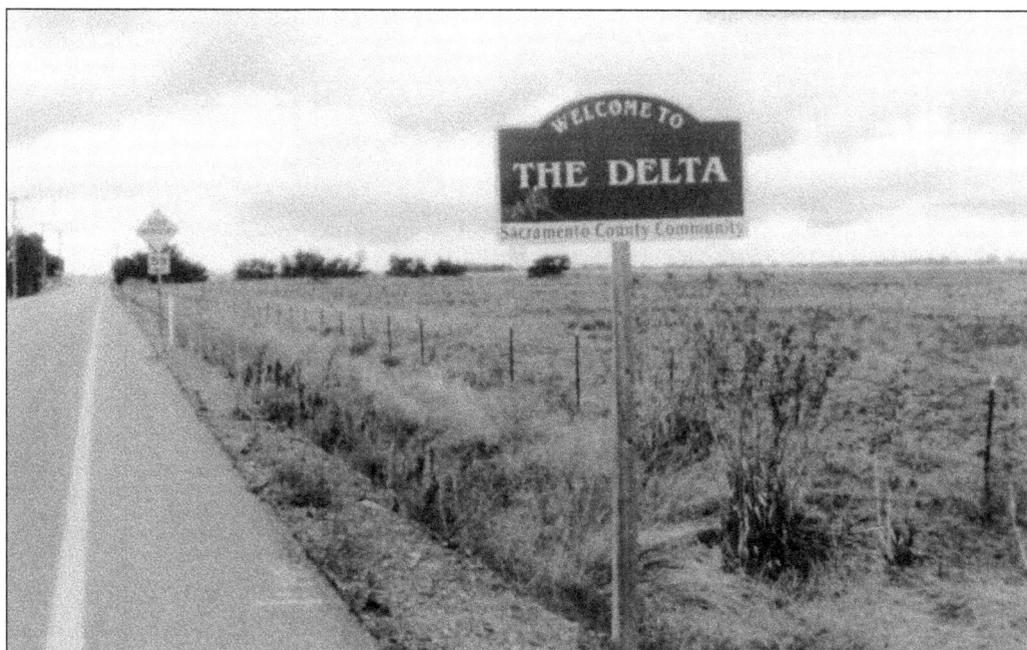

"Welcome to the Delta" greets visitors to the Sacramento River delta, which begins in the north from the town of Freeport and extends to Rio Vista in the south. The Chinese settled in the delta in the 1860s, and by the latter part of the 1800s, there were several thousand Chinese farmers and workers.

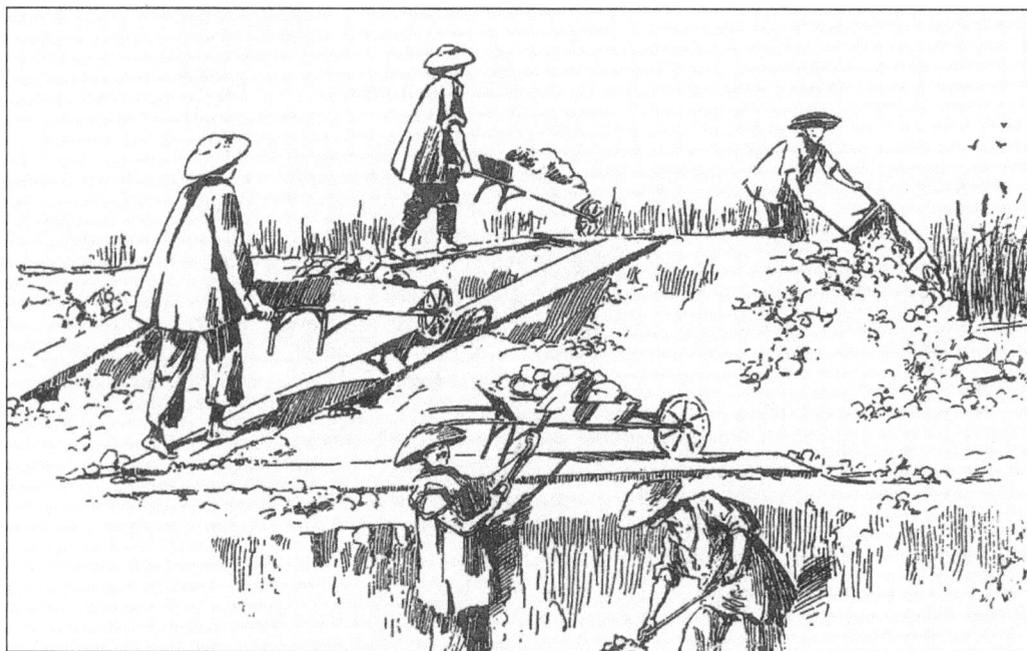

After the completion of the transcontinental railroad, Chinese railroad workers returned to the cities or settled in the delta. It was estimated that the Chinese labor force reclaimed 250,000 acres of land. After the levee system was complete, many of the Chinese stayed and continued to work as farm laborers or tenant farmers. (Courtesy Locke Foundation.)

In reclaiming land in the delta, the tule shoe was a critical element. It was invented by the Chinese in the late 1800s to compensate for the difficult farming conditions of the region. The soft marshy soil of the delta was difficult for horses to work without sinking, risking injury to the horse and the workers. The idea was to disperse the weight of the horse in a similar way to a snowshoe. It was very successful and allowed for land to be reclaimed that would otherwise be unusable for agriculture. The photograph at right shows a tule shoe, and the photograph below shows levee construction in the late 1800s. (Both, courtesy Locke Foundation.)

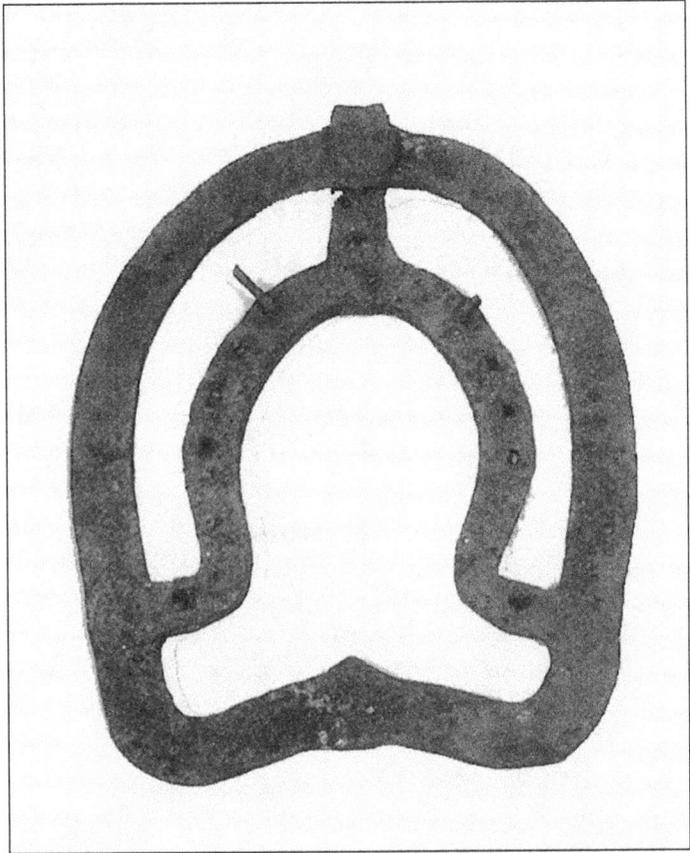

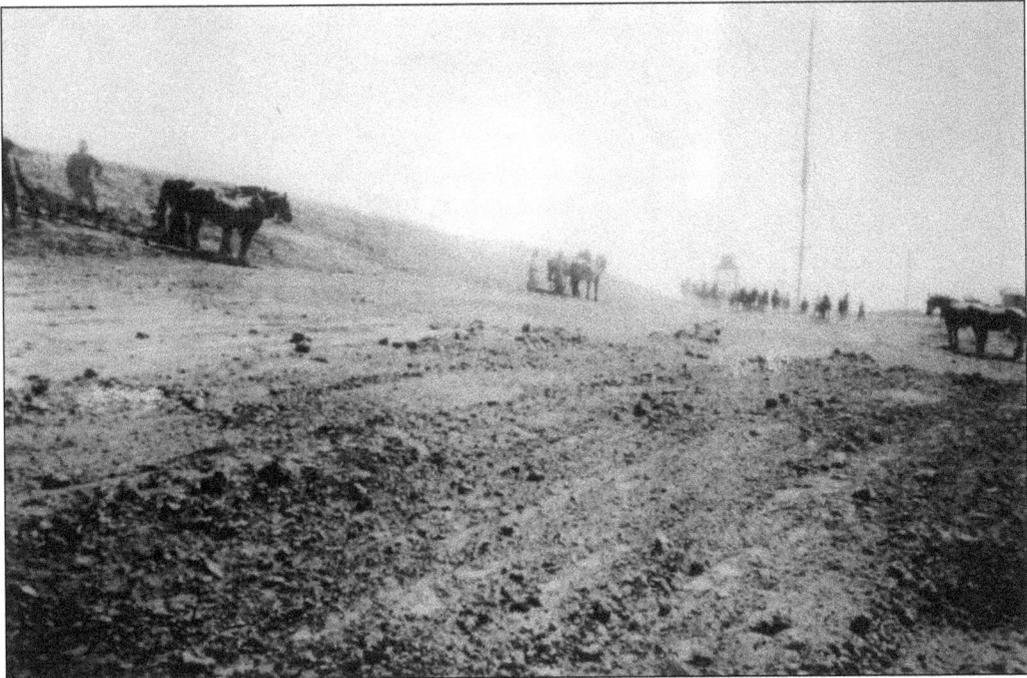

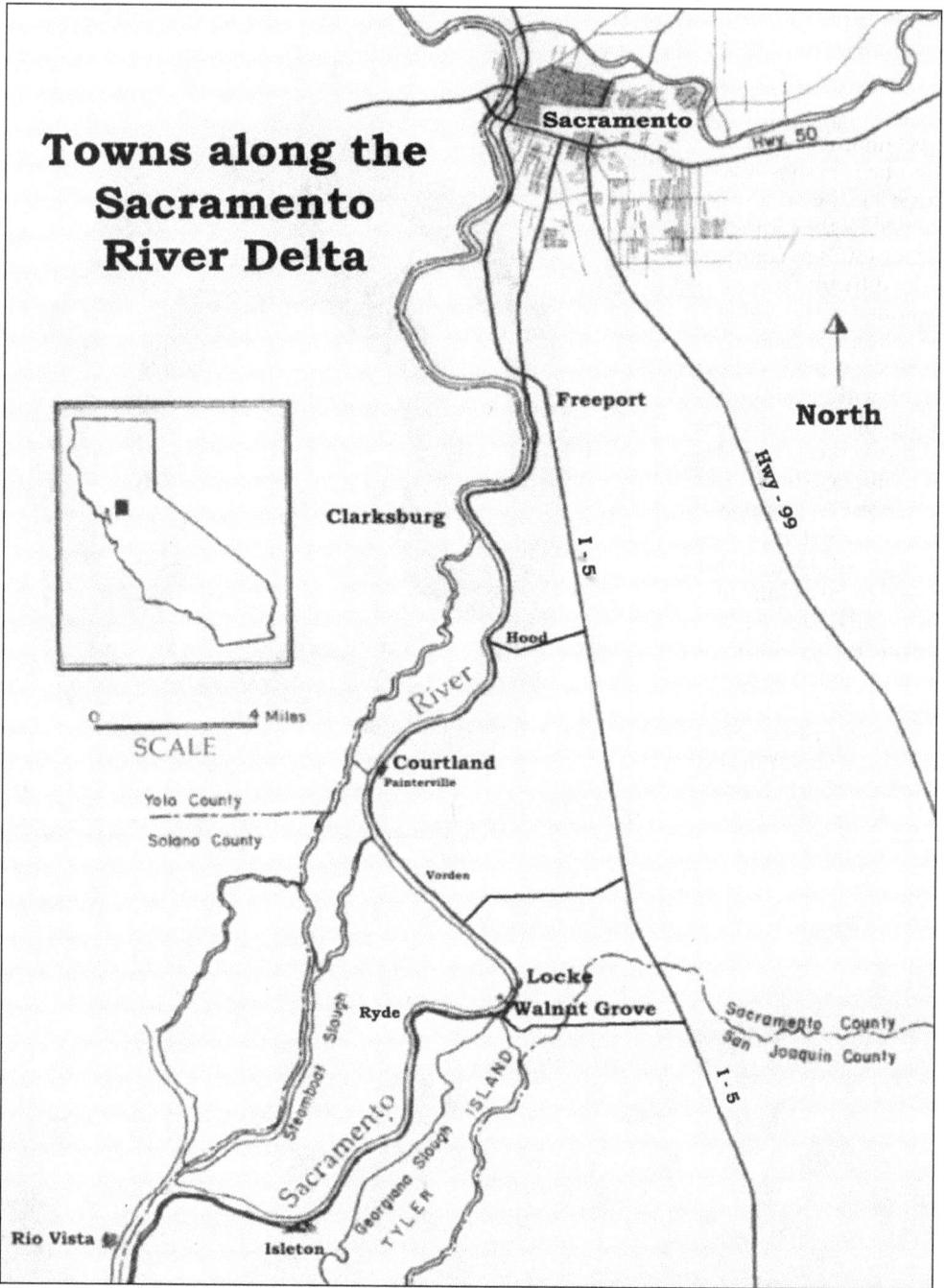

# Towns along the Sacramento River Delta

Sacramento

Hwy 50

Freeport

North

Hwy - 99

Clarksburg

I - 5

River

Hood

SCALE

0 ——— 4 Miles

Yolo County

Solano County

Courtland
Painterville

Vorden

Locke

Ryde

Walnut Grove

Steamboat Slough

Sacramento

Georgiana Slough

TYLER ISLAND

Sacramento County

San Joaquin County

I - 5

Rio Vista

Isleton

This map shows Locke and the delta Chinatowns during the first part of the 1900s. Thousands of Chinese lived and worked in these Chinatowns and on surrounding farms during that time. Beginning in the 1930s, the Chinese left the delta for better education and more job opportunities. Only four towns in the Sacramento River delta—Courtland, Locke, Walnut Grove, and Isleton— have any remnants of a Chinatown. Of those, Locke and Isleton have preserved the contributions of the Chinese in the delta by establishing several museums and restoring a State Historical Landmark Building as part of the California State Parks system.

20

# Three

# COURTLAND'S CHINATOWN

The first Courtland's Chinatown was established before the 1870s upstream from the Courtland Wharf. It was constructed on stilts next to the levee overhanging the Sacramento River. A fire in December 1879 burned down the Chinatown. It was rebuilt but burned down again in 1906. The Chinese then rebuilt that Chinatown at the present location on the land side of the levee immediately north of the town of Courtland. Soon after it was established in 1906, Courtland's Chinatown became a center of Chinese activities both commercially and politically on issues involving China. The Chinatown was not very large but served a big Chinese population that lived on the surrounding farms. The main street had stores, social halls, restaurants, bakeries, boardinghouses, and a Chinese school with over 120 students enrolled at its peak. The Chinese in Courtland were strong supporters of Dr. Sun Yat-sen in his fight against the Qing Dynasty. Dr. Sun, the first president of the Republic of China, was from the Chungshan district in China, and many of the Chinese in the delta were from the same district. A branch of the Young China Association was established in the early 1900s and was very active in the support of Dr. Sun's political reform in China. In the 1930s, the Chinese in Courtland were heavily involved in raising funds for the Kuomingtang (Chinese Nationalist Party) in their efforts to resist the Japanese invasion of China. Tsai Ting Kai, the general of the Chinese 19th Route Army that fought the Japanese in Shanghai, received a hero's welcome when he visited Courtland and the other delta towns in 1934. Chinatown was decorated and a building was specifically constructed to accommodate the ceremony for his visit. Today, the only visible building identified as a Chinese structure is the Wo Chong building that is immediately south of the entry road to the old Courtland Chinatown. It was last operated by Bo You Mark and was closed in 1974 when he retired. This Chinatown no longer exists.

### Sacramento River

Perry Landing

To Locke  State Highway 160 — River Road  To Sacramento

Gas Station

Post Office

Up

Pool Hall

Andy's Bar Wo Chong

Wo Chong Warehouse

Japanese School

Chew

Owyang

Muranishi Barber Shop

Mark

Japanese Meeting Hall

Bow

Barn

Theater

Ng Jang

Yuen

Canopy over Street

Chauncey Chew Co.

Association Building

Chan

Hongs

Cheung

Gambling

Gee

Yamada

Jang

Big Fig Tree  Ting

Fujii

Horishsu

Kwong Chong Chan Co.

Chan

Japanese Hotel

Changshan Chinese School

A

Gambling

Fish Market

North

Joe

Water Tower & Fire Fighting Equipment

Chung Wah Gung So Association Hall

Ow

Go

Pear Orchard

Note: The road had a slight bend to the right at point 'A' on the map

This map of Courtland's second Chinatown is a composite of two hand-drawn maps, one by John Owyang and another by Deming Chew. Both were born and raised in Courtland, and both are licensed architects. This was the Chinatown around 1930s through to 1940s. The map is not to scale. There is a slight bend in the main street (identify at point A) that is not reflected on the map.

The first Chinatown in Courtland was established upstream from the Courtland Wharf in the 1870s. It was constructed on stilts atop the levee overhanging the Sacramento River. A fire in December 1879 burned down the Chinatown. It was rebuilt but burned again in 1906. The Chinese then rebuilt the town at the present location on the land side of the levee immediately north of the town of Courtland. (Courtesy Edna Chew Liang.)

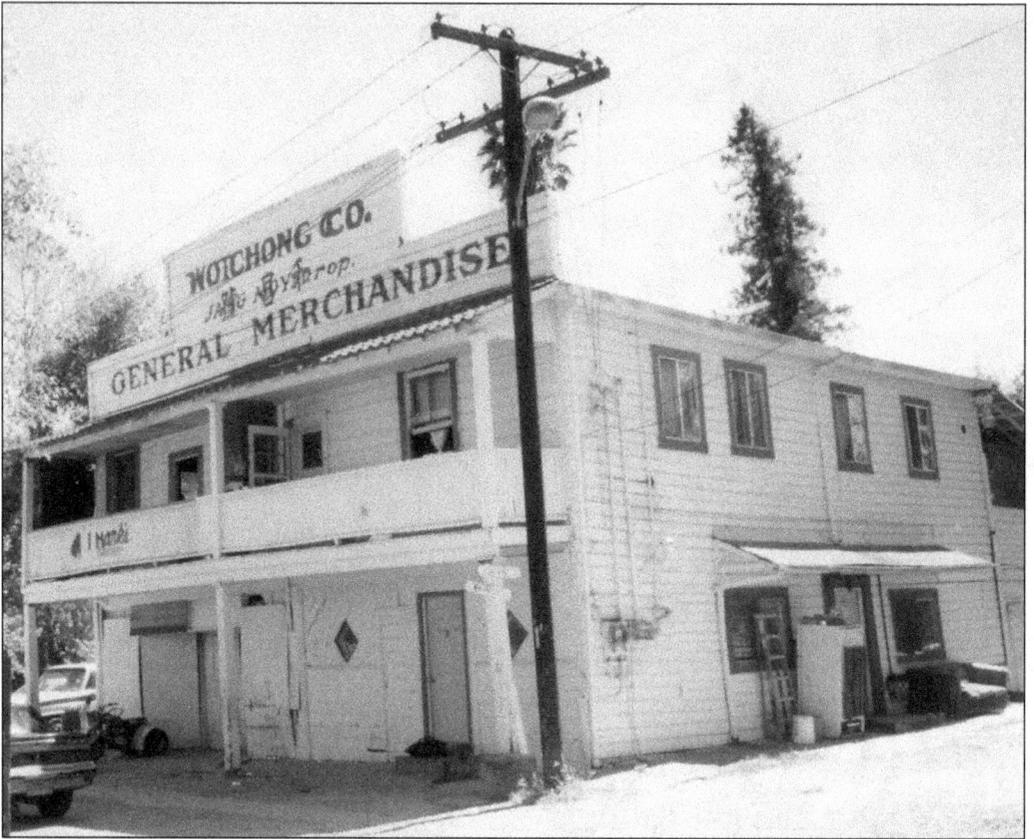

Wo Chong was a dry goods store that was established in 1887, overhanging the Sacramento River. The business moved to the land side of Courtland's Chinatown after the fire of 1906. It moved again to its present location after another fire. The store was owned by the Jang family for many years and was subsequently sold to Bo You Mark in 1966. (Courtesy Elsie Owyoung Yun.)

Bo You Mark came to America in 1919 and worked the various farms and ranches around the delta. He returned to China and married Chew Lin Owyoung. He returned to America, but Chew Lin did not join him until 1947. Bo You purchased the Wo Chong business in 1966 and named it Mark's Grocery. He operated it for eight years, closed the store, and retired in 1974. (Courtesy Arthur Mark.)

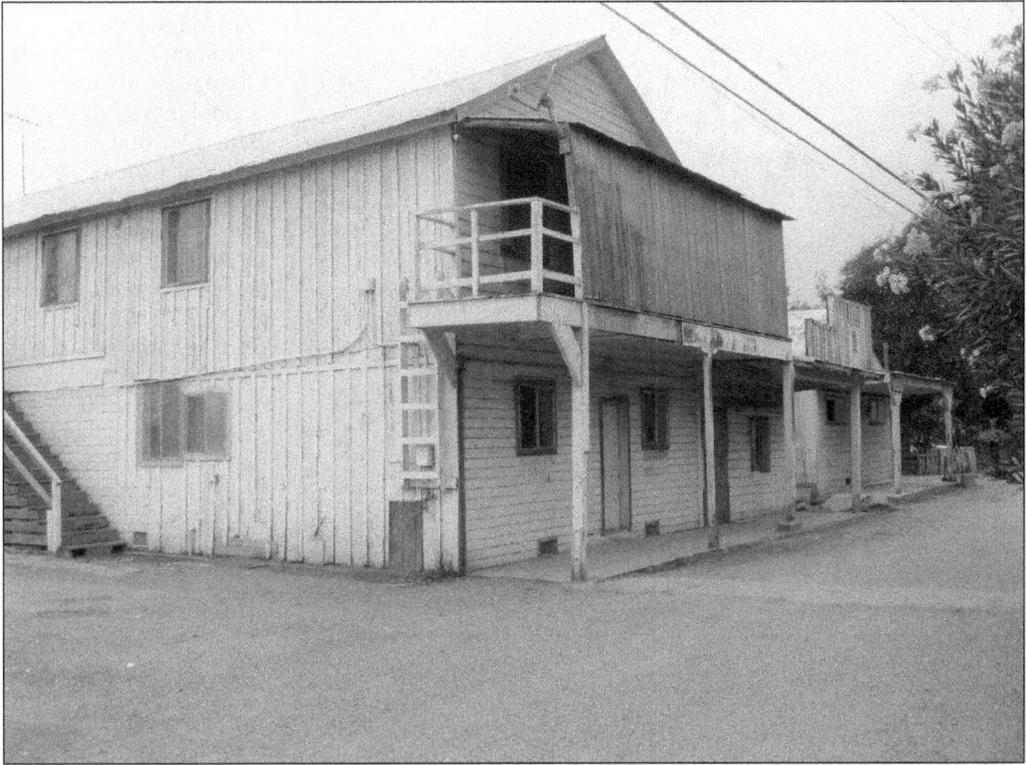

This was the second location of the Chinese school in Courtland. The first Chinese school further back on the main street of Chinatown burned down in the 1927 fire. There were stairs on the front left side that were later removed.

This is the 1933 graduation ceremony at the Chinese school. From left to right are (first row) Edna Chew, Chauncey Chew, Owyang Cheong, and Joe Yum Dare; (second row) Mary Owyang, Elsie Hing, Ruby Jang, Laura Hing, and Violet Chew; (third row) Jay Foo Wah, Henry Gee, unidentified, Evan Jang, and Ed Gee Edwin Jang; (fourth row) John Jung, Jimmy Hing, Henry Au, Irving Joe, and Lincoln Chan. (Courtesy Paulette Liang.)

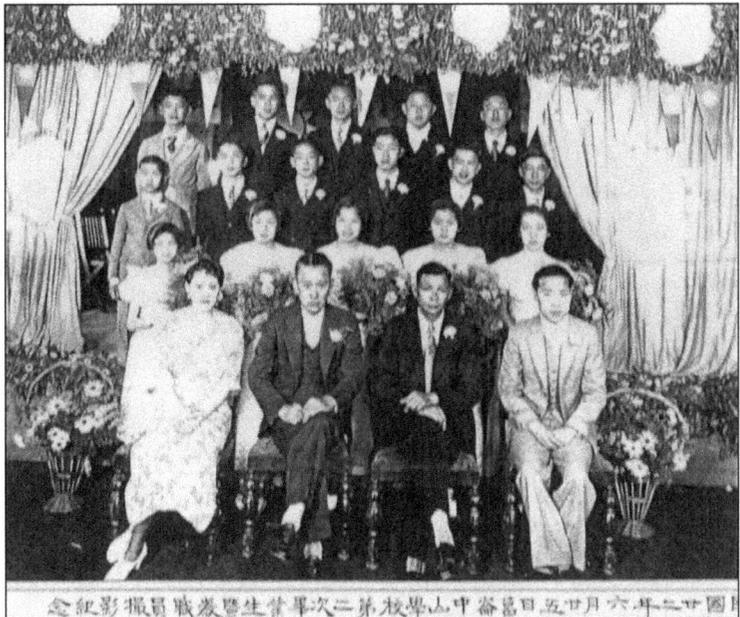

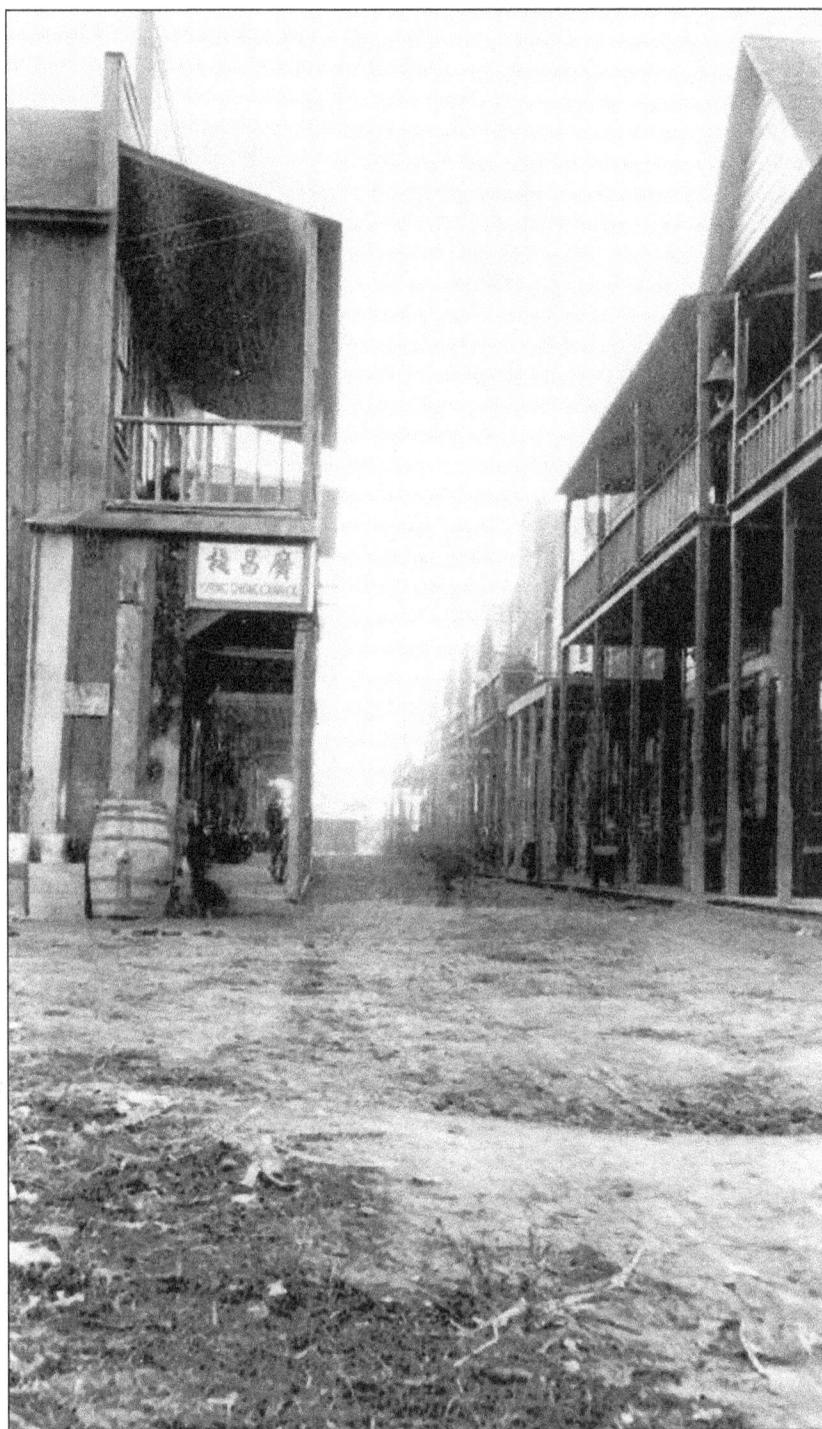

Soon after it was rebuilt on the land side of the Sacramento River in 1906, Courtland's Chinatown became the center of Chinese activities in the upper delta. This is the main street in the early part of the 1900s with the Kwong Chong Chan Store on the left. The streets were not yet paved. The water barrel on the left outside the Kwong Chong Chan store was in case of fire emergencies.

As noted on the partnership papers of the Kwong Chong Chan Company on September 1895, the company was already in existence by 1885. In 1911, Chong Chan became a partner and later assumed complete responsibility for the company. (Courtesy Lincoln, Minnie, and Sonya Chan.)

Chong Chan, second from the right, became a partner of the Kwong Chong Chan Company in 1911. He started farming and later managed large acres of orchards and row crops under lease. Chong Chan was always hospitable, and his dinner table was open to any delta Chinese who was visiting in the area. (Courtesy Helen Jang and Wave Jang.)

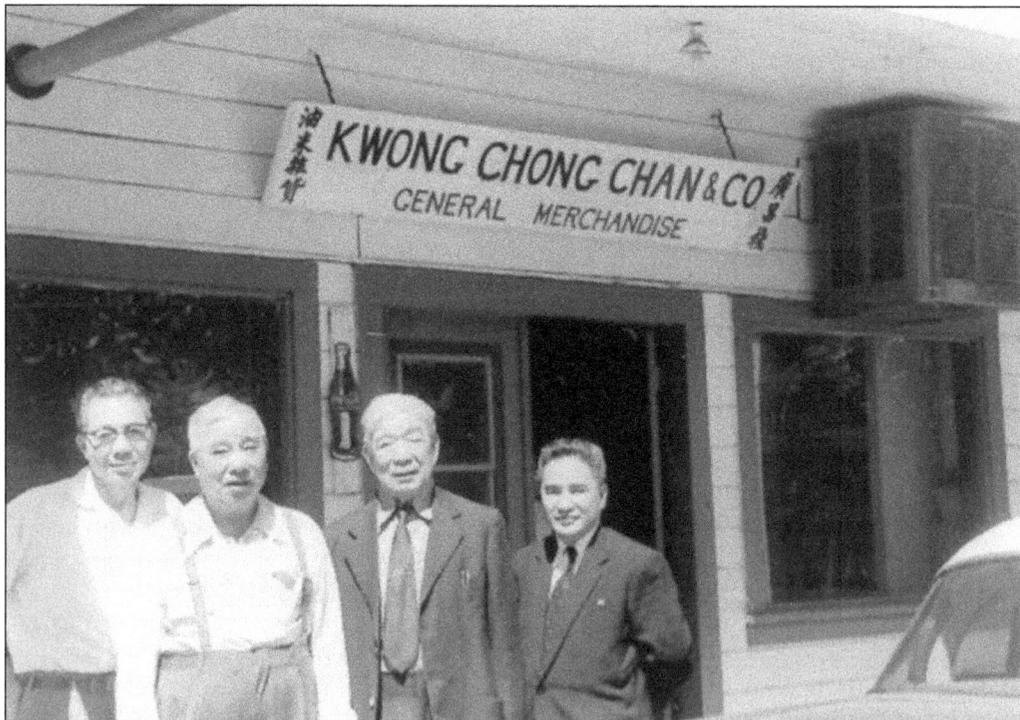

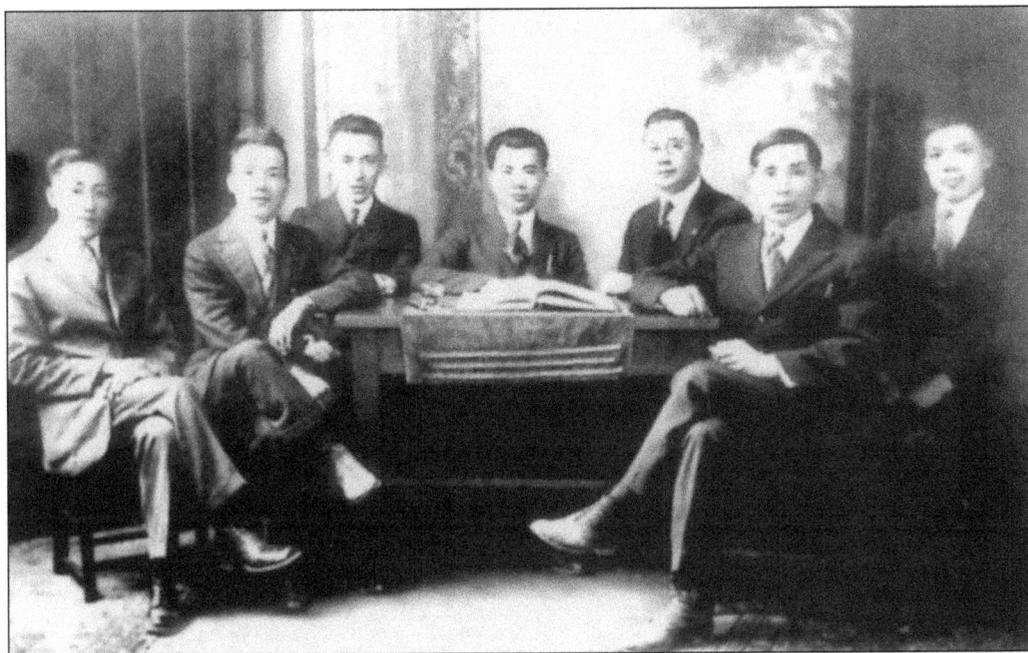

The North America Young China Association in Courtland was a very active organization that supported Dr. Sun Yat-sen in the overthrow of the Qing Dynasty. In this photograph, members of the executive committee of the association in Courtland are pictured in 1910. Jim-Nan Jang was the chairman of this branch at that time and is seated in the center of the photograph. Chauncey Chew is third from the left, and Ngin Jang is the first person on the right. (Courtesy Helen and Wave Jang.)

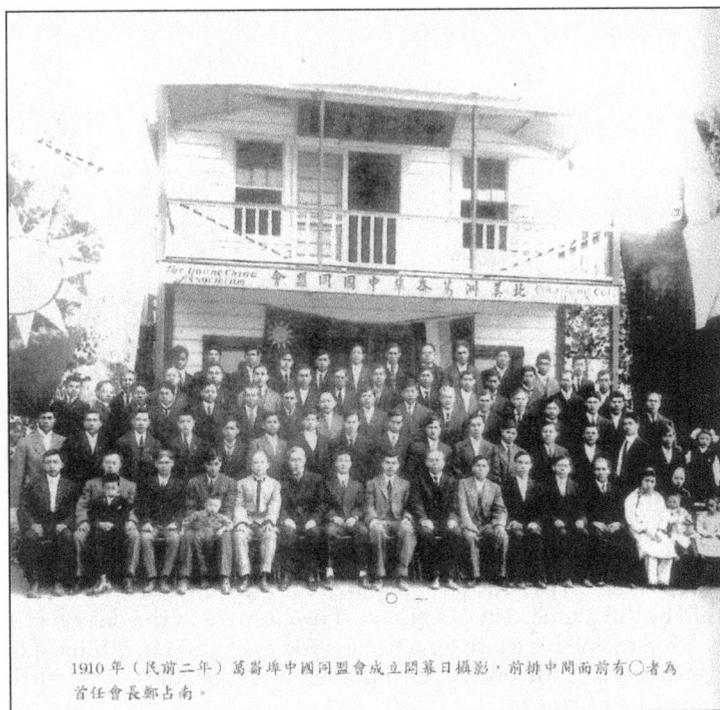

This photograph shows members of the Young China Association in 1910. It had a large membership due to the many Chinese on the surrounding farms. (Courtesy Helen and Wave Jang.)

1910 年（民前二年）葛崙埠中國同盟會成立開幕日攝影，前排中間面荷有○者為首任會長鄭占南。

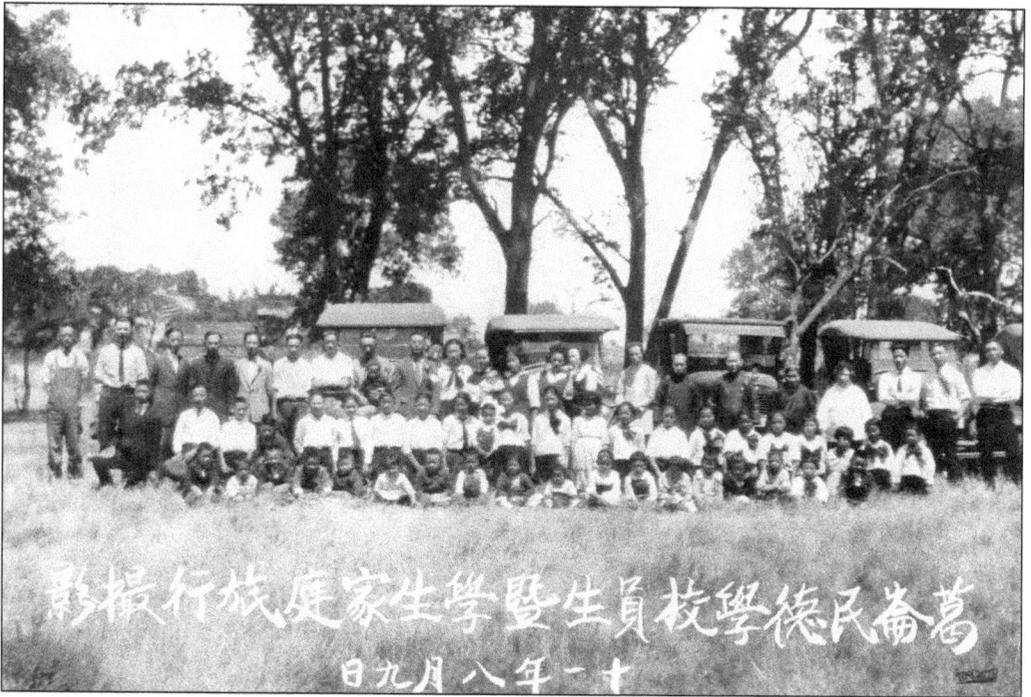

影撮行旅庭家生學暨生員校學德民崙葛
十一年八月九日

This was the annual Sacramento River delta Chinese school picnic held in Ione in 1922. This event was organized by Courtland's Chinese school. All Chinese children from the delta were invited to attend. (Courtesy Edna Chew Liang.)

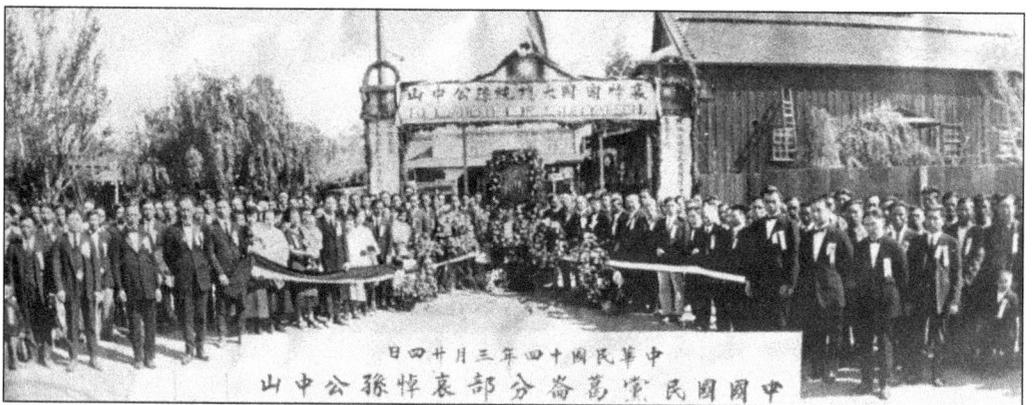

中華民國十四年三月廿四日
中國國民黨萬僑分部哀悼孫中山

Dr. Sun Yat-sen passed away on March 12, 1925. On March 24, an elaborate memorial service was held by the Chinese in Courtland. The Chinese in the delta had always been strong supporters of Dr. Sun and his cause for a democratic revolution in China. The archway for the service was constructed at the entrance to the main thoroughfare of Courtland's Chinatown. (Courtesy Edna Chew Liang.)

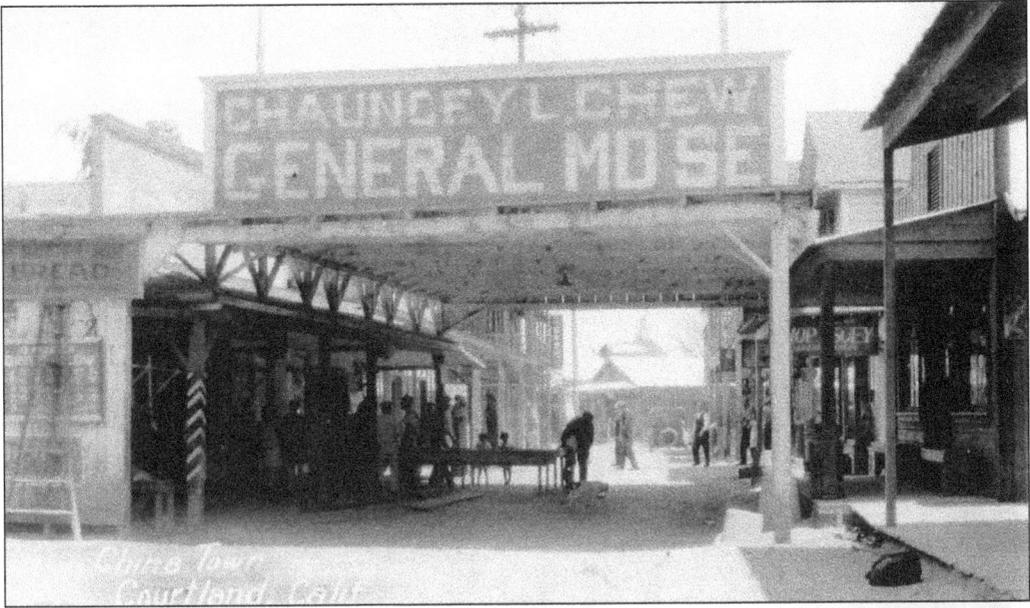

Chauncey L. Chew was born in Hood, where his father, Lum Ah Chew, was a tenant farmer. Chauncey, a student at St. Joseph's Academy in Rio Vista, was one of the few fluent English speakers in the early 1900s. He opened the general merchandise store on the main street in Courtland Chinatown in 1917. He was a dealer in dry goods, notions, hardware, groceries, and auto supplies. Besides the general store, he was a labor contractor during the harvest season, contracting workers from the Bay Area. He was also instrumental in establishing the Chinese school in Courtland. The 1930 photograph above shows his store canopy over the main street in Chinatown. The 1938 photograph at right shows Chauncey. (Both, courtesy Edna Chew Liang.)

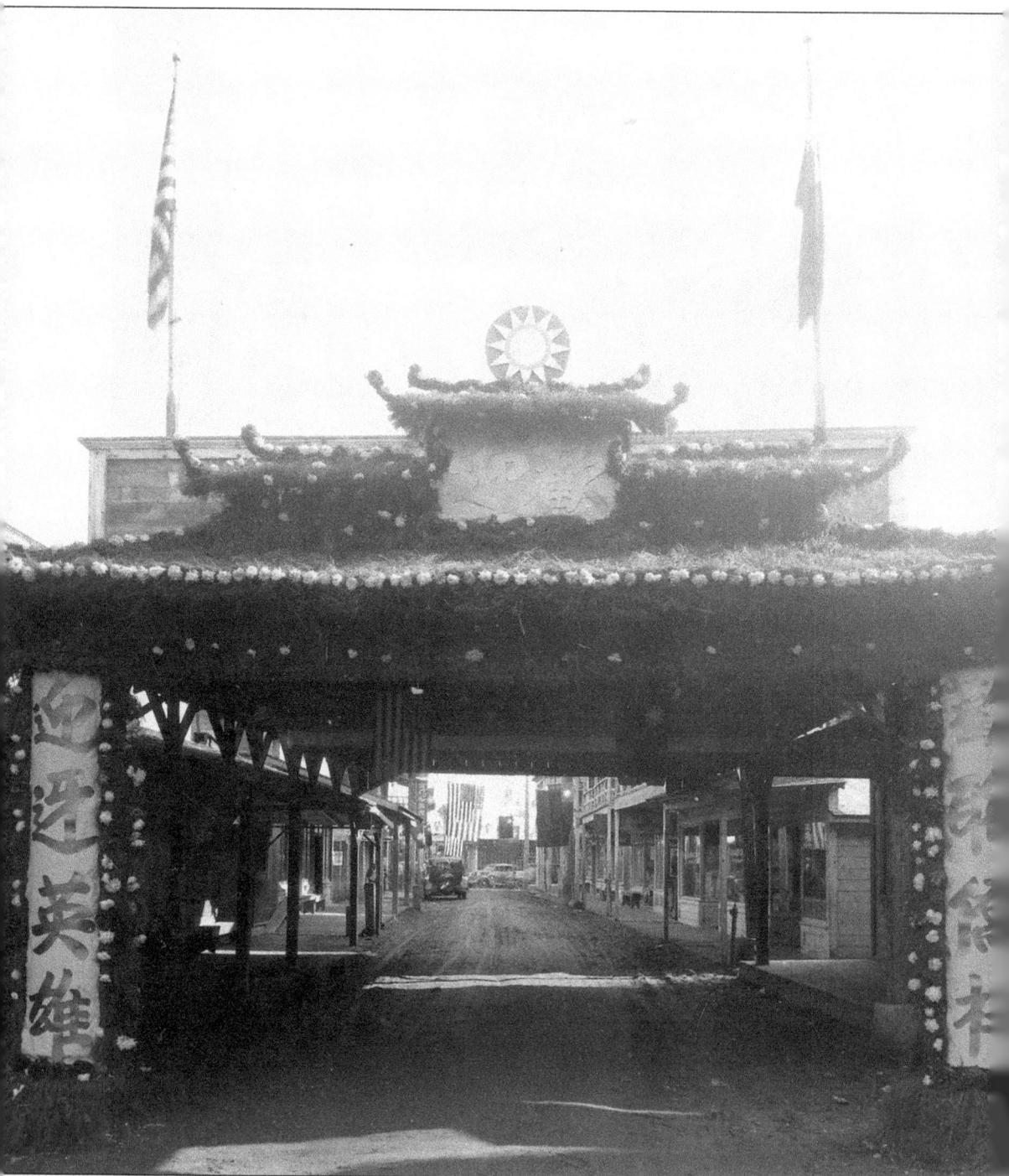

Main Street in Courtland's Chinatown was decorated for Gen. Tsai Tsing Kai's arrival in 1934. General Tsai was a hero in the first battle of Shanghai against a better-equipped and -trained Japanese invasion force. With donations from local citizens and businesses, the arch and reception area was a community project and was completed in seven days. The arch was built in front of the canopy of the Chauncey Chew's store. (Courtesy Edna Chew Liang.)

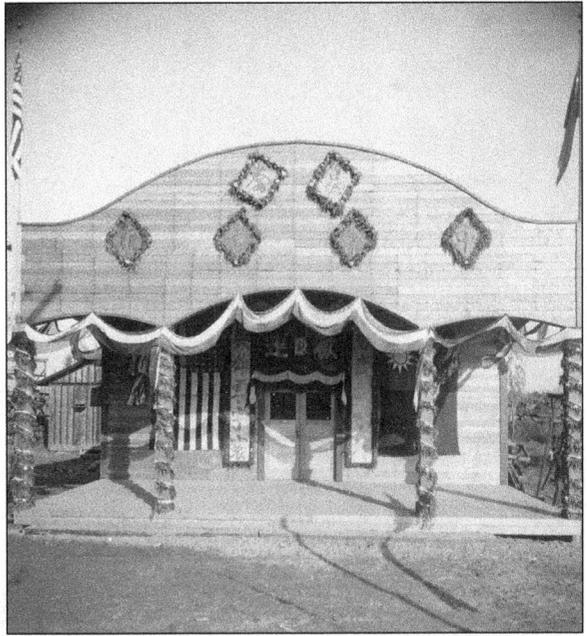

This building at right was quickly constructed and decorated in 1934 for the upcoming visit by Gen. Tsai Ting-Kai. The Chinese in Courtland and the surrounding communities built the wooden structure at a cost of $800. This was considered quite a sum of money considering that it was raised during the latter days of the Great Depression. The photograph below shows the same building in 1995. (Right, courtesy Lincoln, Minnie, and Sonya Chan.)

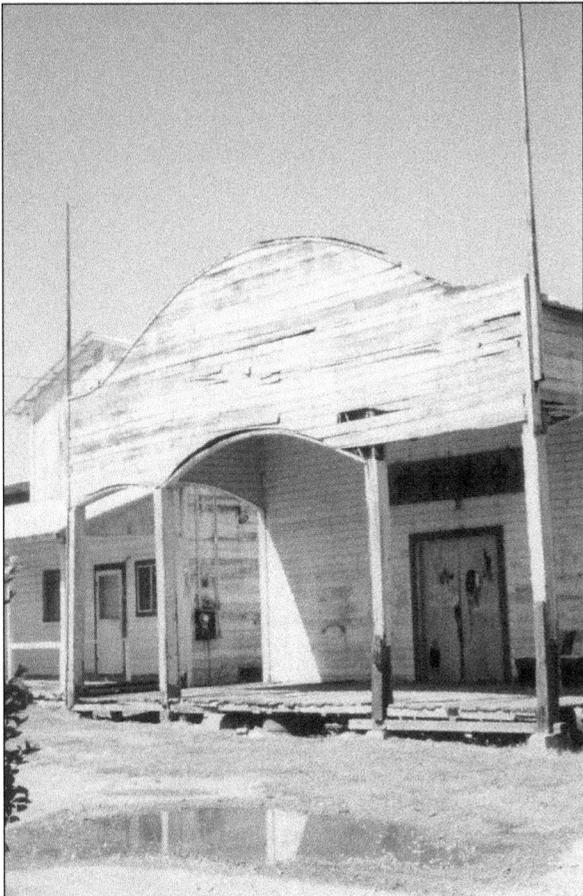

念記攝撮會大軍將館延蔡迎歡僑華體全館會華

武將軍合影 民國二十五年三月二十一日

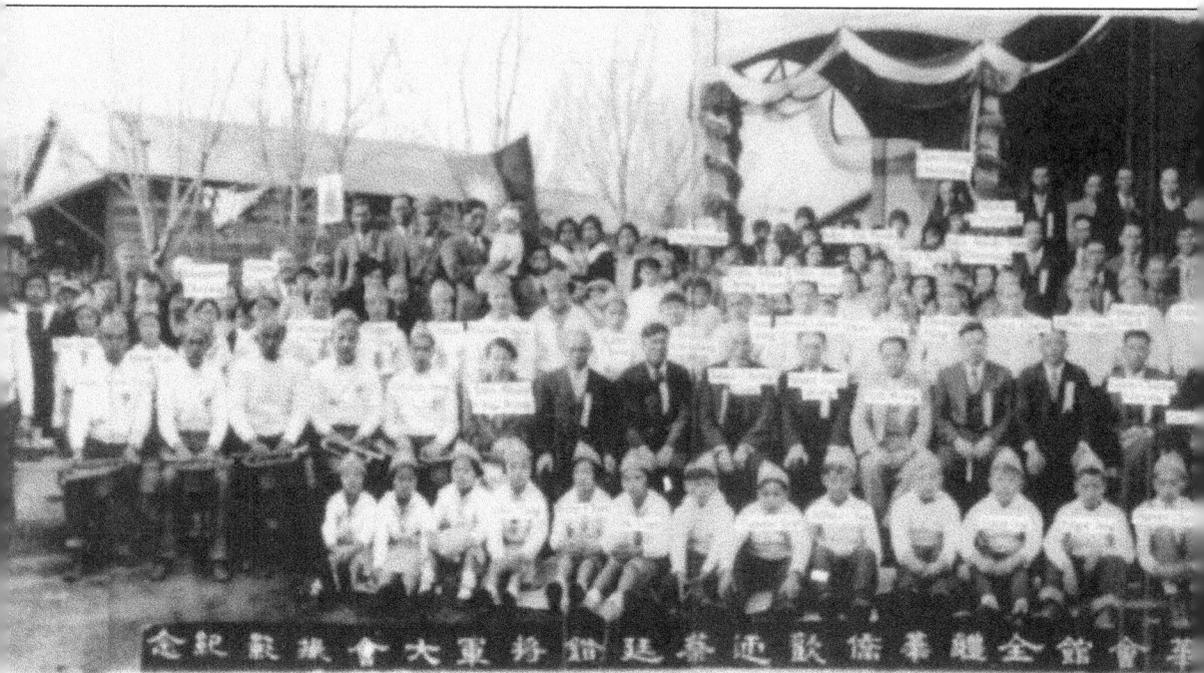

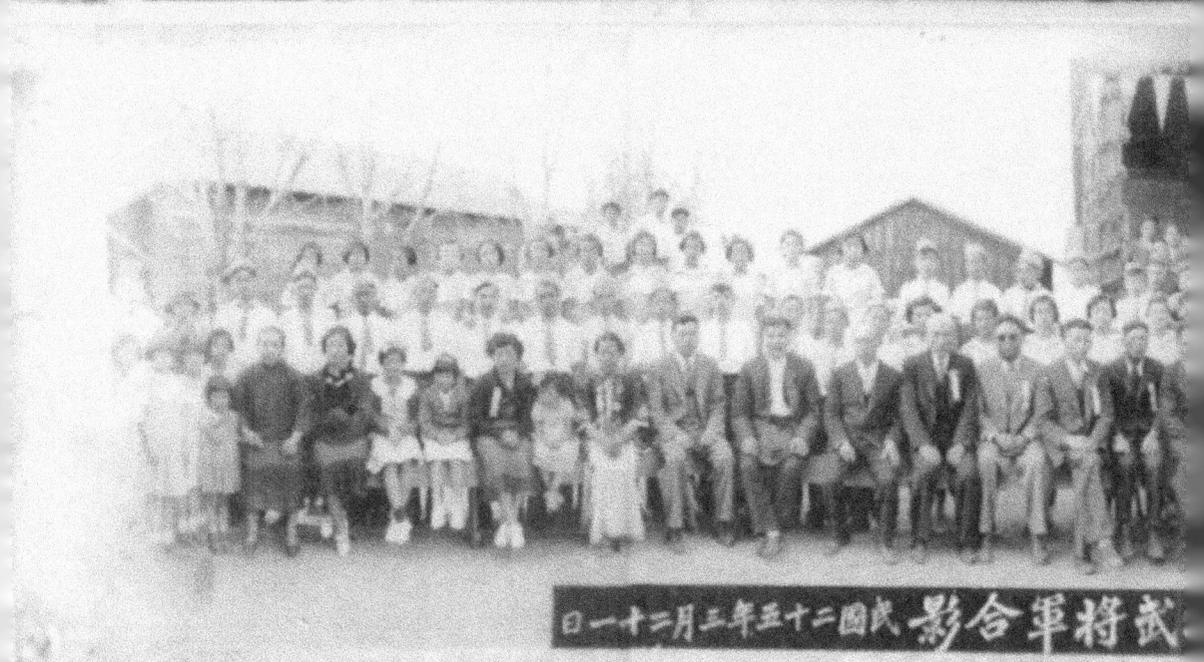

Gen. Tsai Ting-Kai of the Chinese 19th Route Army visited Courtland in November 1934. He was on a worldwide tour to raise funds to fight the war against Japan. This was the welcome ceremony that took place in Courtland. The building in the background was specifically constructed for the celebration in the back of Courtland's Chinatown. He is shown in the upper photograph in the middle of the second row. In the photograph below, Gen. Fong Chun Mo of the Chinese

中華民國二十二年十一月廿五日美洲萬歲

美國萬帝華僑歡迎抗日英

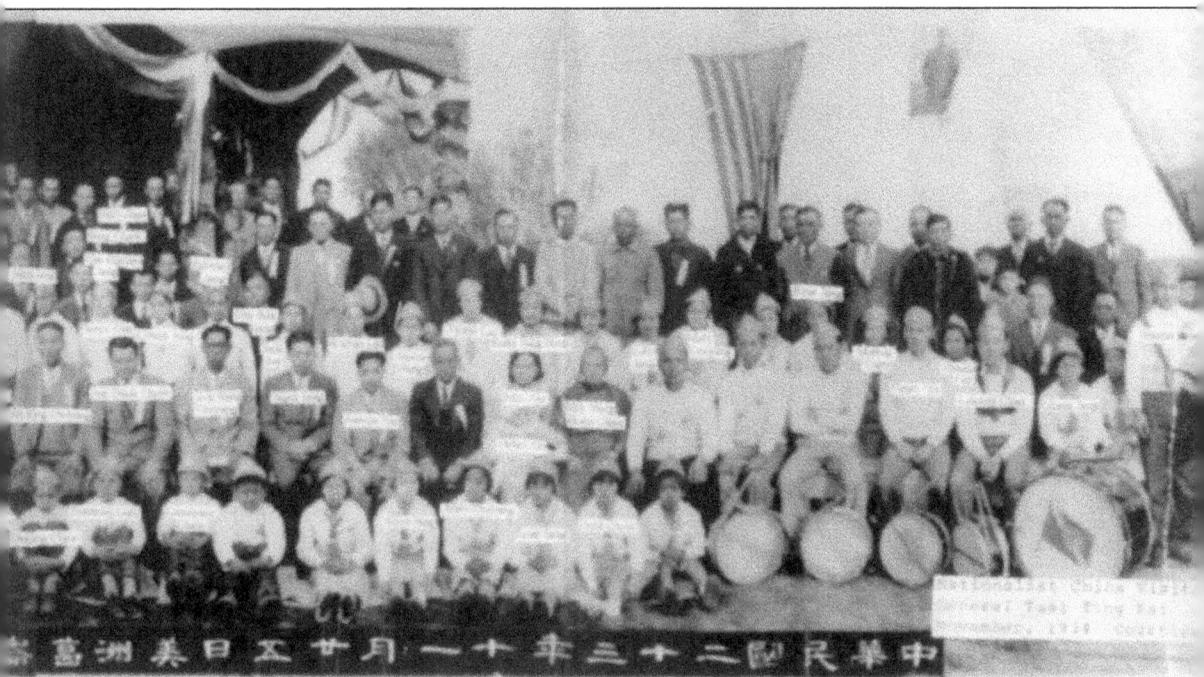

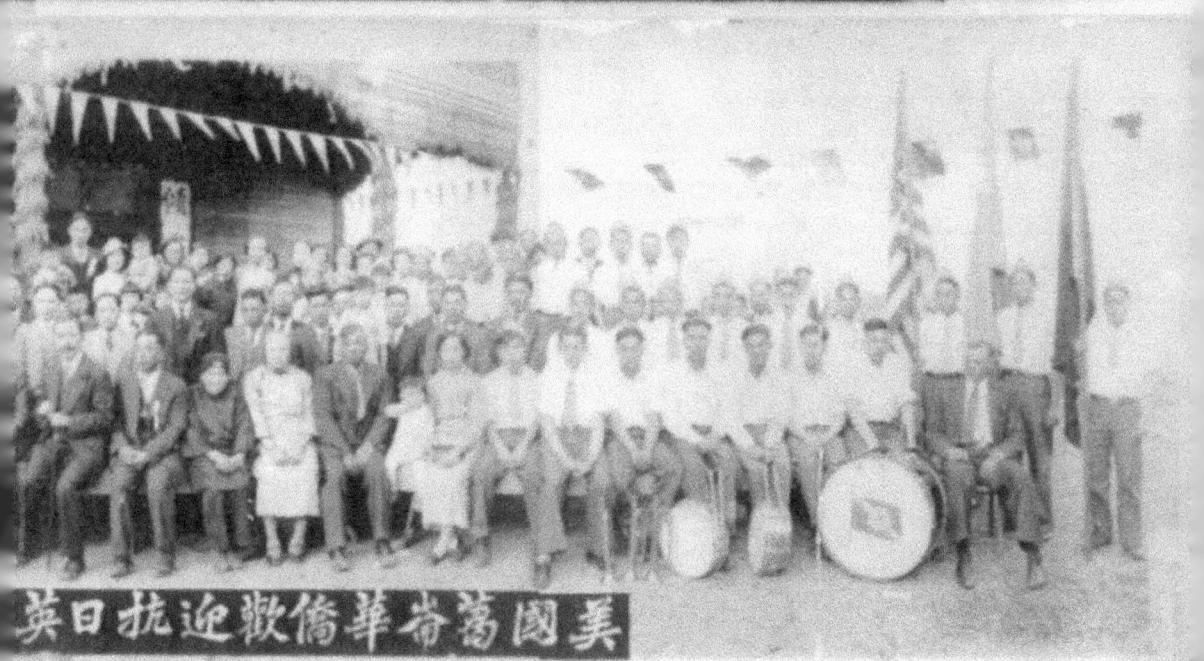

Army followed General Tsai visit's to America to continue raising funds for the war against Japan. This was the welcome ceremony that took place in Courtland in March 1936. General Fong is in the first row in the center of the photograph with the cane in his hand. (Courtesy Elsie Owyoung Yun.)

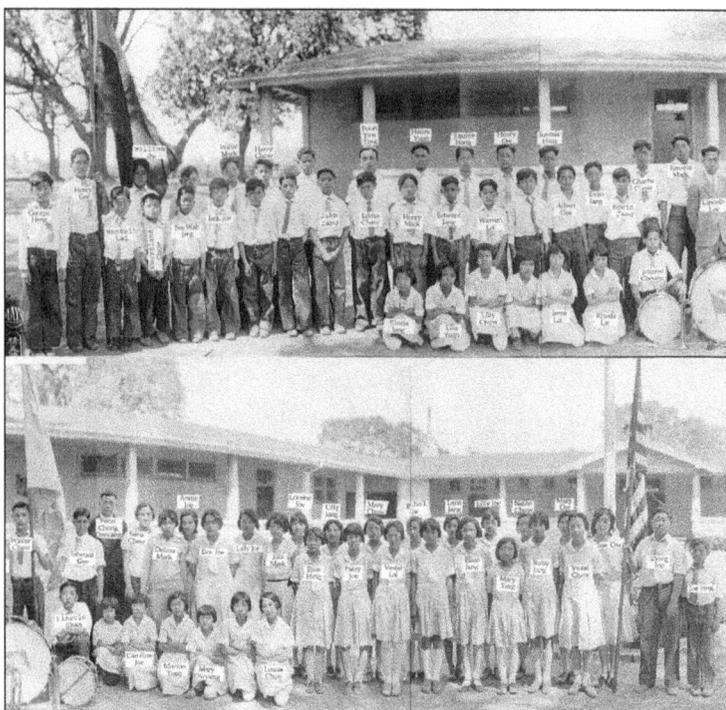

Due to increasing attendance, Courtland's Chungshan Chinese School moved to the Bates Oriental School building. Classes were held from 5:00 to 8:00 p.m. on weekdays, after public school, and 9:00 a.m. to 12:00 p.m. on Saturday. The photograph was taken on April 11, 1931, at the Chinese school, showing all teachers and students. (Courtesy Elsie Owyoung Yun.)

The first segregated Oriental public grammar school in Courtland was built in 1916 and was referred to as the Old Primary School. That school was replaced by the Courtland Bates Oriental Grammar School, built in 1921. Due to the increasing number of Asian students, four more classrooms were added in 1926. Segregation at the delta schools continued until 1942. (Courtesy Frank Lum.)

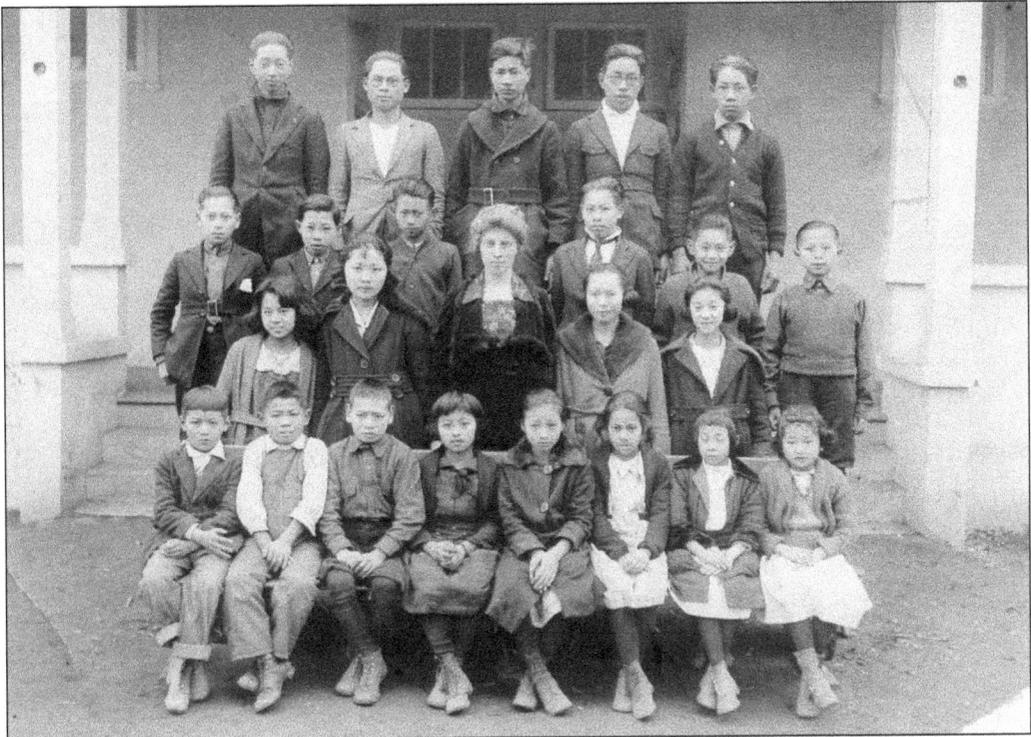

These are the Asian students at the Bates Oriental Grammar School in 1920. The eighth grade students in the back three rows are, from left to right, (second row) Louise Gunn, Gladys Wu, Mrs. Horton (teacher), Ella Lai, and Rita Ow; (third row) Jack Chew, Tim Jang, unidentified, Ernest ?, Harry Ow, and Gred Gunn; (fourth row) Ping Ow, Delbert Mar, Foon Yuen, unidentified, and Albert Law. (Courtesy Elsie Owyoung Yun.)

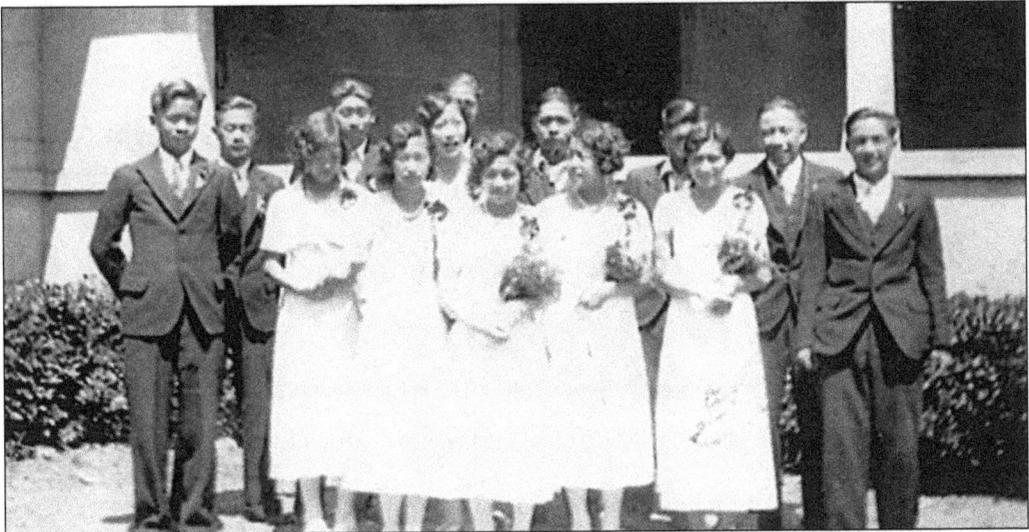

These are the graduates and friends from the Courtland's High School in 1930. In the photograph are, from left to right, (girls) unidentified, Ethel Ow, May Young, unidentified, unidentified, and Edna Chew; (boys) Jimmy Hing, Henry Ow, Jimmy Mark, unidentified, Bo You Mark, unidentified, Chester Chew and Henry Gee. (Courtesy Arthur Mark.)

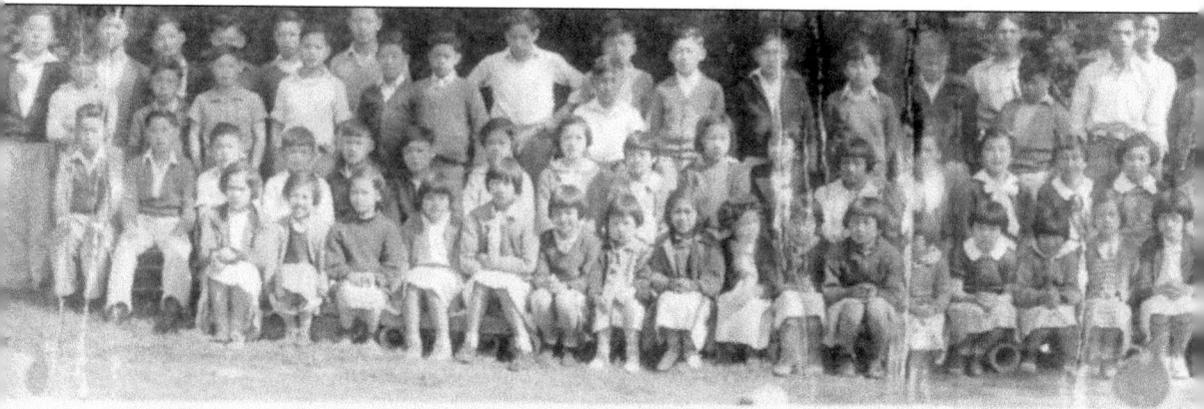

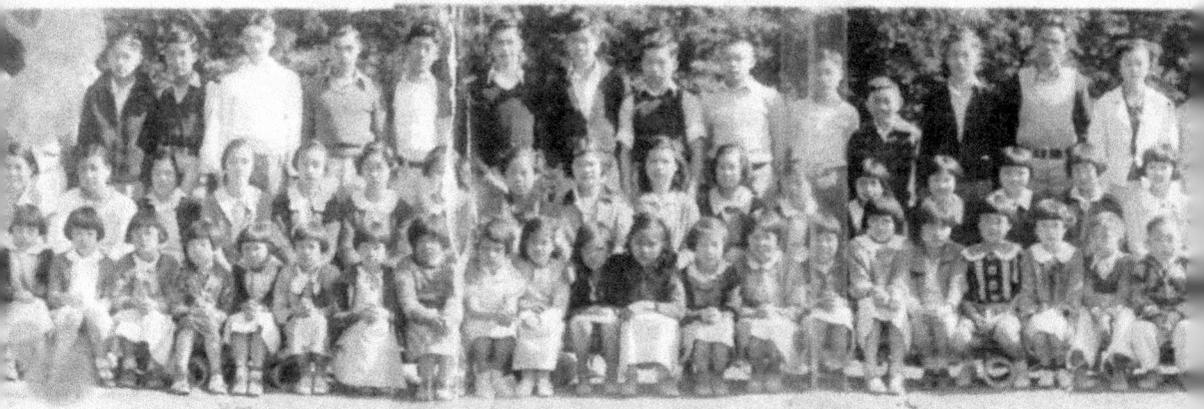

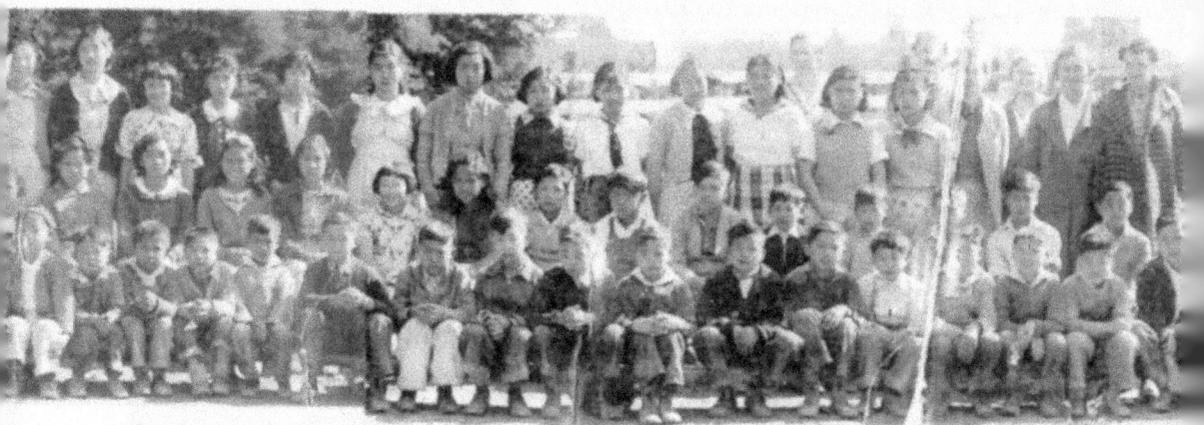

These are the students and the teachers at the Bates Oriental Grammar School in Courtland in 1937. (Courtesy Frank Lum.)

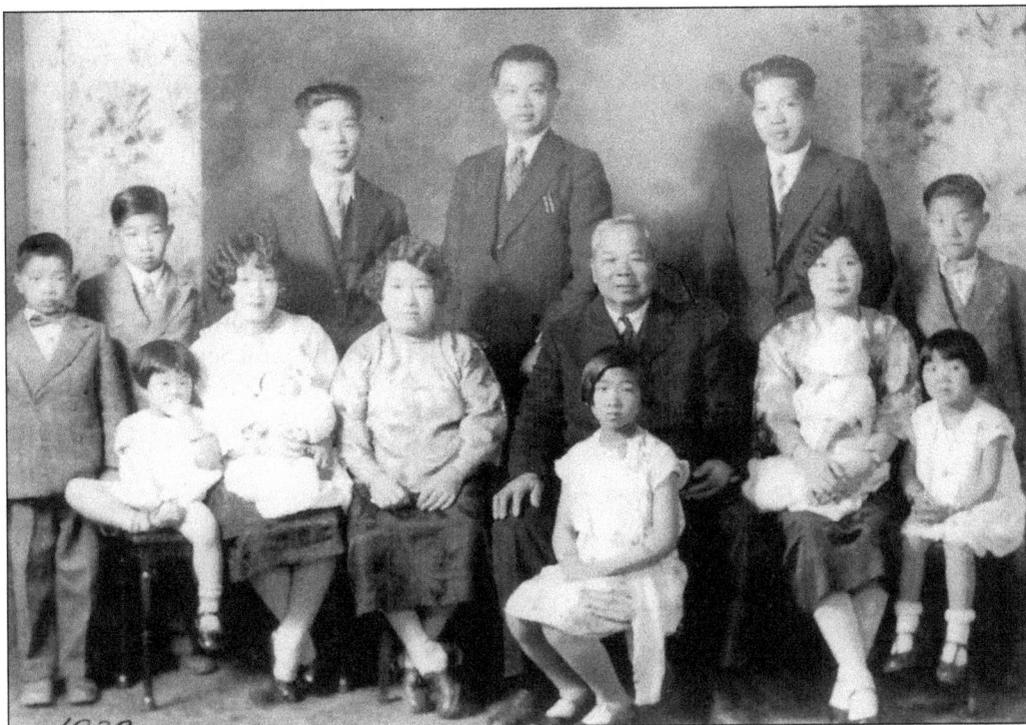

Hung-on Jang came to America in the 1800s and helped worked on the levees. He became a partner in the Wo Chong Company in Courtland's Chinatown in the early 1900s. He was very active in supporting the effort of Dr. Sun Yat-sen, and when Dr. Sun visited America, he had stayed at his home in Courtland. This is Jang with his family in 1929. (Courtesy Helen and Wave Jang.)

This is the partnership paper for Wo Chong Company in 1911. Hung-on Jang (aka Jang Tai) became a partner in the early 1900s and eventually assumed full responsibility for the company. The company was sold in 1966 to Bo You Mark. (Courtesy Lincoln, Minnie, and Sonya Chan.)

List of Partners of the firm of
Wo Chong & Co.,
Courtland, California.

----oOo----

State of California, }
City and County of San Francisco.} SS.

Jang Tai, whose photograph is hereto attached, being first duly sworn upon oath, doth depose and say:-
That affiant is the managing partner of the firm of Wo Chong & Co., dealers in General Merchandise, at Courtland, in the County of Sacramento, State of California, and that he makes this affidavit for and on behalf of the said firm. That the place of business of the said firm is located in the said Town of Courtland.
That the capital of the said firm is the sum of $10,100.00 consisting of stock on hand and solvent credits.
That the following is a true and correct list of all of the members of the said firm, their respective interests in the said firm, and their places of residence being also given, together with their respective names written in Chinese characters.

| Name | Residence | Interest | Names written in Chinese characters. |
|---|---|---|---|
| Jang Tai | Courtland, Cal. | $1100.00 | |
| Jang See Lock | Courtland, Cal. | 1200.00 | |
| Wong Gang Hoon, | Courtland, Cal. | 1200.00 | |
| Jang Goon Ngin, | Courtland, Cal. | 1000.00 | |
| Lee Ah Chin, | Courtland, Cal. | 1000.00 | |
| Lee Lun Jung, | Courtland, Cal. | 1400.00 | |
| Jang Koon Mooey, | Courtland,Cal. | 1500.00 | |
| Chung Hung Yuen, | Courtland,Cal. | 1700.00 | |
| | | Total.............$10,100.00 | |

Subscribed and sworn to before me this ....day of December, A. D. 1911.

Notary Public,
In and for the City and County of San Francisco, State of California.

Jang Tai

37

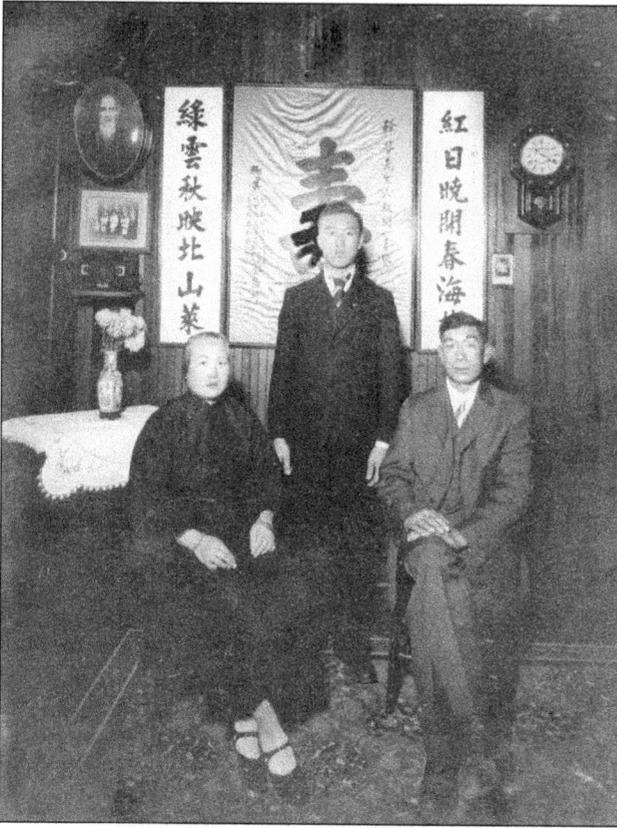

Chong Chan from San Francisco settled in the Courtland area in 1906 after the earthquake. He worked in farming for five years and saved enough money to become a partner in the Kwong Chong Chan Company in 1911. This store operated until 1965. This is Chan with his wife, Luk Shee, and son Lincoln Chan in 1937. (Courtesy Lincoln, Minnie, and Sonya Chan.)

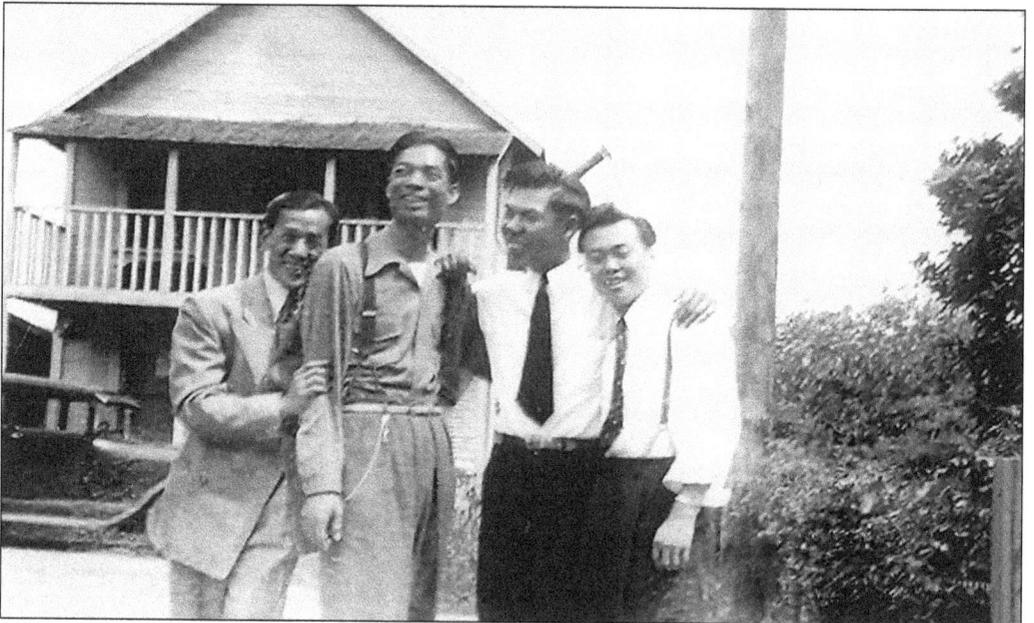

Phillip Liang, second from the right, and his friends from San Francisco were visiting his relatives in Courtland Chinatown during the early 1940s. The Ting's two-story house is in the background. (Courtesy Helen Jang and Wave Jang.)

Pictured in 1936, Helen Jang came to America in 1935 and settled in Courtland. She was the wife of Ngin Jang. She assisted her husband in managing Wo Chong and taught at the Chinese school in Courtland. (Courtesy Helen Jang and Wave Jang.)

This 1922 photograph shows Lum Bo Lin, born in Courtland in 1908. After all her children grew up and left home, she enrolled in the University of Pacific in Stockton and received a bachelor's degree in English in 1958. She later earned an elementary school teaching credential. (Courtesy Nytee Chan Young.)

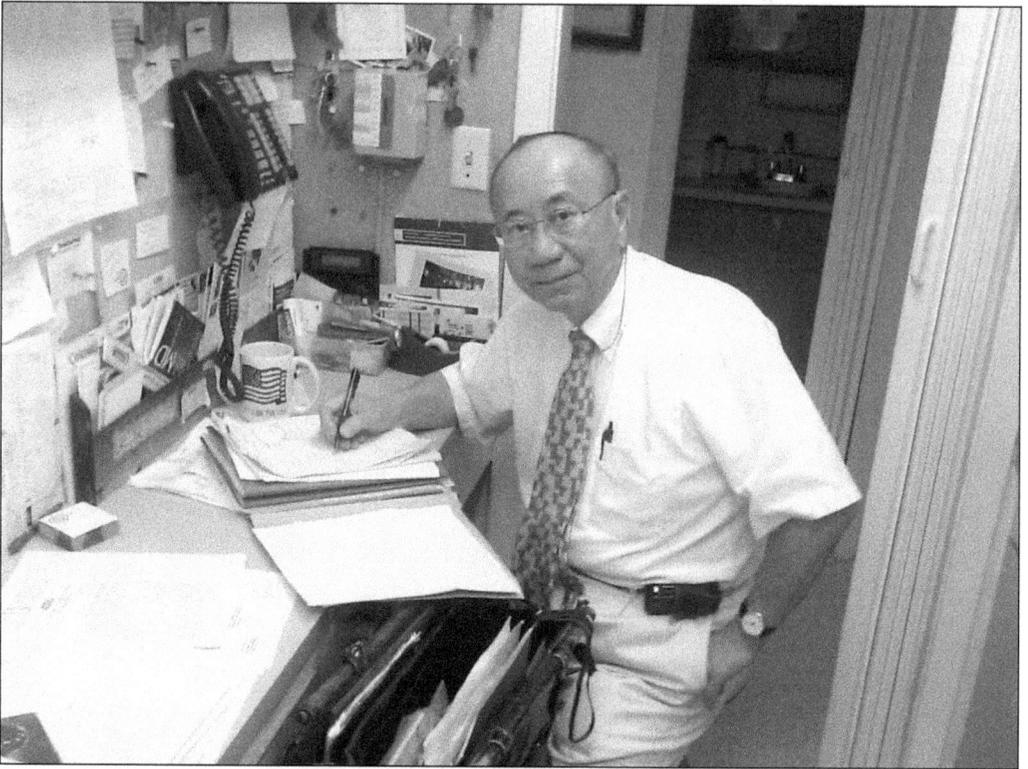

Dr. Henry Go is a native of Courtland. He was delivered by Dr. Raymond Primasing, a physician in Courtland. Henry spent his early life working on the family's farm. He completed his medical education at the University of California, Los Angeles, Medical School in 1959 and did his residency at Cedars Lebanon Hospital in Los Angeles. In 1961, after completing his residency, he returned to Courtland and joined Dr. Primasing in his practice. (Courtesy UCDHS.)

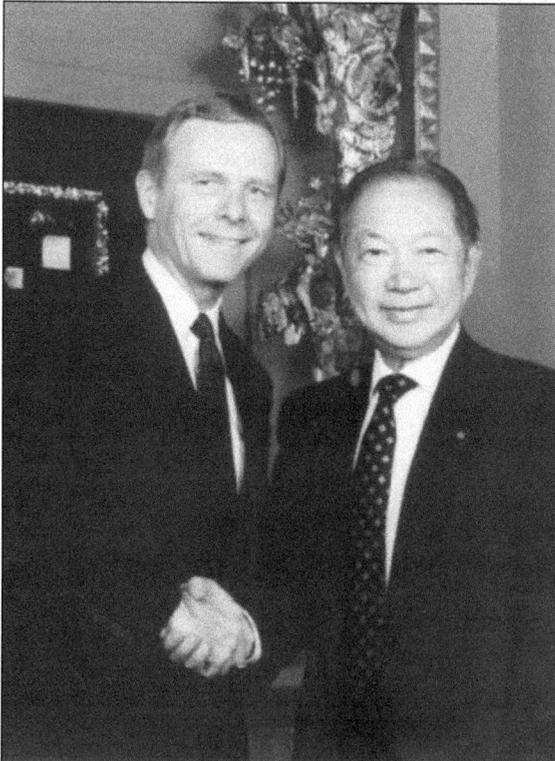

Smith "Archie" Jang, born in Courtland, was very active in politics at the state and federal level. He received much recognition from the Republican Party, and after the successful reelection of Pres. George W. Bush, he was invited to the presidential inauguration in January 2005. Here, Pete Wilson, the governor of California, thanks Jang for his support during his successful 1991 election. (Courtesy Helen Jang and Wave Jang.)

# *Four*

# LOCKE—A TOWN BUILT BY AND FOR THE CHINESE

Locke is a very unique town in America. It was built by the Chinese, and until recently, it was inhabited almost exclusively by the Chinese. In 1912, three businessmen—Tin Sin Chan, Wing Chong Owyang, and Yuen Lai Sin—had three buildings constructed in a pear orchard owned by George Locke. This property was one mile north of Walnut Grove. Two years earlier, Southern Pacific Railroad had constructed a packing shed and a railroad spur that led to the shed. Realizing the business potential of serving the transit labor force for the packing shed, the three businessmen felt that by locating close to the shed, they would attract customers to the area. The three buildings included a saloon (owned by Tin Sin Chan), a boardinghouse (owned by Wing Chong Owyang), and a gambling hall (owned by Yuen Lai Sing). The location of the first three buildings became known as Lockeport. Then, in October 1915, when a fire destroyed the Chinatown in Walnut Grove, a group of Chungshan Chinese merchants headed by Lee Bing decided to build a new town at Lockeport.

Since the Chinese could not own land, Lee Bing leased the property from George Locke and built seven buildings, six stores, and one gambling hall. The town continued to grow, and eventually included a church, a Chinese school, a post office, a lodge, a theater, restaurants, boardinghouses, saloons, grocery stores, a hardware and herb store, a fish market, dry goods stores, a dentist's office, cigar stands, a shoe repair shop, a poolroom, and a bakery, in addition to several gambling halls and brothels. The town had a permanent population of 400. During harvest season, that number increased to over 1,000. When the post office in the town of Vorden, north of Lockeport, was closed and moved to Lockeport, mail was constantly being incorrectly forwarded to Lakeport. The name Lockeport was then shortened to Locke. The Chinese called the town "Lockee," which means "happy living."

Entering from the north, this is the first sign visible in Locke. In 1912, Tin Sin Chan constructed a saloon across River Road from the Southern Pacific Railroad packing shed. Two other buildings were constructed at the same time—Wing Chong Owyang's boardinghouse and Yuen Lai Sin's gambling hall, both on Levee Road. In 1915, the town of Locke grew quickly after the fire in Walnut Grove, and a group of Chinese merchants, headed by Lee Bing, decided to build here.

Wing Chong Owyang was the owner of the boardinghouse, one of the first three buildings in Locke. (Courtesy Wally Owyang.)

# North

**LOCKE ROAD**

Boarding House
Museum 2008

Yuen Chong
garage

Kou Min School 1926
Joe Schoong School 1954
Museum

Yuen Chong
warehouse

RIVER ROAD (COUNTY ROAD E-13)

Yuen Chong
Market

Gambling
Drug Store

Baptist
Mission 1922

Community
Garden

Boarding House
(Burnt Down)
Memorial Garden

To water
tower

Wah Lee
Dry Goods

Fish
Market

Bakery
Lunch Parlor

Beauty
Palor

MAIN STREET

KEY STREET

Al Wop
Restaurant

Star Theatre
Colombia Rooms

Jan Ying Assoc.
Museum

Lim Kee-Hoy Kee
Pool Hall

Dai Loy Gambling
Museum

Victory Gambling Hall
Pool Hall

Hing Yick
Gambling

Chinese School

Kee Sing
Barber shop

Foon Hop
Market

Hing Lee
Moon Cafe
Lantern Restaurant

Sun Hing Chong
Happy Cafe
Post Office

Yuen Lai Sing
Gambling
Est: 1912

Shoe Maker
Repair
Location

Republic
Restaurant
saloon
Est: 1912

LEVEE ROAD

Radio
Shop

Locke
Hotel
Location

Sacramento

Boarding House
Drygoods Store
Restaurant
Est: 1912

## Town of
## Locke in the 1912-1960

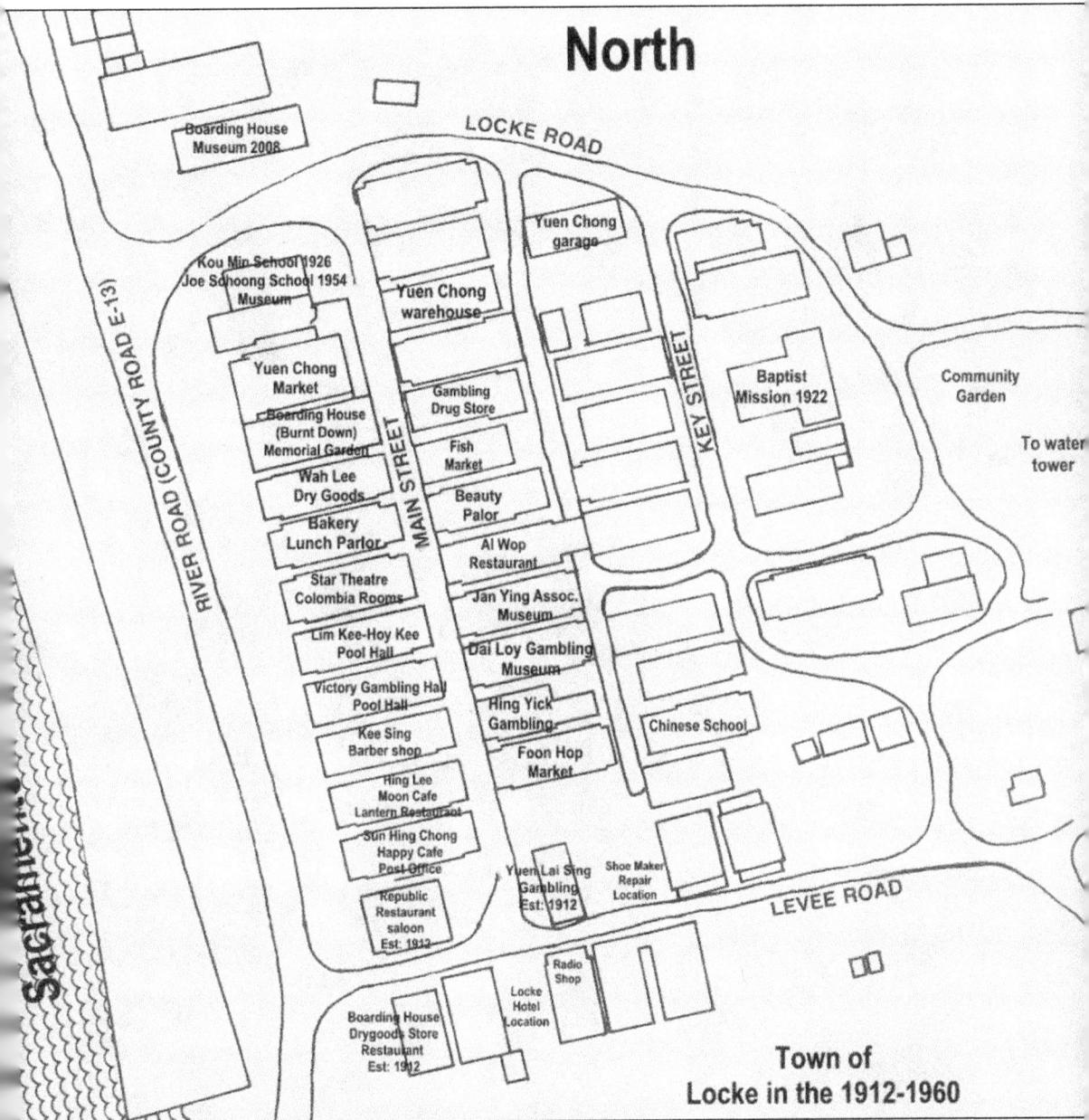

The town of Locke occupied 10 acres. Many of the building on Main Street served as both businesses and homes to the Chinese families. Ownership and use of the buildings on Main Street varied from 1915 to 1950. The first three buildings are identified by the year they were constructed.

This 1940 view facing north shows Main Street in Locke. The Moon Café is on the left. Across the street from the Moon Café is the Foon Hop Market with the c. 1920 vintage gas pump by the car in front of the market. At that time, it was a two-way street with cars parked on both sides,

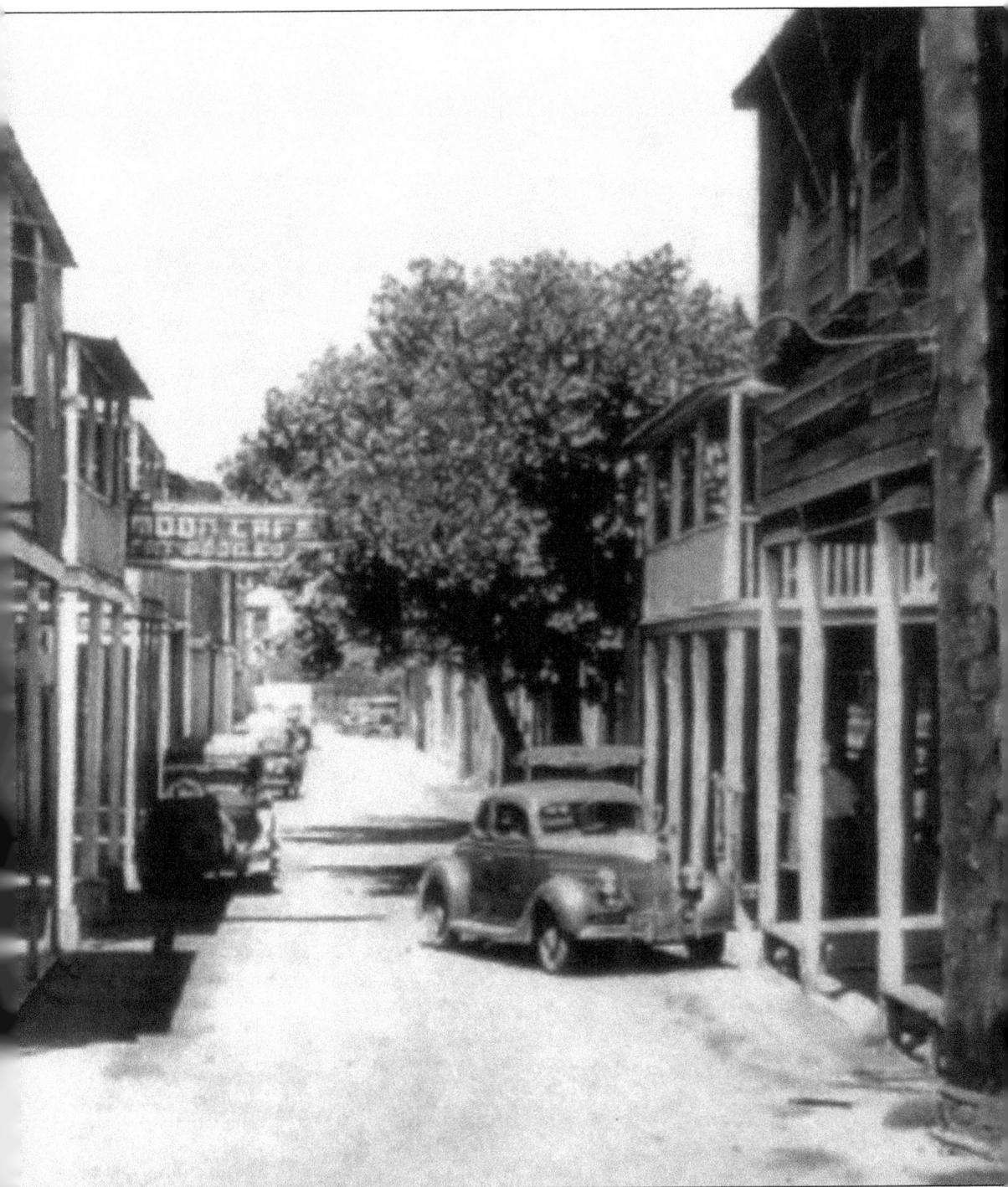

however, due to its narrowness in emergency situations, signs were posted in the 1950s that made it a one-way street heading south. The appearance of the town has changed very little since that time. (Courtesy Ping Lee.)

Starting in 1921, the Kuramoto family operated the boardinghouse at 13916 Main Street. The family lived on the ground floor and rented the rooms on the second floor to seasonal farm laborers. In 2008, the building was restored as the Locke Boarding House Museum for exhibits and as a learning center. It is part of the California State Parks system. (Courtesy Locke Foundation.)

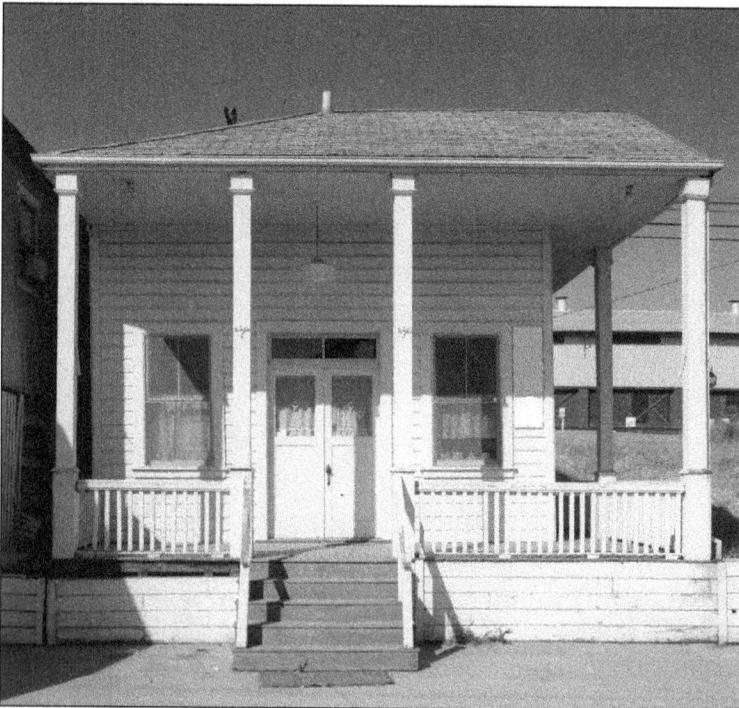

This building at 13920 Main Street was the second group of buildings constructed in 1915 with funding by the Kuomingtang (Chinese Nationalist Party). The building also served as the town hall. In 1926, it was the location of the Kuo Ming School. It taught second-generation Chinese Americans the language, history, and culture of China. This school operated until 1949, and later reopened as the Joe Shoong School. (Courtesy Locke Foundation.)

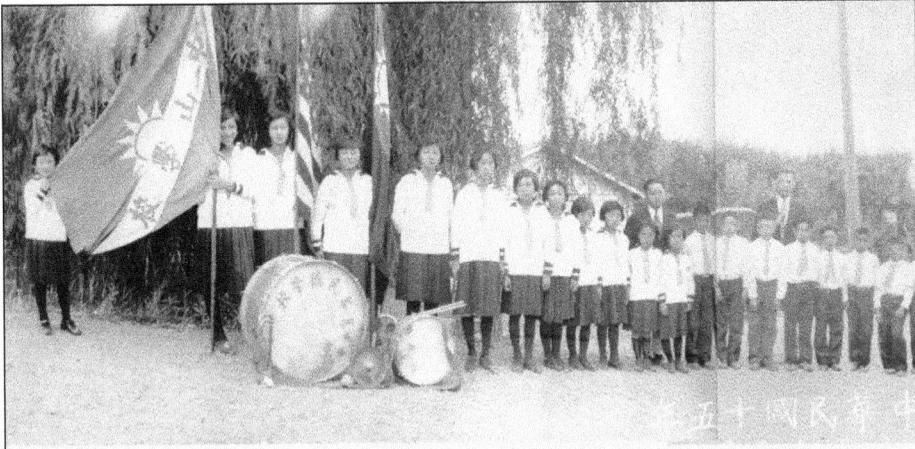

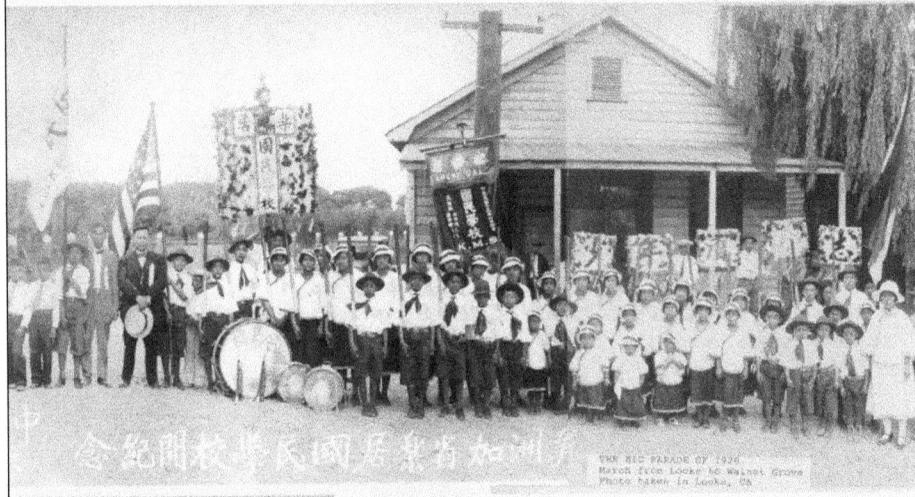

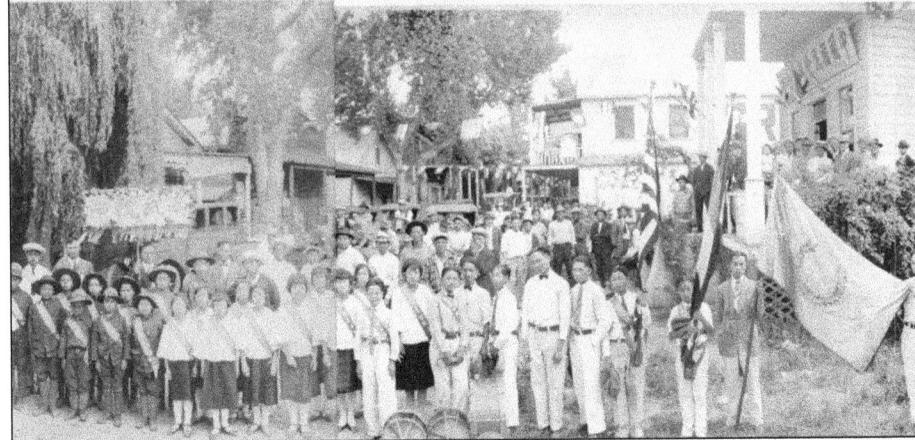

In 1926, the Locke community celebrated the opening of the Chinese Kuo Ming school in Locke. The whole community joined in the celebration by marching from Locke to Walnut Grove and back to highlight the opening. The panoramic photograph was taken from Locke Road on the left (top) to the Chinese school building on Main Street on the right (bottom). (Courtesy Locke Foundation.)

Hoon Gee taught many of the Chinese children in Locke for over 10 years at the Kuo Ming School on Main Street. He also worked as a cook and a butcher at the Yuen Chong Market. Hoon left the Chinese school in 1945. He is pictured on one of the school's outings in the meadows behind the mission building on Key Street in 1935. (Courtesy Don Chan.)

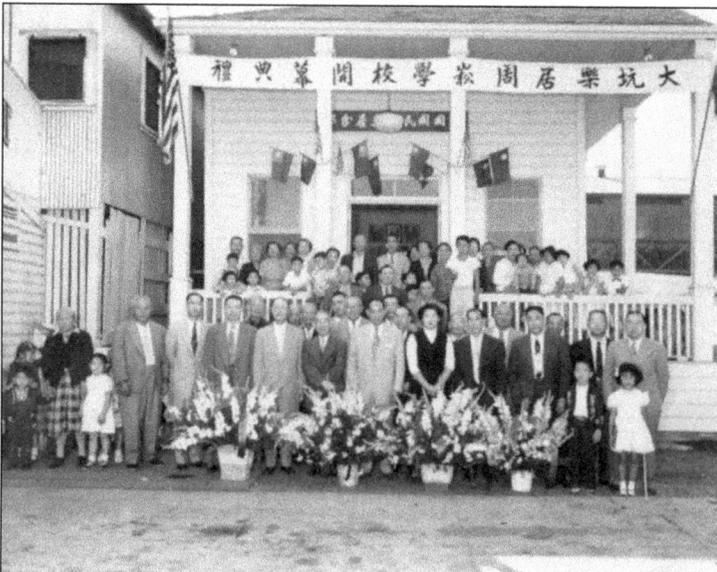

The Joe Shoong School was dedicated in 1954. The building housed the Kou Min School, established in 1926. However, it fell into disrepair after the school closed in 1949. Joe Shoong, the founder of the National Dollar Store, funded the restoration of the building, renamed the Joe Shoong School. The school closed in the mid-1980s due to the lack of Chinese children. (Courtesy Locke Foundation.)

Joe Shoong immigrated to America in 1899 and opened his first store selling dry goods in Vallejo, California. He operated as many as 45 retail outlets called National Dollar Store throughout the West. In 1938, he was cited as one of the highest-paid executives in the United States. He was a philanthropist noted for his generous donations, including his contribution to the Locke Chinese School. (Courtesy Locke Foundation.)

In 1952, Howard Chan approached Ping Lee to restore the Chinese school with funding from his father-in-law, Joe Shoong. Ping Lee, seated on the right, became the facilitator for the restoration and later the first school principal. These are the Locke community leaders at the dedication of the Joe Shoong School in 1954. The newly hired lady schoolteacher is seated to the left of Ping Lee. (Courtesy Ping Lee.)

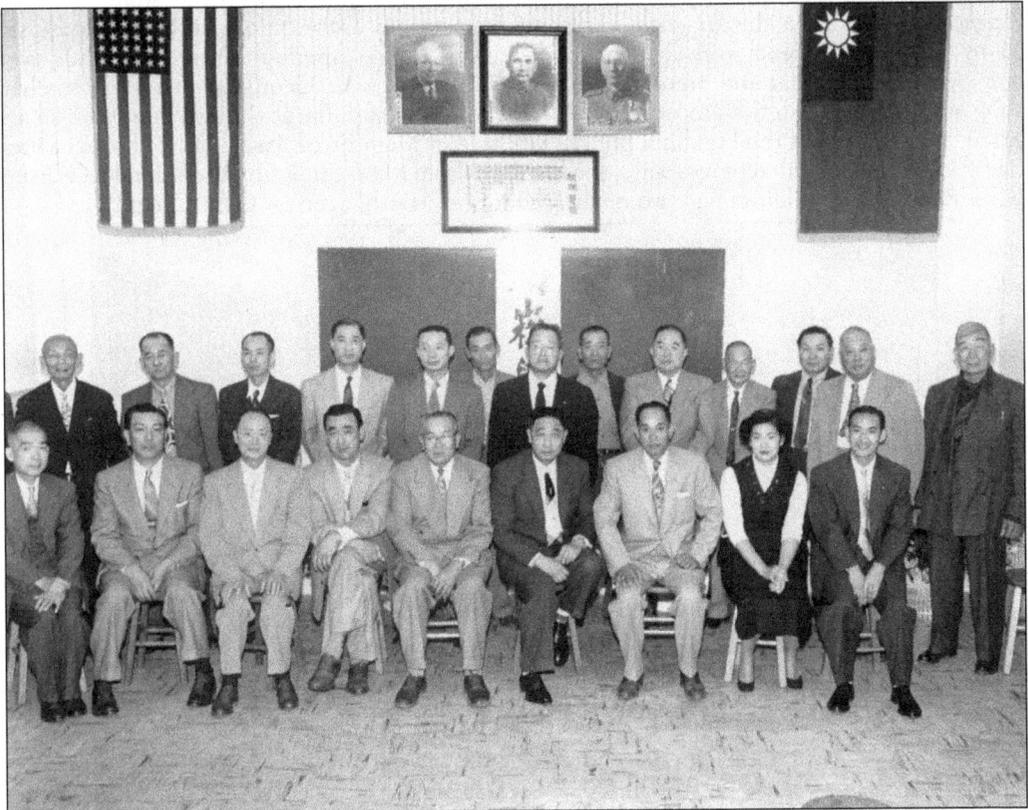

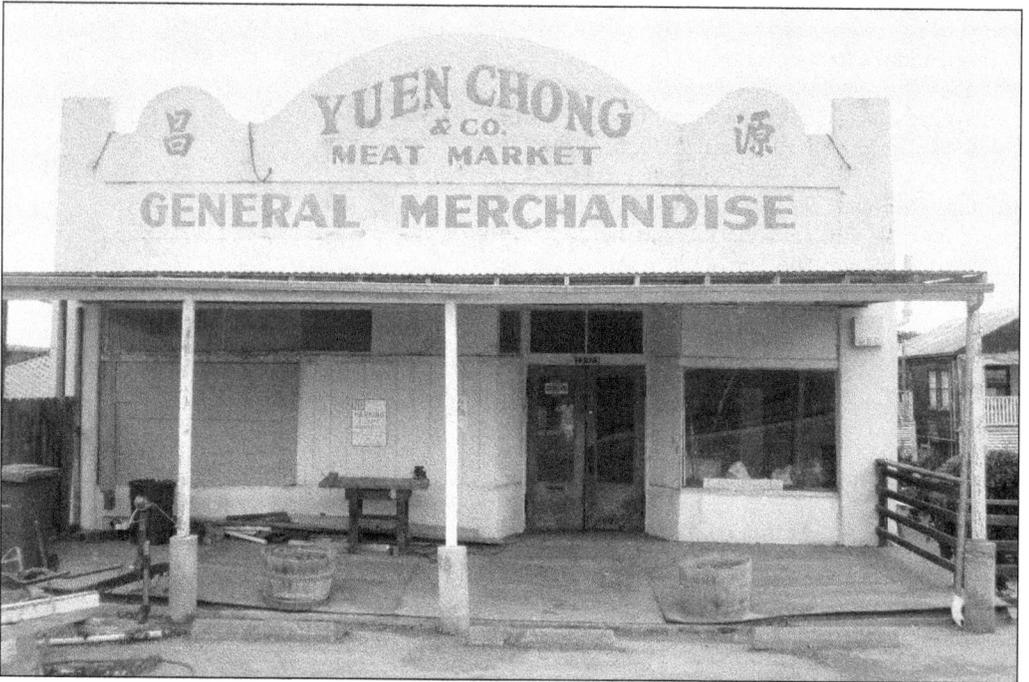

Yuen Chong Market was located at 13923 River Road (13924 Main Street). It was built by a cooperative from Walnut Grove in 1915 and was Locke's first and largest grocery store. Upstairs, facing River Road, was the dry goods and general emporium. Downstairs was the grocery store. Many of Locke's residents worked at the market at one time or another. In the early 1960s, two employees, George Mar and Stanford King, purchased the store. George operated the butcher shop, and Stanford ran the grocery. Yuen Chong also sold gasoline at the two pumps on Main Street. Since many of the buildings on the west side of Main Street backed into the levee and had entry from two different roadways, the first level from Main Street and the second level from River Road, these buildings had two mailing addresses. (Both, courtesy Gene Chan.)

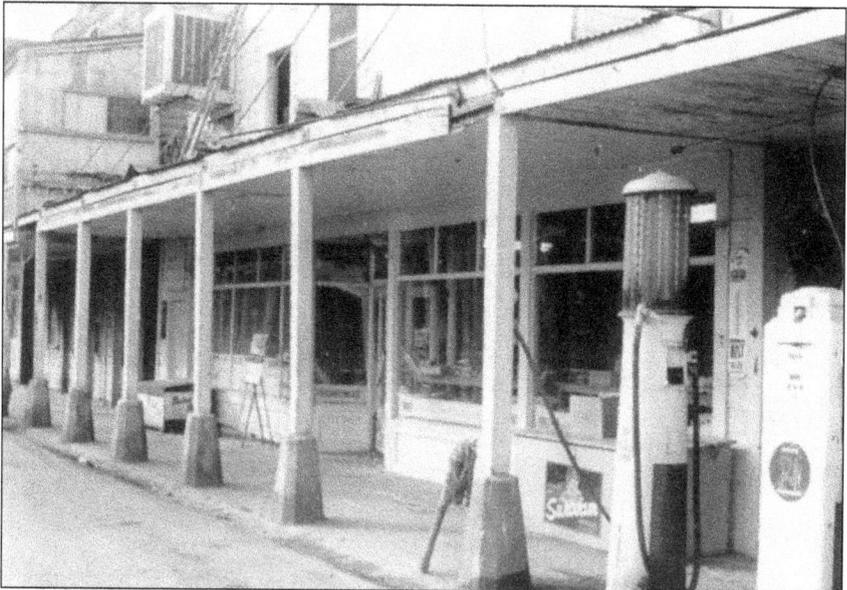

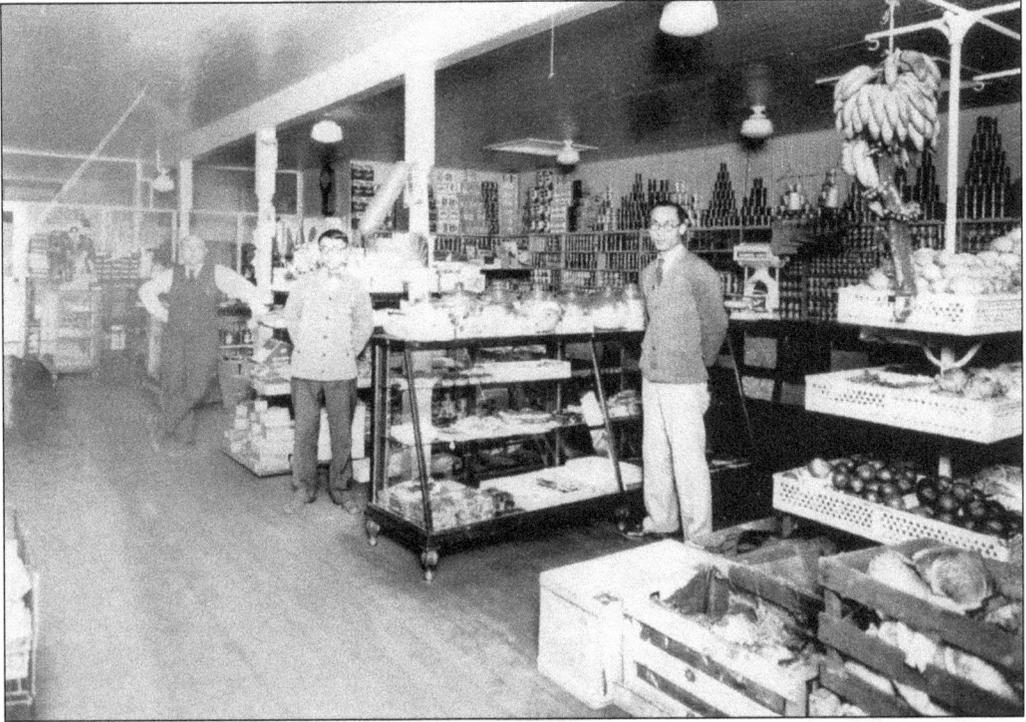

This was the grocery section of Yuen Chong downstairs. The entries to this section were from either Main Street or a grand stairwell from the second level. It was the largest grocery store in Locke. Pictured, from left to right, are Chin King, Francis Chan, and Wing Owyoung. (Courtesy Gene Chan.)

Wednesday, March 18, 1946 · DELTA HERALD · Five

# YUEN CHONG MKT. LOCKE CALIF.

**YOUR MEAL-TIME WORRIES DISAPPEAR . . .**

SERVE YOURSELF AND PAYLESS

Specials for Thurs., Fri. and Sat.
MARCH 14th, 15th AND 16th

| HO Lge. 25c | QUALITY MEATS | CAMAY |
| --- | --- | --- |
| | FRESH FISH DAILY | The Soap of Beautiful Women |
| | GRADE A OVEN ROAST ............... lb. 43¢ | 3 bars 19c |
| DEW DROP | GRADE A CHUCK POT ROAST ......... lb. 29¢ | |
| | FRESH KILLED FRICASSEE HEN ......... lb. 40¢ | CLAPP'S |
| **PEAS** | SHORT RIB FOR STEWING ............. lb. 20¢ | Junior Foods |
| No. 2 can 2-25c | FRESH FRUITS AND VEGETABLES IN SEASON | 3 for 25¢ |
| | WHITE STAR GRATED TUNA ...4 oz. can 29¢ | |
| | SANDY POINT CLAMS ............7 oz. can 33¢ | |
| Tolo Bartlett | MORRELL PIGS FEET .............9 oz. bot. 19¢ | |
| | E-Z SERVE TONGUE LOAF ...........Can 38¢ | ½-gal. |
| **PEARS** | HEINZ CONDENSED TOMATO SOUP..11 oz. can 13¢ | 24c |
| | MISSION CUT GREEN BEANS.........No. 2 can 14¢ | |
| No. 2½ can 36¢ | SEASIDE BRAND BUTTER BEANS....No. 2 can 17¢ | |
| | LIBBY'S LOGANBERRY JUICE ..........Pt. 30¢ | |
| | CAL-PRIZE DILL MIXED PICKLES .1 pt. 8 oz. bot. 33¢ | 1 lbs. 18c |
| 14-oz. | LAURA SCUDDER PEANUT BUTTER. . .1 lb. jar 35¢ | |
| 17c | KRAFT DINNER ....................Pkg. 11¢ | |
| | SUTHO SUDS ............3 lb. 2 oz. pkg. 68¢ | TREESWEET |
| | LA FRANCE BLUEING ...............Pkg. 9¢ | Grapefruit |
| **SHELL-TOX** | SKAT HAND SOAP ............Jumbo size 25¢ | Juice |
| INSECT SPRAY | VISIT YUEN CHONG'S | Qt. 34c |
| Gal. can $1.15 | **New Variety Store** | |
| | Everything you need at lowest possible prices. Under the roof. | |

## COMPLETE STOCK OF
# Choice Wines and Liquors
### LOWEST MARKET PRICES

This is an advertisement for the Yuen Chong Market, published in the delta *Herald* on March 20, 1946. Notice that chuck pot roast was 29¢ a pound.

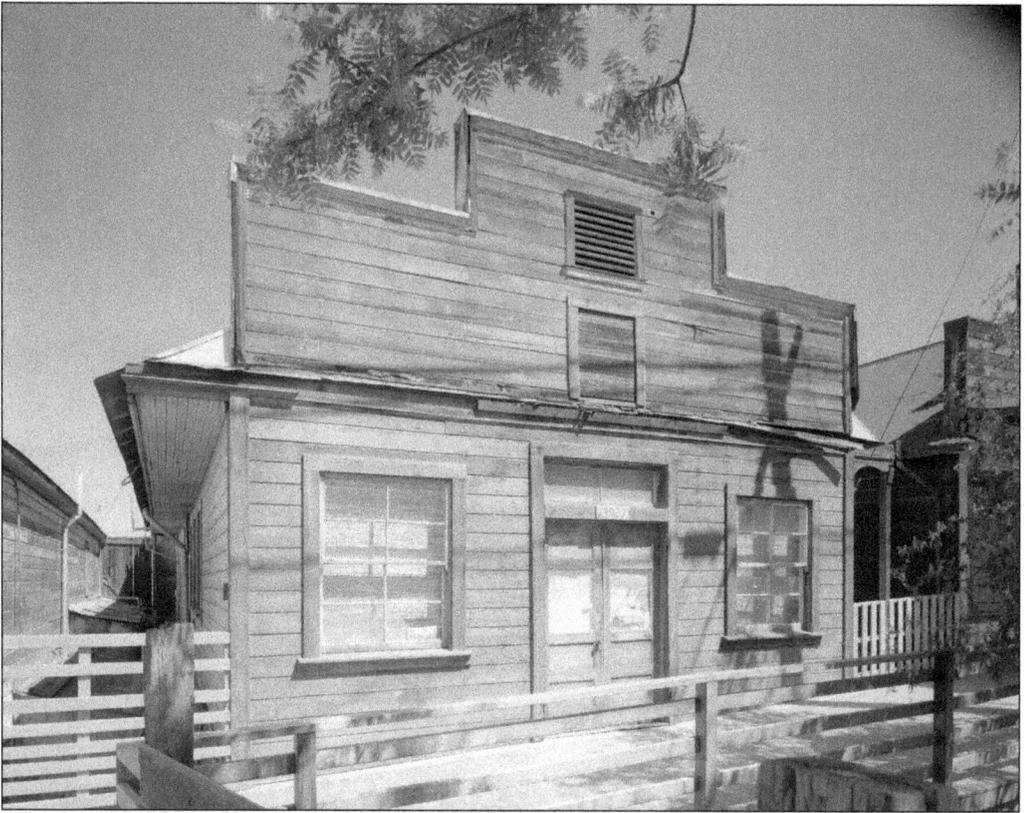

This building was located on 13927 River Road (13928 Main Street) between Yuen Chong Market and Wah Lee Dry Goods and Hardware Store. Upstairs was a boardinghouse; downstairs was a brothel. The building burned down in 1984, and the site is now a memorial park dedicated to the Chinese who built the railroad, levees, and the town of Locke and established California agriculture. (Both, courtesy NPS.)

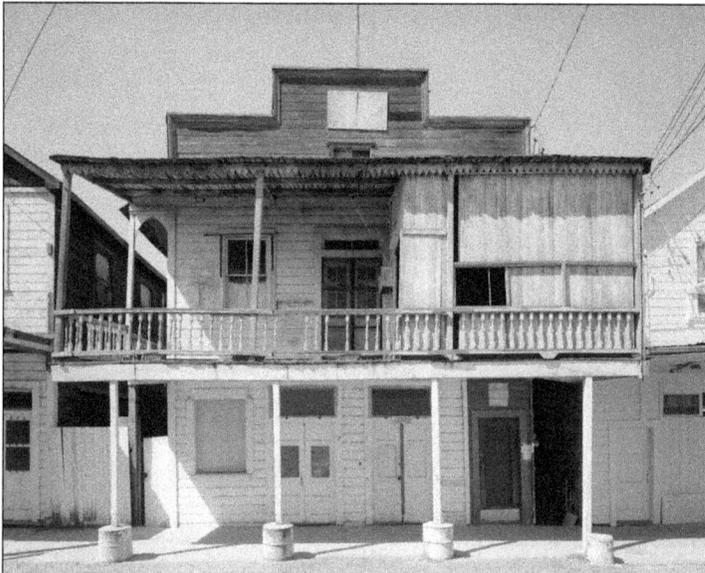

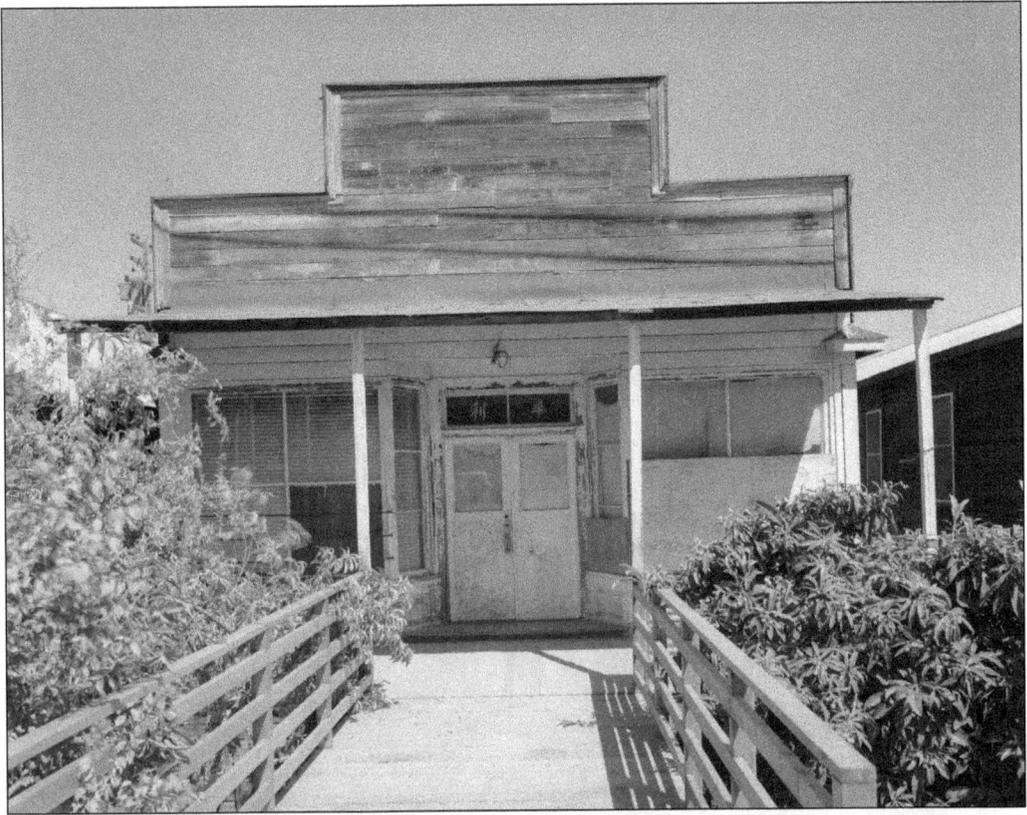

This building was located at 13931 River Road (13932 Main Street). Kan Chun and Shee Lum came to America in the early 1900s, settled in Locke, and established the Wah Lee Store in 1918. It was a dry goods store, selling stocking boots, clothing, and other items needed by the many farmworkers from 1918 to the 1960s. (Both, courtesy NPS.)

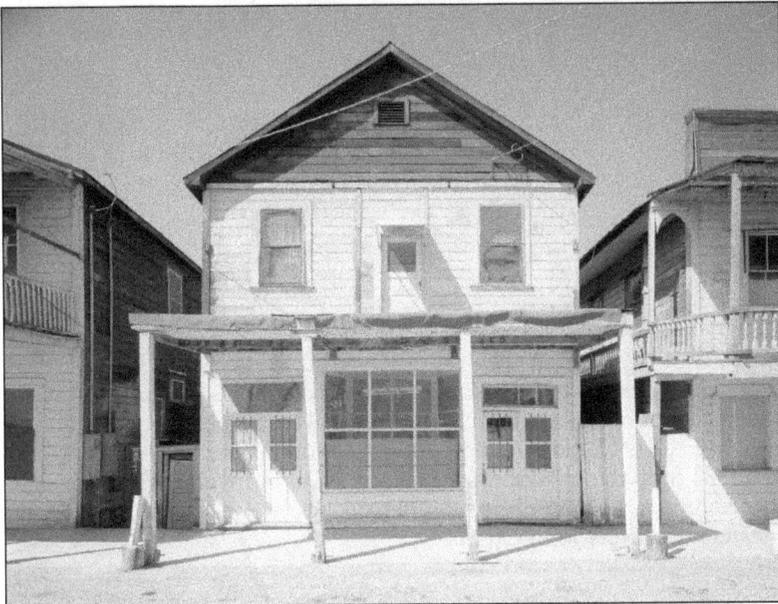

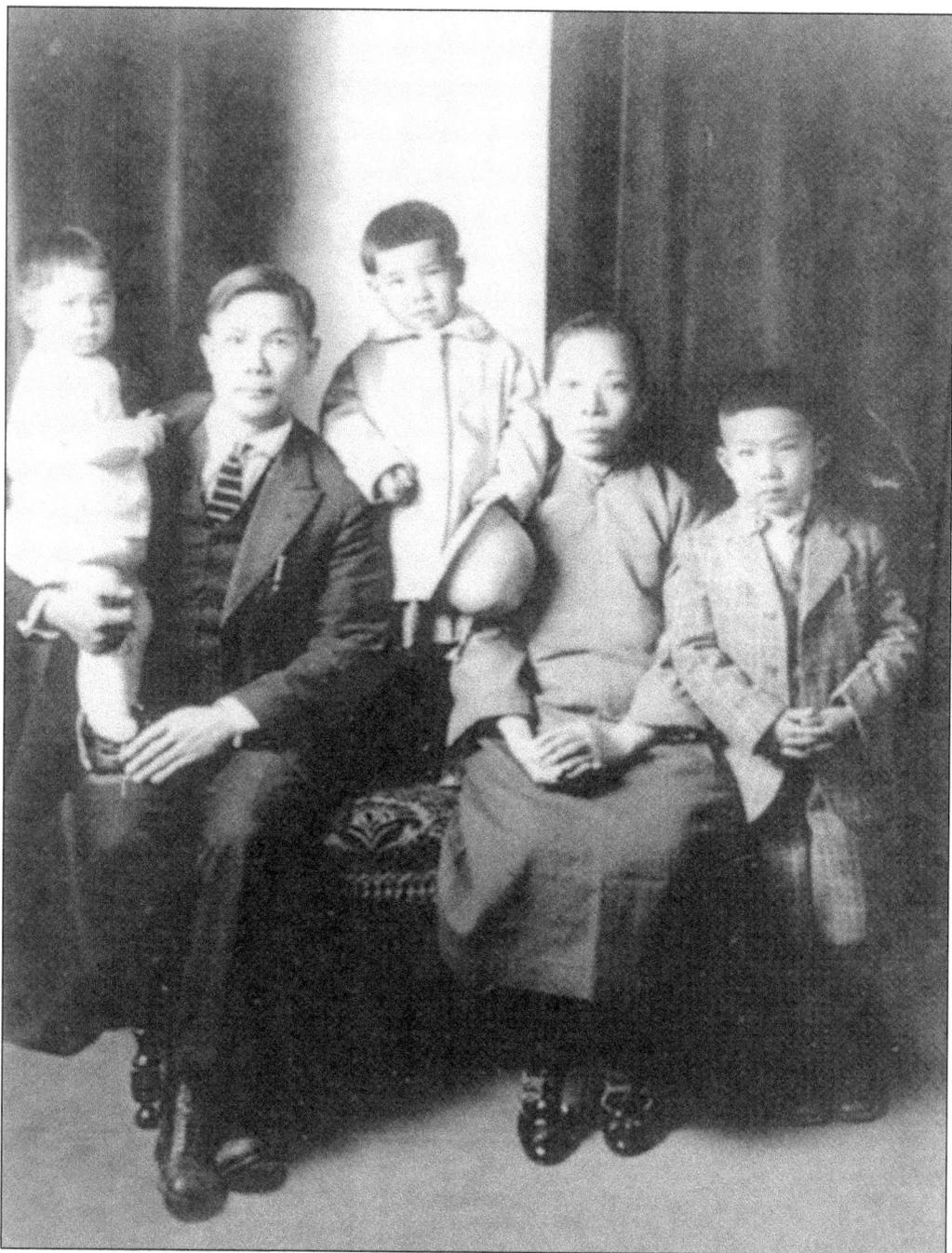

Kan Chun and Shee Lum are shown with their three children—Edna, Amelia, and Morrison—in 1928. Morrison, born in 1920 and the eldest of eight children, obtained his bachelor of arts degree in chemistry in 1943 from the University of California. During World War II, he served in the US Army as a first lieutenant, and after being discharged, he returned to the university and obtained his master's degree. (Courtesy John Chun.)

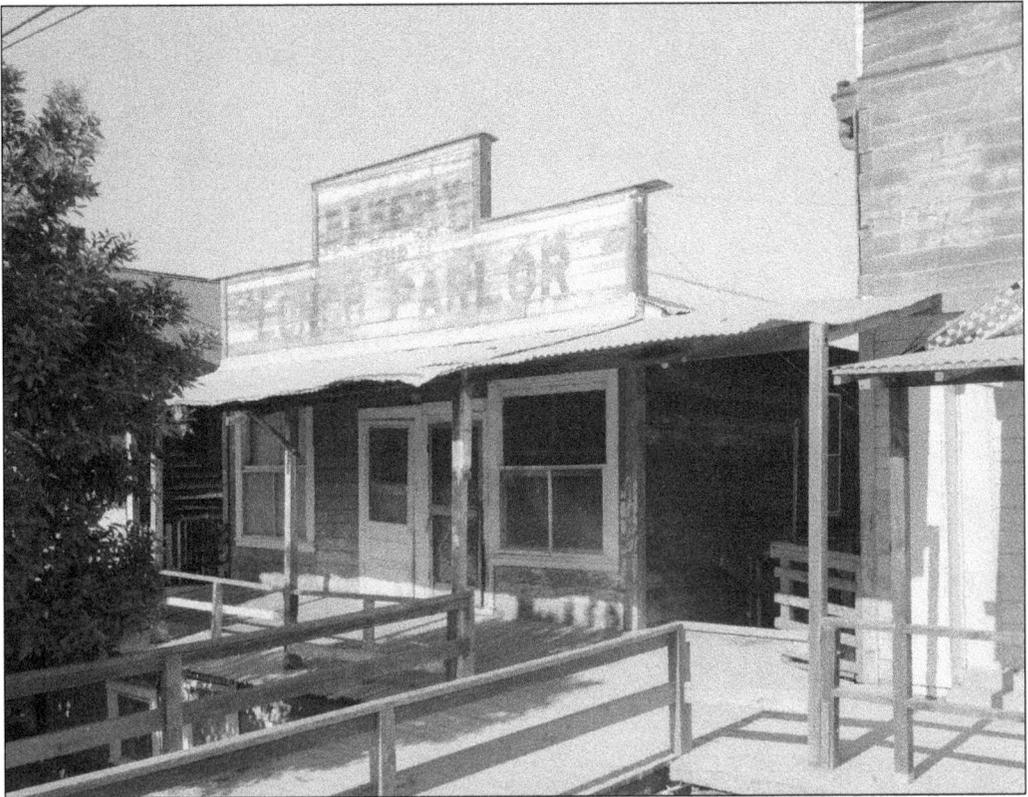

This building at 13935 River Road (13936 Main Street) was a bakery with a lunch parlor upstairs. The lower level was a gambling hall facing Main Street. (Both, courtesy NPS.)

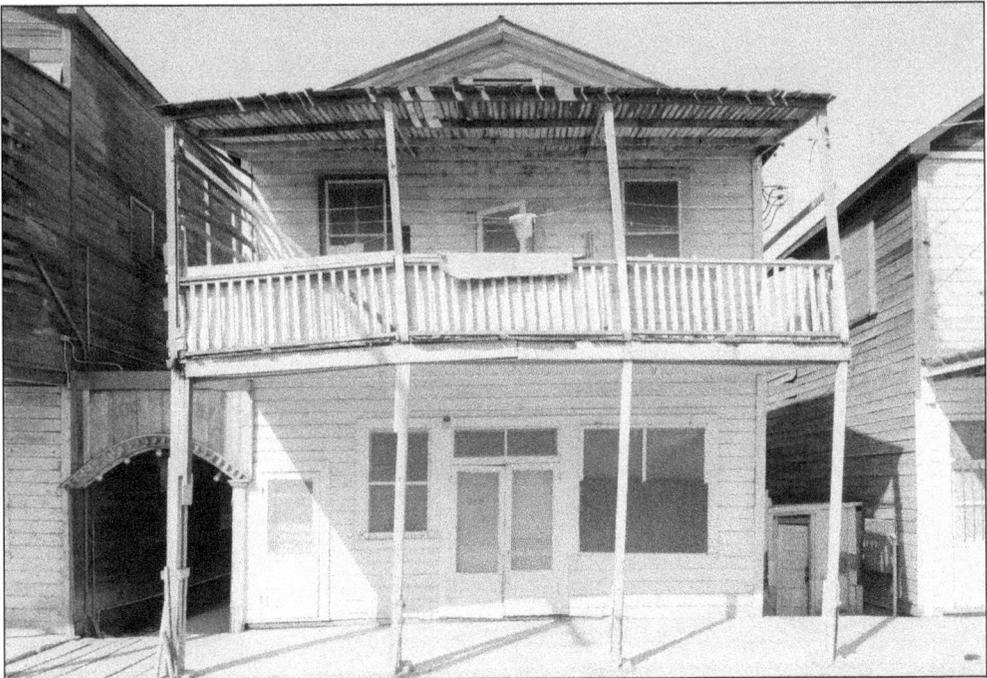

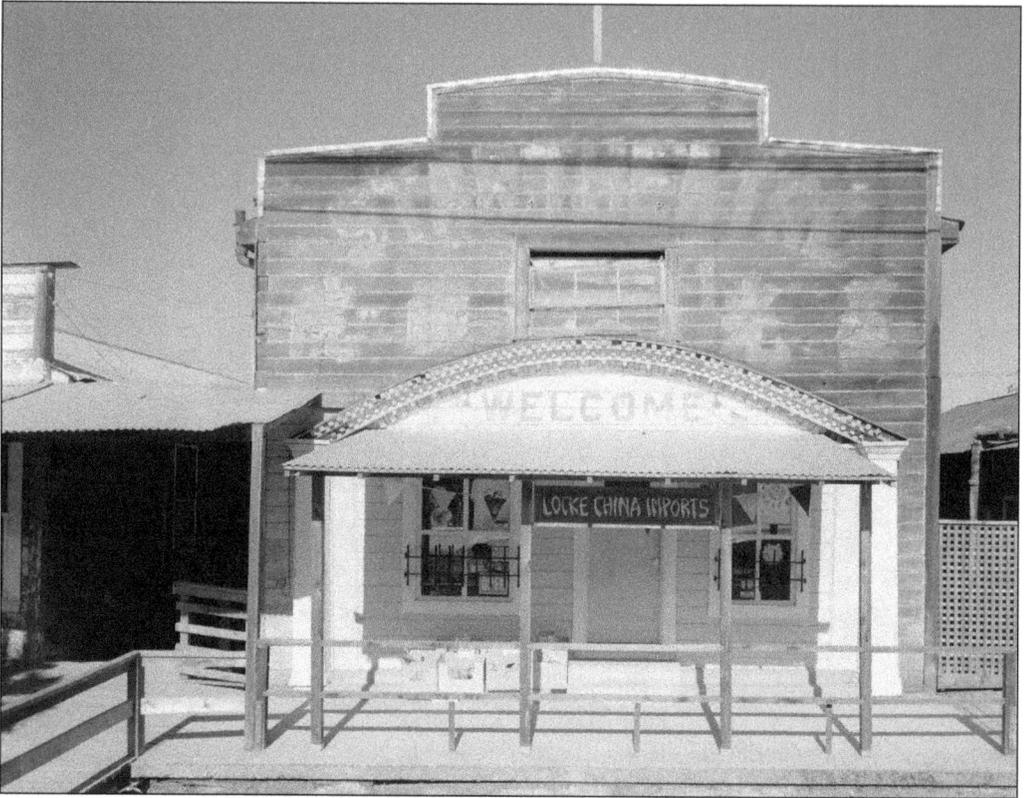

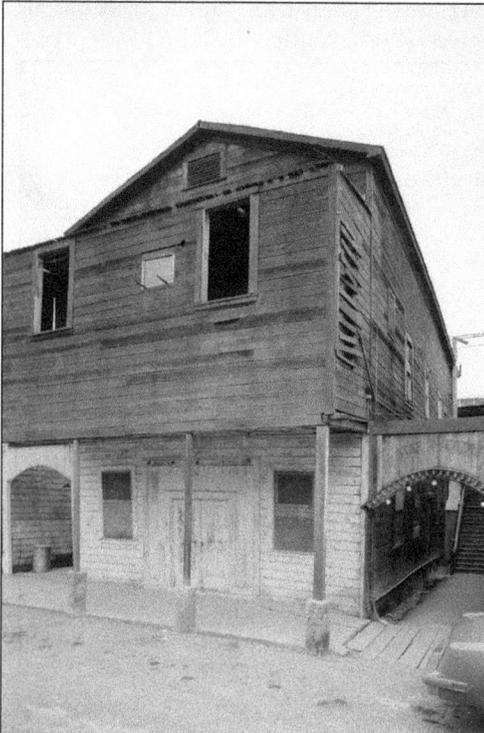

The Star Theatre building at 13939 River Road (13940 Main Street) was constructed in Locke in the 1920s. In addition to black-and-white movies, traveling Chinese theater companies presented operas there in the early days. The first floor of the building has been used as a brothel, boardinghouse, and gambling hall. The photograph at left shows 13940 Main Street, the back side of the Star Theatre. (Both, courtesy NPS.)

The archway up the stairs leads to the River Road entry to the Star Theater. Chinese opera singers from San Francisco frequently performed at the Star Theater. The two Chinese ladies standing to the side of the entry were referred to as "Sing Song" girls, performing in Chinese operas. (Both, courtesy Gene Chan.)

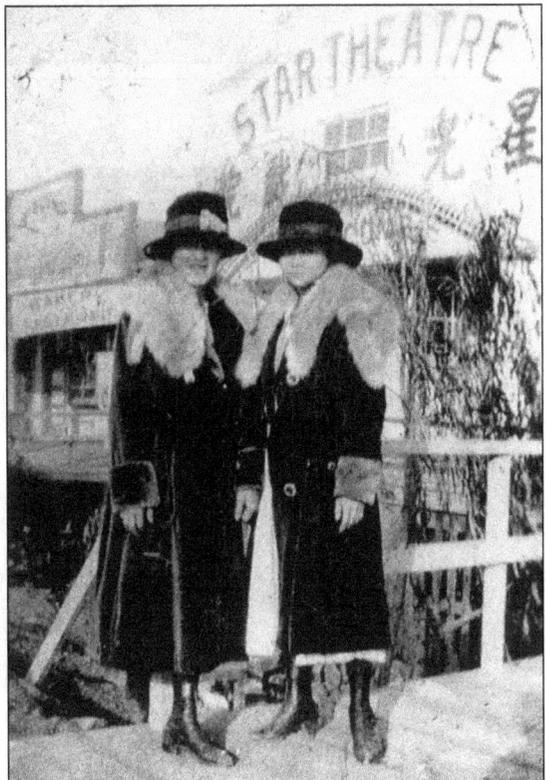

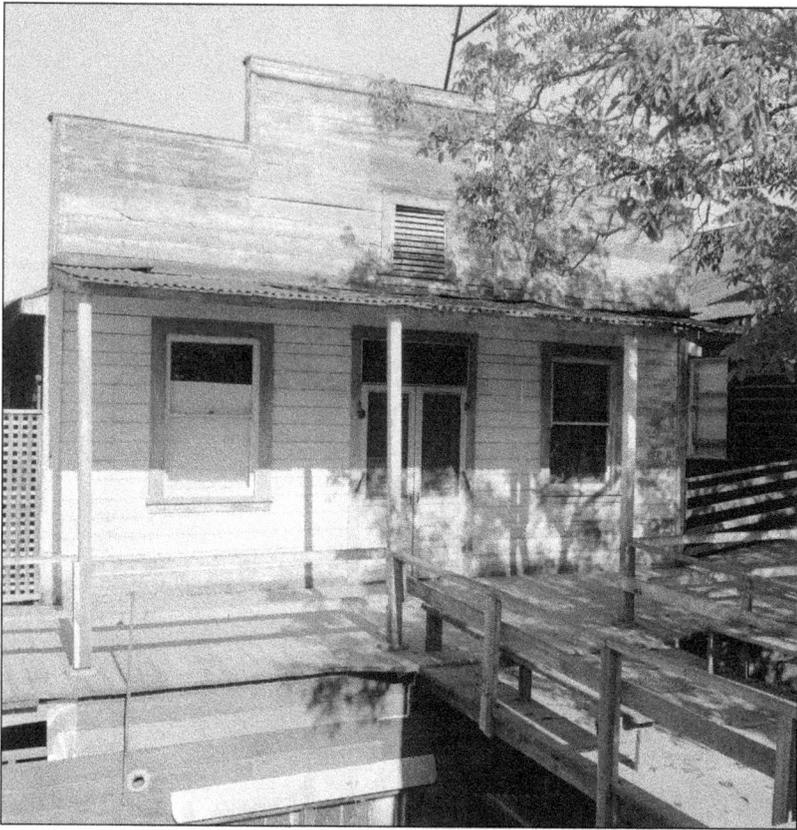

This building, located at 13943 River Road (13944 Main Street), was called Lim Kee or Hoy Kee, depending on the time period. It has been a market, pool hall, and ice cream fountain. Many of the local children worked here. (Both, courtesy NPS.)

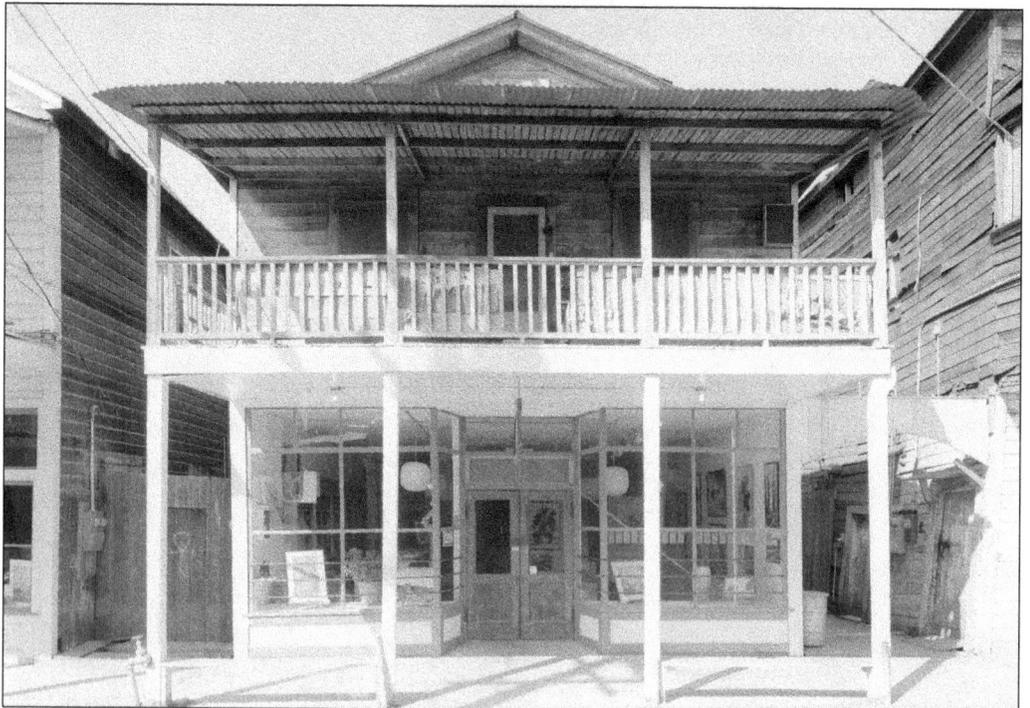

This building was located at 13947 River Road (13948 Main Street). The downstairs was called Sing Lai Gon or Victory Hall. The name was most appropriate for a gambling hall, since there were seven glass panels above the door. The number 7 represents good fortune. The structure was also an ice cream parlor. Upstairs was a residence. (Both, courtesy NPS.)

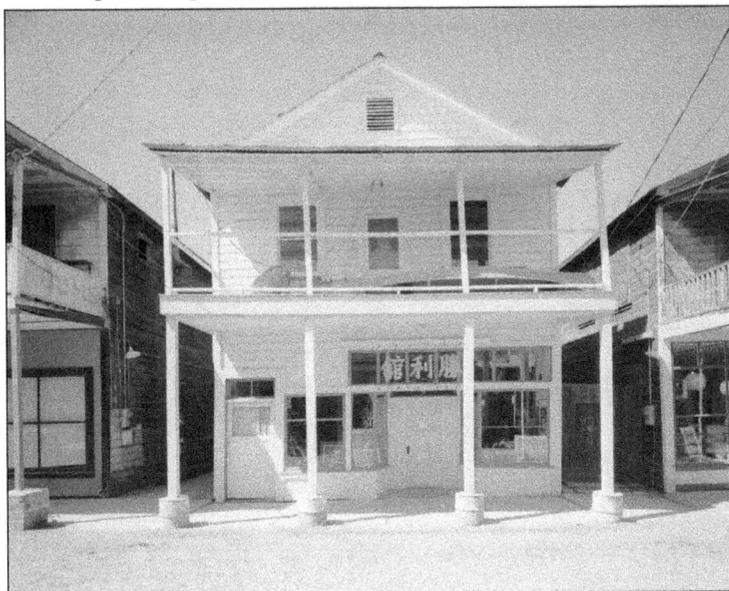

This building, located at 13955 River Road (13956 Main Street), was built by Lee Bing in 1915 at the cost of $1,200. The store was called Hing Lee. The business relocated from Walnut Grove after the 1915 fire. This was also the residence of Bing and his family. It was a dry goods store, herb shop, and served as headquarters for a variety of Bing businesses. In 1937, Larry Chee bought the business and opened the Moon Café. (Both, courtesy NPS.)

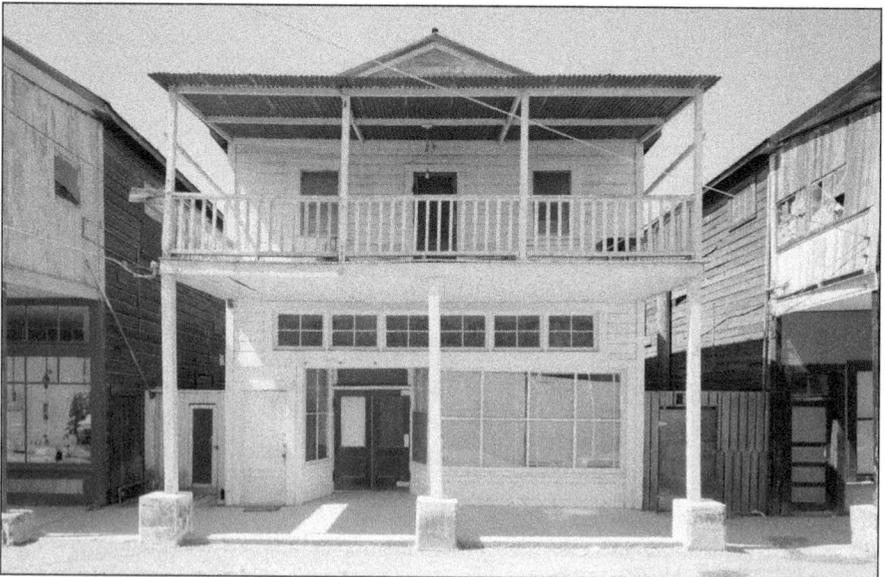

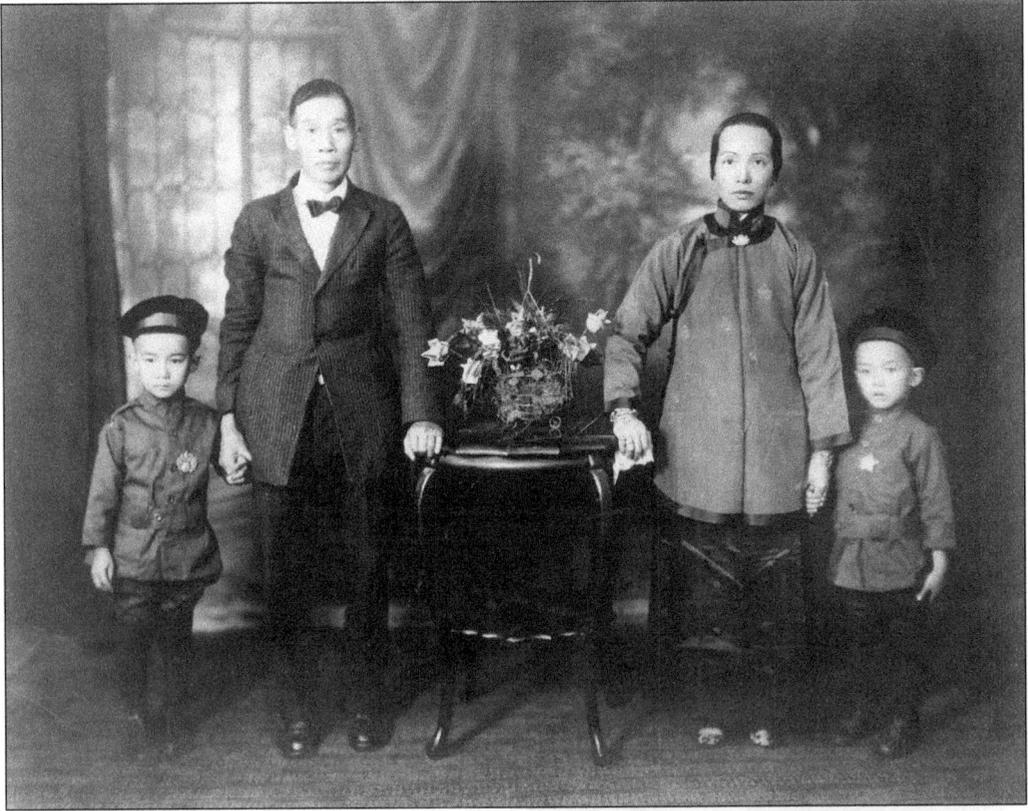

Lee Bing was the leader of the group of Chungshan Chinese that relocated to Locke after the 1915 fire in Walnut Grove. He operated many businesses, including two gambling halls, a restaurant, and a farm. In addition, he was also a Chinese herbalist. This 1923 photograph shows Bing with his wife, Lee Bo-Ying, and his sons, On Lee (right) and Ping Lee. (Courtesy Ping Lee.)

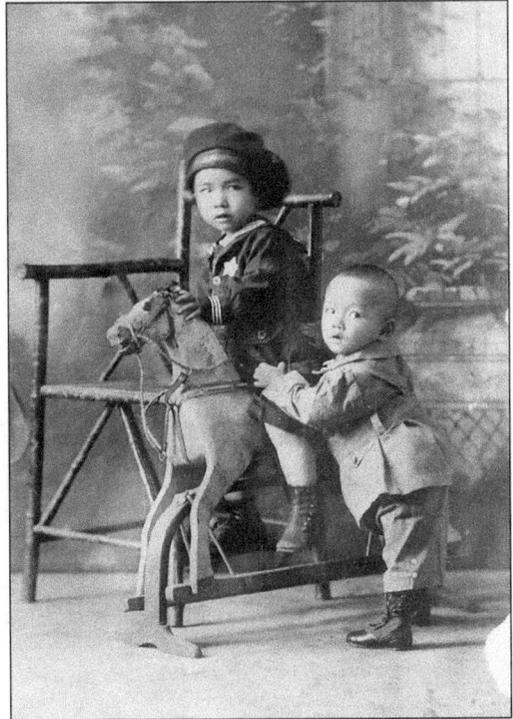

Ping Lee and On Lee, sons of Lee Bing and Lee Bo-Ying, test out a rocking horse in the early 1920s. After graduating from the University of California and working in Sacramento, Ping returned to Locke in 1951, and for the next 28 years, he was the unofficial mayor of Locke. (Courtesy Ping Lee.)

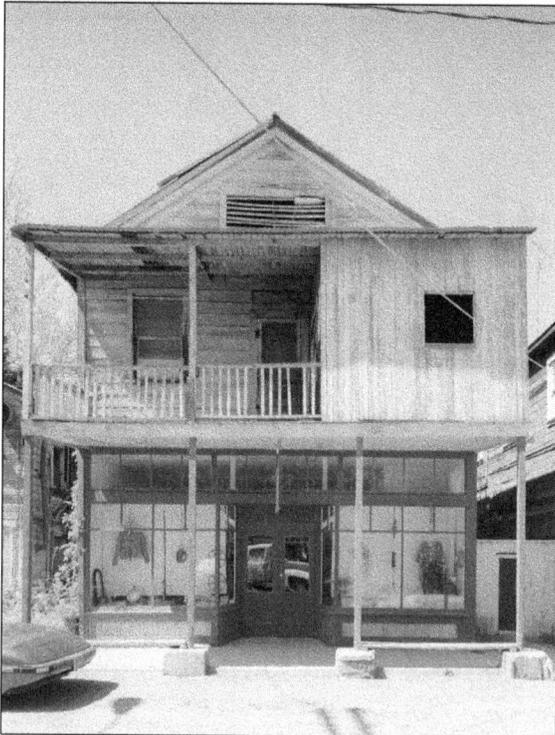

This building at 13963 River Road (13964 Main Street) was built in 1915. An ice cream parlor and living quarters for the Chuck Wing Chan family occupied the first floor. On the second floor (with entry from River Road) was the Happy Café. There was also a very small post office (relocated from Vorden) on the second level facing River Road. (Both, courtesy NPS.)

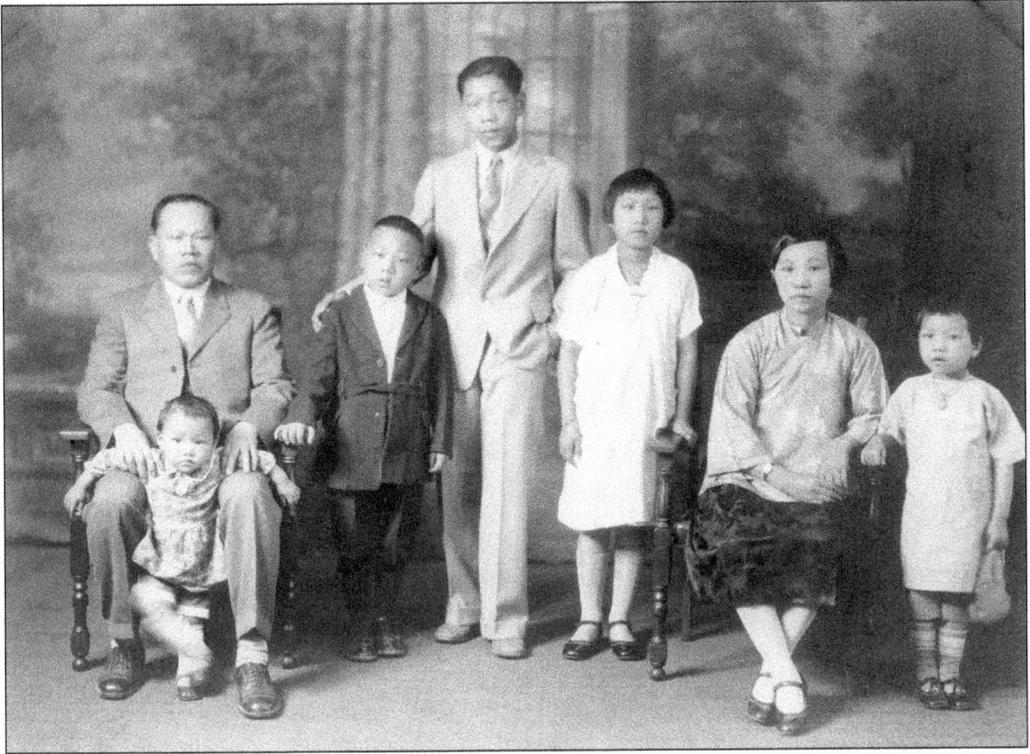

The Chuck Wing Chan family operated the restaurant at 13963 River Road (13964 Main Street). The family moved from Walnut Grove in the early 1930s. Pictured above, from left to right, are Chuck Wing Chan (holding Amy), Wayet, Edward, Mary Ann, Lum Sue Ying, and Ruth. The photograph below shows the parking lot on River Road in front of the Happy Café in the 1930s. (Both, courtesy Ruth Chan Jang.)

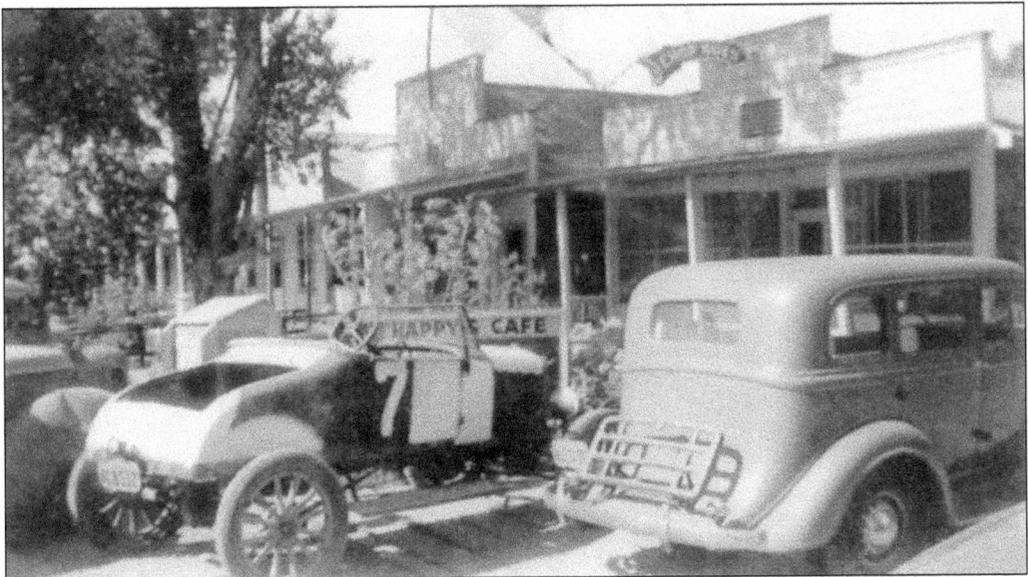

This building, located at 13967 River Road and referred to as "the Tule," was built in 1912 by Tin Sin Chan. He operated the building as a store and saloon, serving workers at the Southern Pacific Railroad who were loading sheds across River Road. In the 1950s, Bob Jang, a Locke community leader, had a restaurant there. Jang was also the principal of the Joe Shoong Chinese School for a time. (Courtesy Elsie Owyoung Yun.)

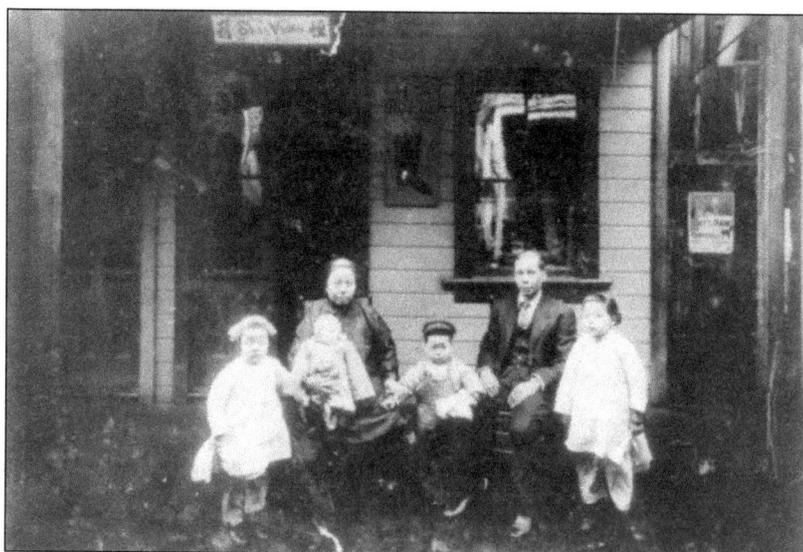

The Lum Kai Hon family is pictured about 1925. Hon operated a shop in Locke that made and repaired shoes. The family's home and business was located on Levee Road. (Courtesy Robert Young.)

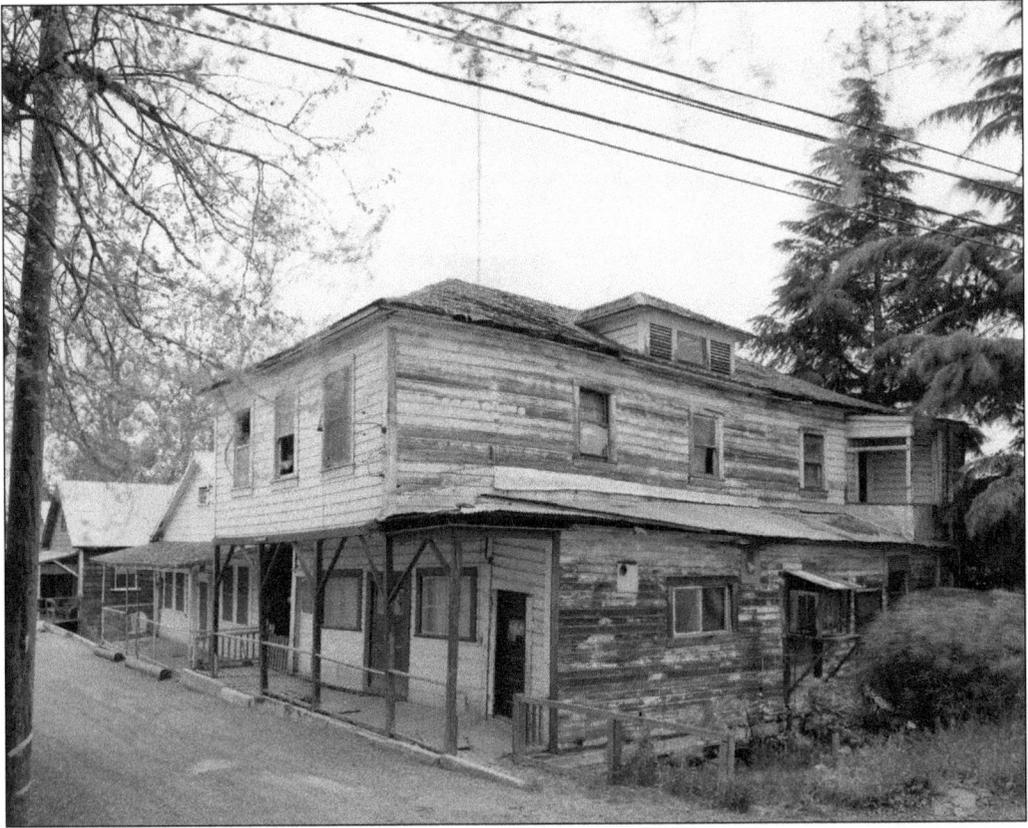

Pictured about 1984, the building above was located at 1250 Levee Road at the corner of Levee and River Roads. It was one of the first three building constructed in 1912 on the George Locke property and was home to Wing Chong Owyang family, who occupied the first level. The second level was a dry goods store, and the third level was a boardinghouse. Wing Chong came to America in 1892 and settled in Walnut Grove. He was manager of the Kwong Hop Lee Co. in Walnut Grove and later was a pear rancher. Pictured below about 1915 are, from left to right, Ethel, his wife, Jare Ping, Bobbie, Ken, Wing Chong, Rita, and Annie (in the front). (Above, courtesy NPS; below, courtesy Wally Owyang.)

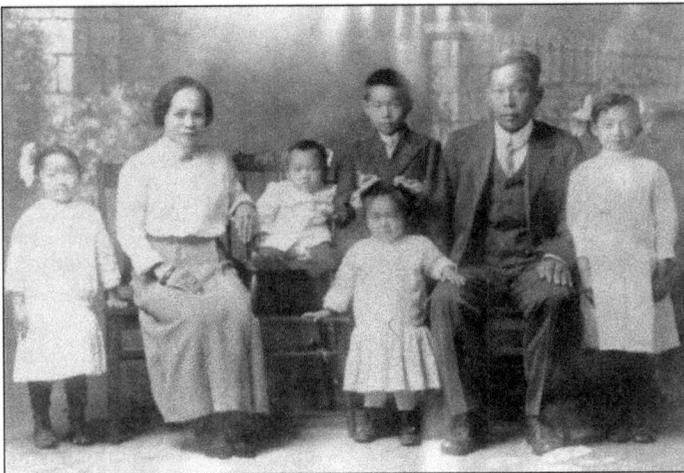

The structure at 13923 Main Street was the warehouse for Yuen Chong Market, located across the street at 13924 Main Street. It has also been used as a theater. (Courtesy NPS.)

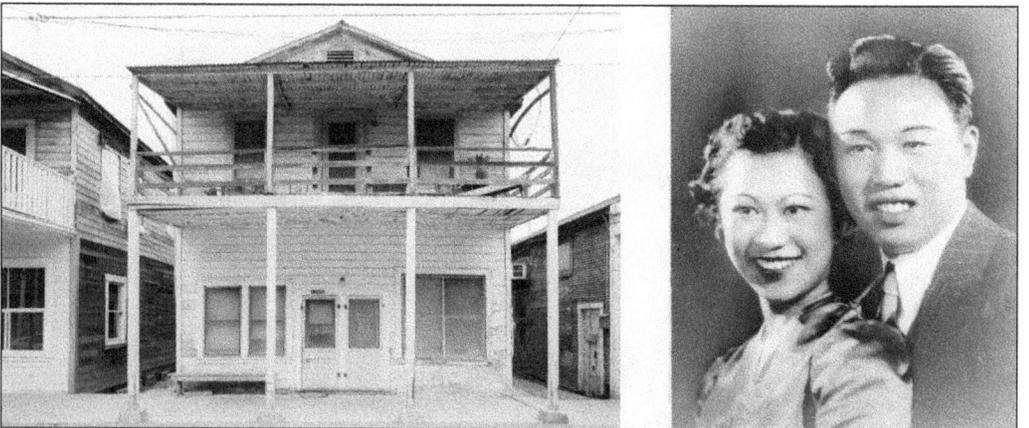

The building at 13939 Main Street once housed a beauty parlor and the King family home. Annie King, wife of Chester King, operated the beauty parlor. Annie and Chester are pictured here about 1940. (Left, courtesy NPS; right, courtesy Robin King.)

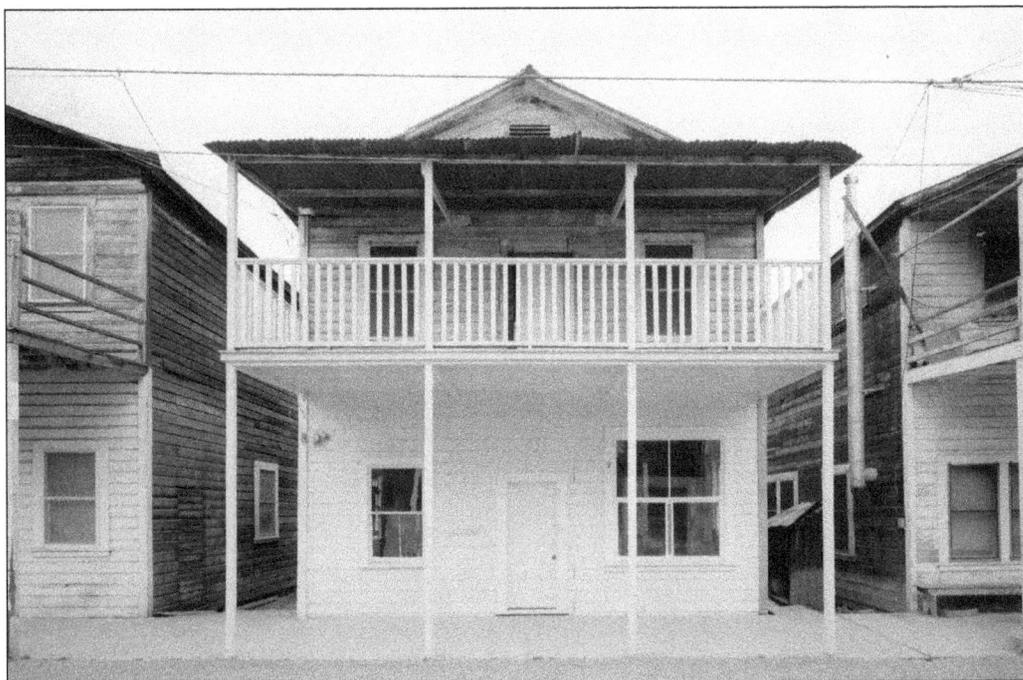

The building at 13935 Main Street was a fish market and the home of the Choy Jang family. This is the Choy Jang family with 10 of their children in 1927. (Above, courtesy NPS; below, courtesy Edna and Herbert Leong.)

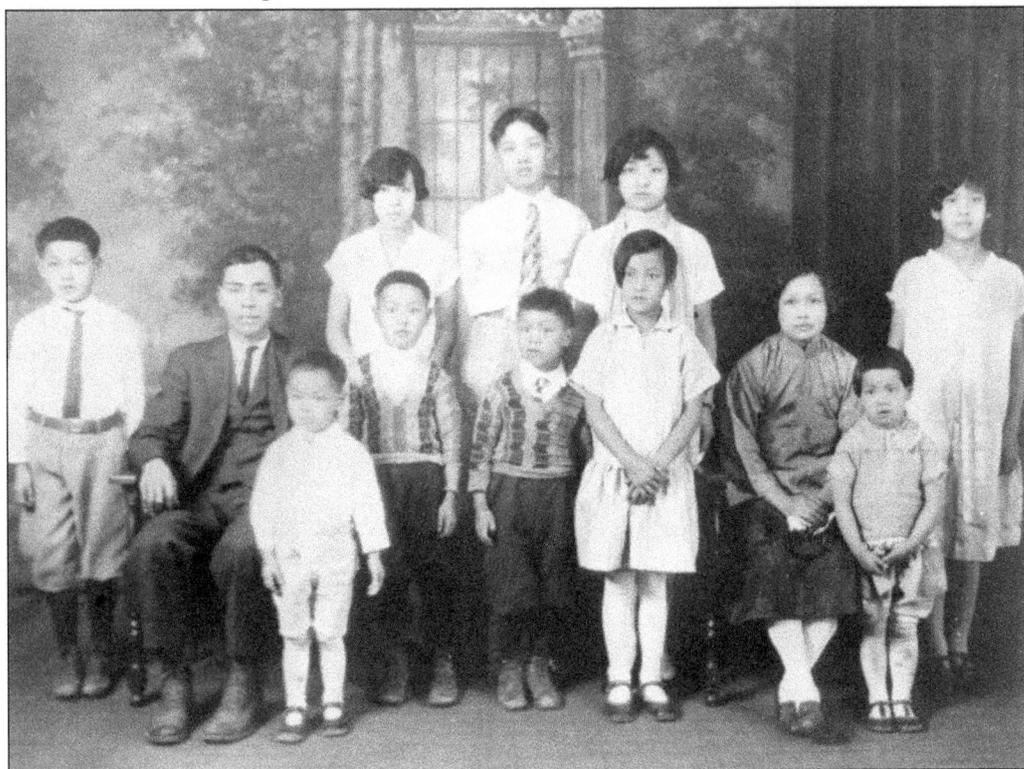

Al's Place, also known as "Al the Wop's Restaurant," is located at 13943 Main Street. The building was constructed and owned by Lee Bing and three partners in 1915. Bing operated the building as a restaurant until 1934 when he sold it to Al Adami and an associate who came up the river from Ryde and it became the only non-Chinese business in town at the time. (Courtesy NPS.)

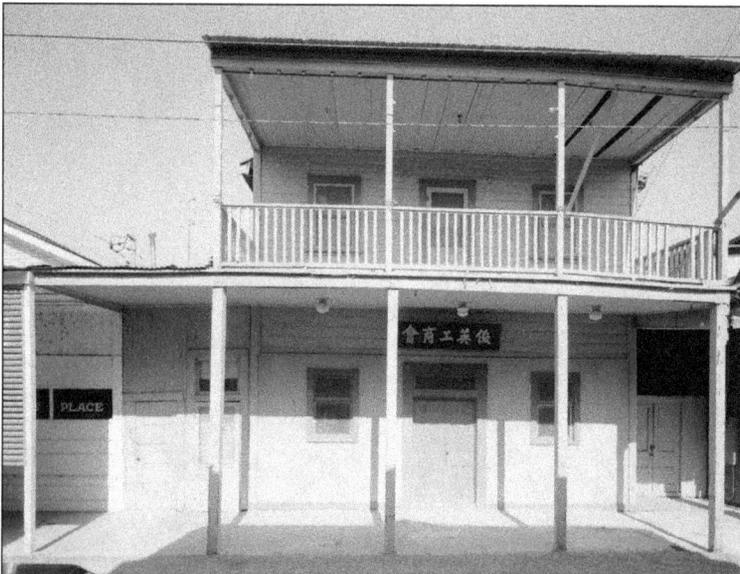

This building, constructed in 1916, is located at 13947 Main Street. It is the Jan Ying Association, an organization that only the people of the county of Chungshan could join. Unlike the tongs, this was more of a social center for the members. They could go to this association to converse in a dialect familiar to them, receive mail, and socialize. (Courtesy NPS.)

Pictured here in 1984 is the front meeting room on the first floor of the Jan Ying Association building. A kitchen was immediately behind this room. The building is now a museum. (Courtesy NPS.)

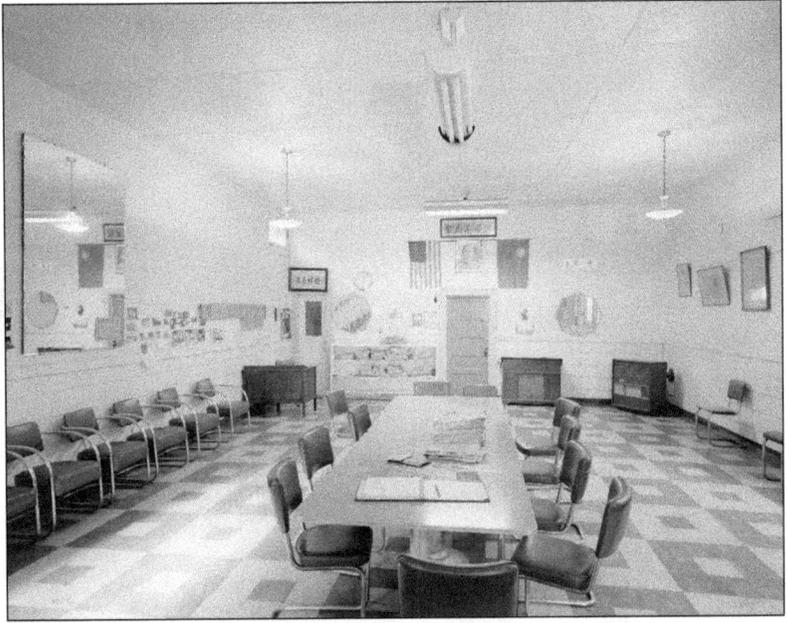

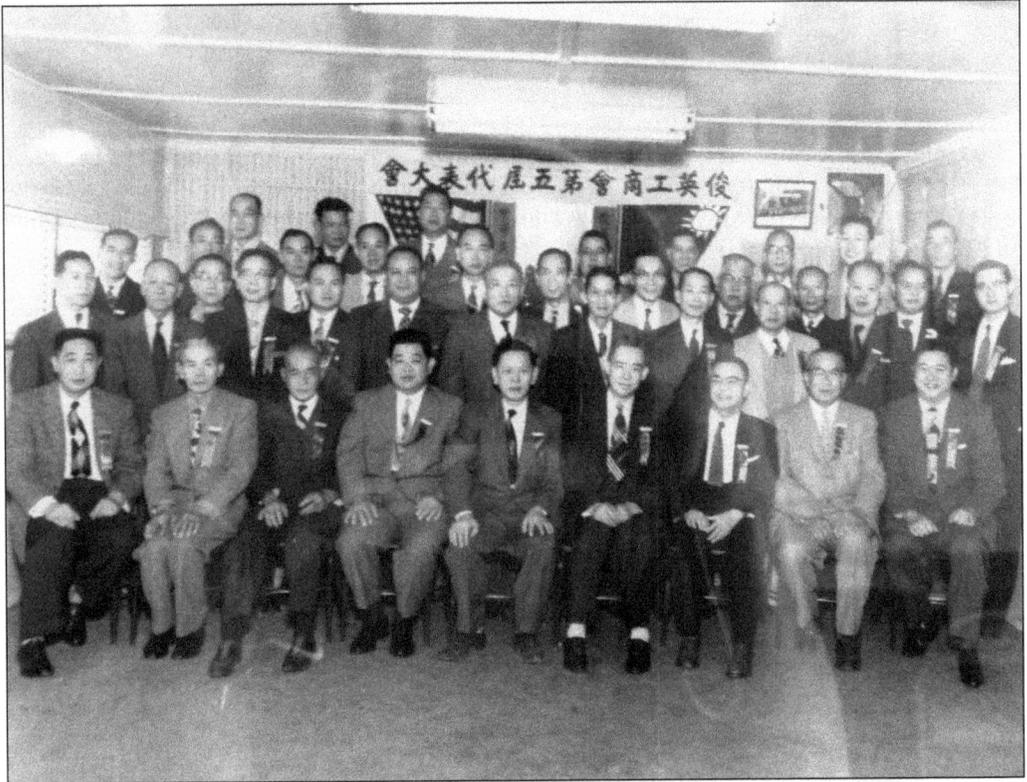

The Jan Ying Association had its fifth national convention in Locke in the 1940s. All the Jan Ying Associations in the United States were represented. These are the delegates who attended from Locke and from the other Jan Ying Associations. (Courtesy Locke Foundation.)

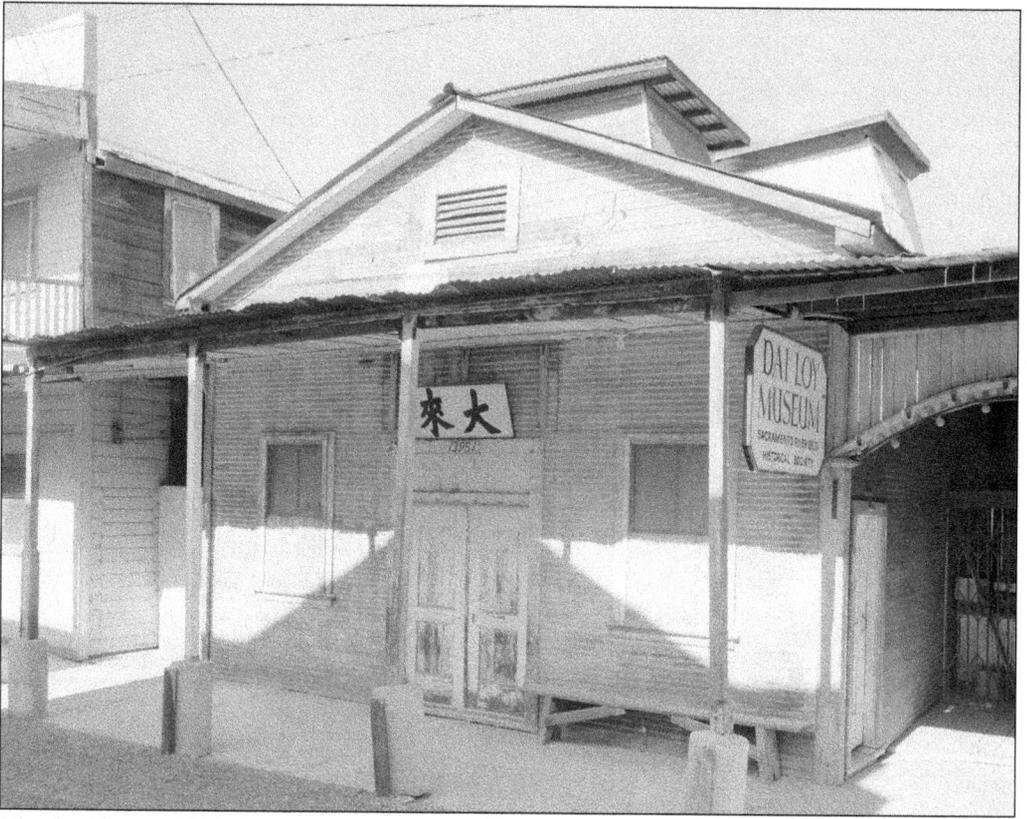

This building at 13951 Main Street housed the Dai Loy Gambling Hall, established by Lee Bing. It was built in 1915 and operated as a gambling house until 1950s, when it was closed by the authorities. The building is presently a museum, and the interior has been restored to its original condition. (Both, courtesy NPS.)

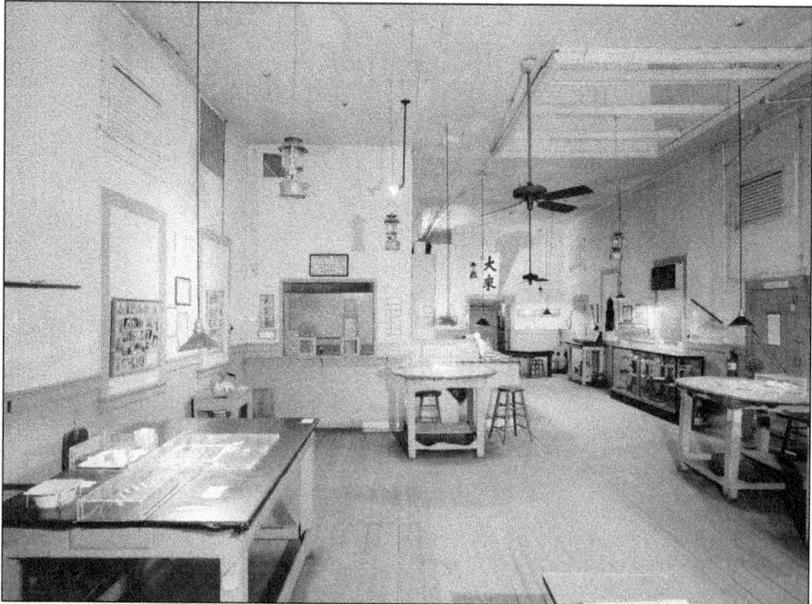

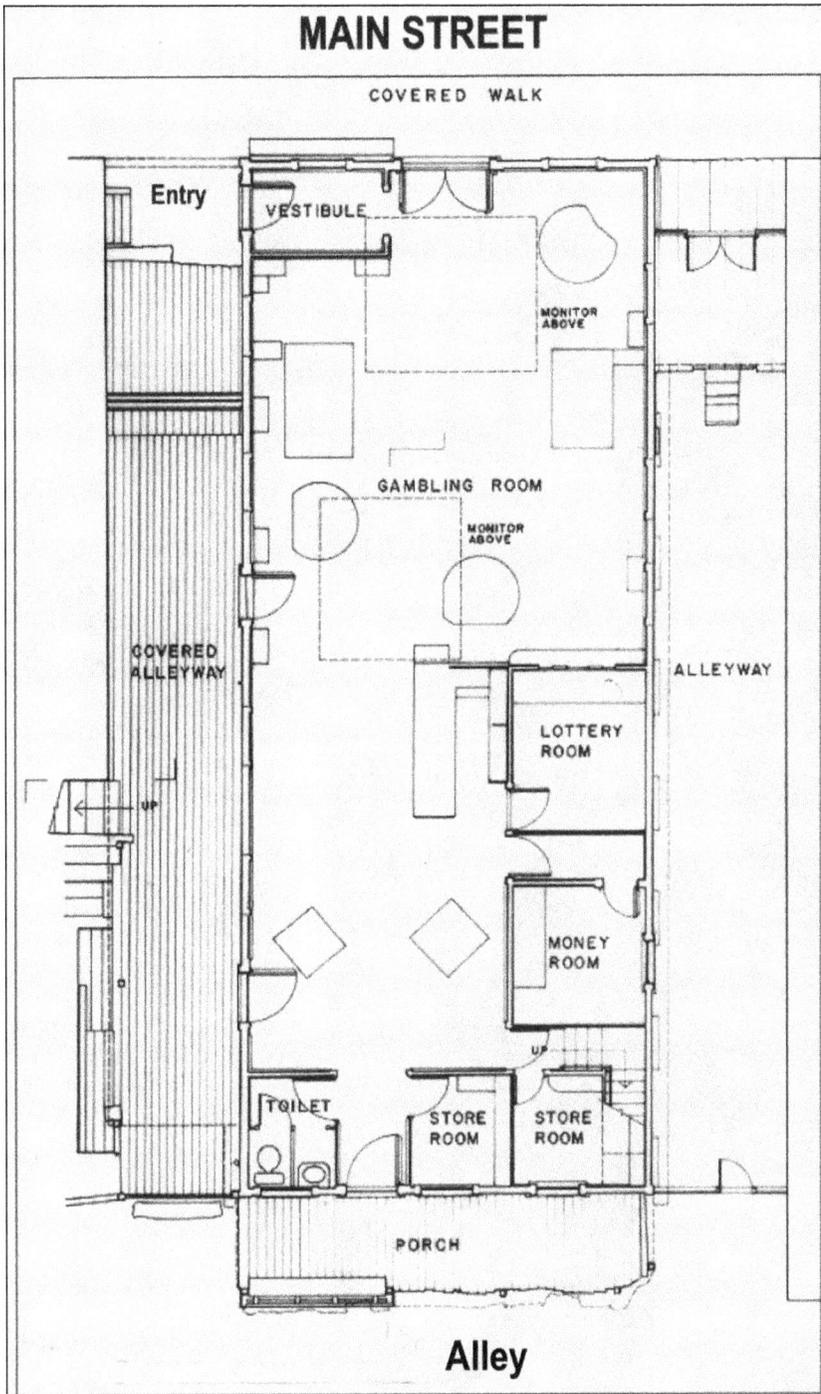

## MAIN STREET

COVERED WALK

Entry

VESTIBULE

MONITOR ABOVE

GAMBLING ROOM

MONITOR ABOVE

COVERED ALLEYWAY

ALLEYWAY

LOTTERY ROOM

UP

MONEY ROOM

UP

TOILET

STORE ROOM

STORE ROOM

PORCH

## Alley

The entry to the first floor is at the southwest corner of the south facade, opening into a vestibule, then into the large, open gambling room. There are two small rooms (the money and lottery rooms) immediately behind the gambling room. In the back is a stairway leading to the second floor. The upstairs is primarily used as living quarters for the caretaker. There are also two large openings to monitor the gambling activities below. (Courtesy NPS.)

The building at 13959 Main Street was a gambling establishment that closed in 1918. Soon afterward, Cheung Sik, C.P. Chan, and other family members opened a business in the building, initially selling tofu but expanded into Chinese groceries and cooked food. The business was called the Foon Hop Company. It also sold gasoline by a single, 1920s gasoline pump, pictured here. The business operated at this location for over 20 years (Above, courtesy NPS)

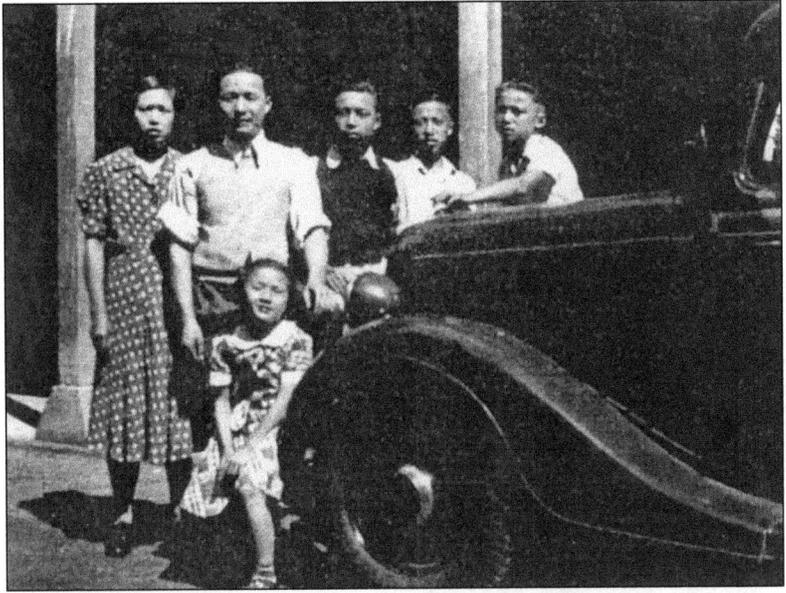

C.P. Chan, one of the partners, operated Foon Hop Company in the 1930s. Chan family members are, from left to right, Mrs. Chan, C.P. Chan, and their four children—Mon, Steve, Joe, and Alice (in the front). (Courtesy Locke Foundation.)

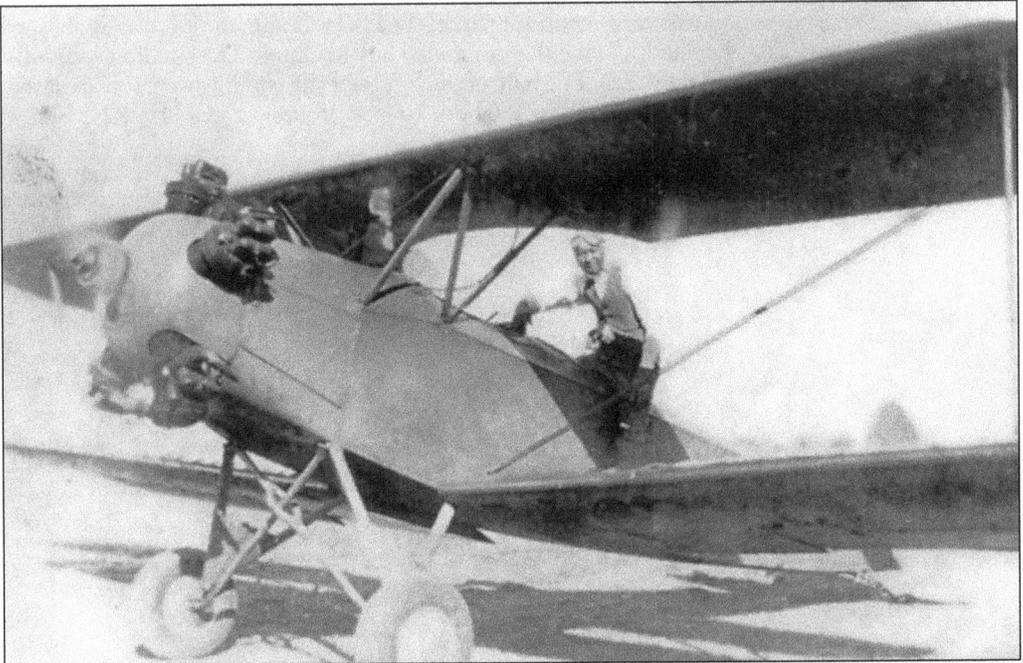

Cheung Sik, pictured in the early 1930s, was born in China and settled in Locke. He was one of the partners of Foon Hop Company and was the first Chinese pilot in the Sacramento delta. (Courtesy Harry Sen.)

The Chinese Baptist mission was a very important part of the Locke Community. It was established in 1919 by Rev. Charles R. Shepherd, a former Baptist missionary to China. The building, located at 13937 Key Street, was completed in 1922. The bulk of the funds for the building were solicited from the Main Street gambling houses. It closed in 1964 due to lack of support. (Courtesy NPS.)

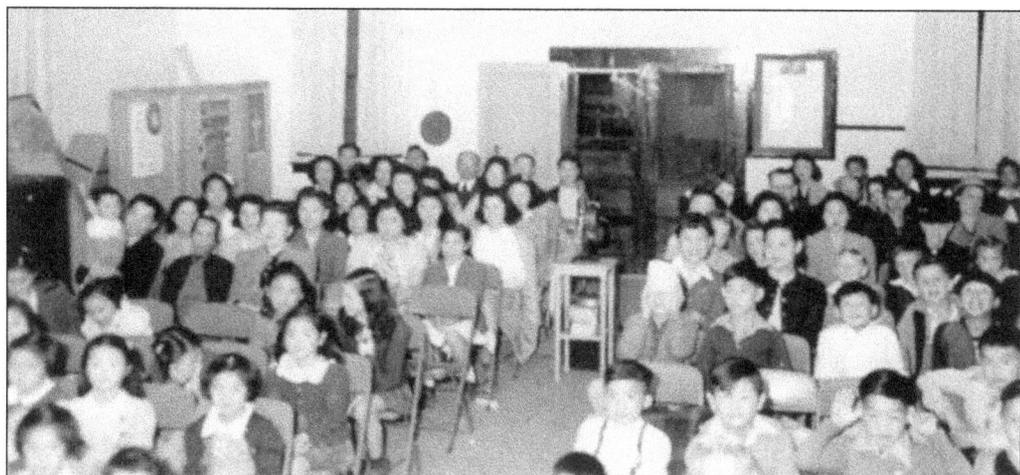

Pictured in April 1943, the Baptist mission building was used for many functions by the residents in Locke. In addition to Sunday school and social activities, it was also used as a movie theater. (Courtesy Gene Chan.)

Faith Joys, or Miss Joyce, as the Chinese called her, was an early missionary at the Baptist mission. Pictured in the early 1930s, she played an important role in the life of the Chinese in the delta. Though she was living in Locke, she made weekly trips to the other delta Chinatowns. In addition to Bible studies, she taught English and organized various functions. (Courtesy Helen Jang and Wave Jang.)

Other missionaries who played an important role in Locke were Florence Benson and Hattie Evans. Pictured in the 1950s, they are shown with the Chinese women's group in Locke. Benson is in the back row, third from the left, and Evans is on the first row, on the right. (Courtesy Gene Chan.)

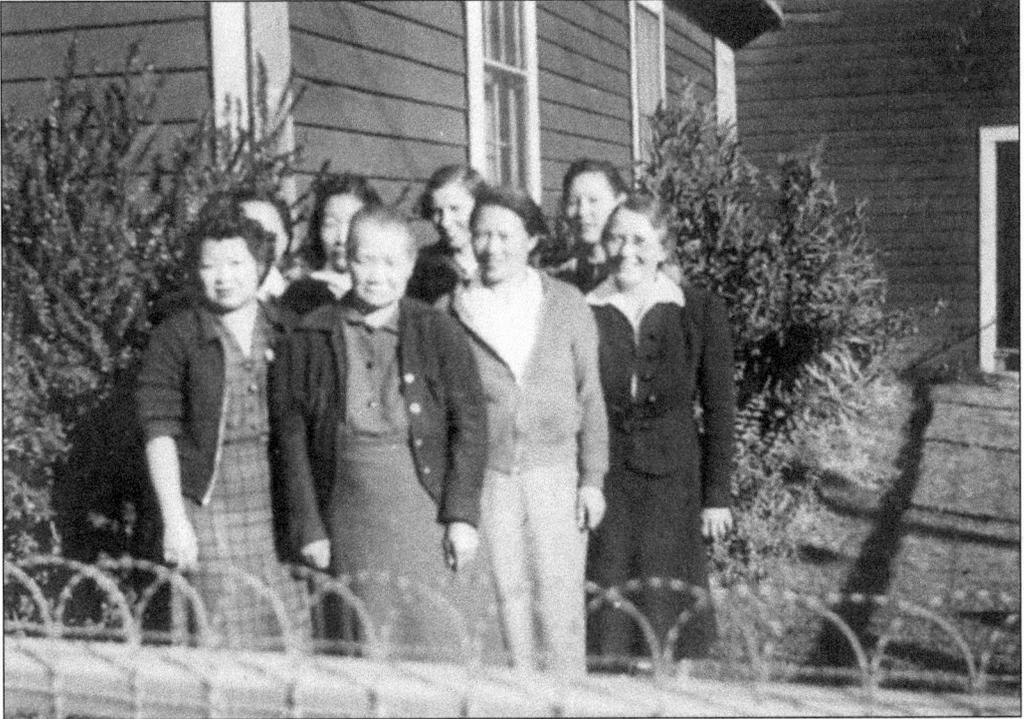

In order to let students know that it was time to attend the Baptist mission Sunday school, students rang a bell to call their peers to class. Collin Lai was assigned that responsibility in the early 1930s. (Courtesy Locke Foundation.)

These girls attended Sunday school at the Baptist mission in 1938. The name the girls selected for their group was Willing Workers Club. Some of the girls in the group are Nytee Chan, Ruby Chan, Lorraine Chew, and Loretta Law. (Courtesy Ed and Mary Ann Chun.)

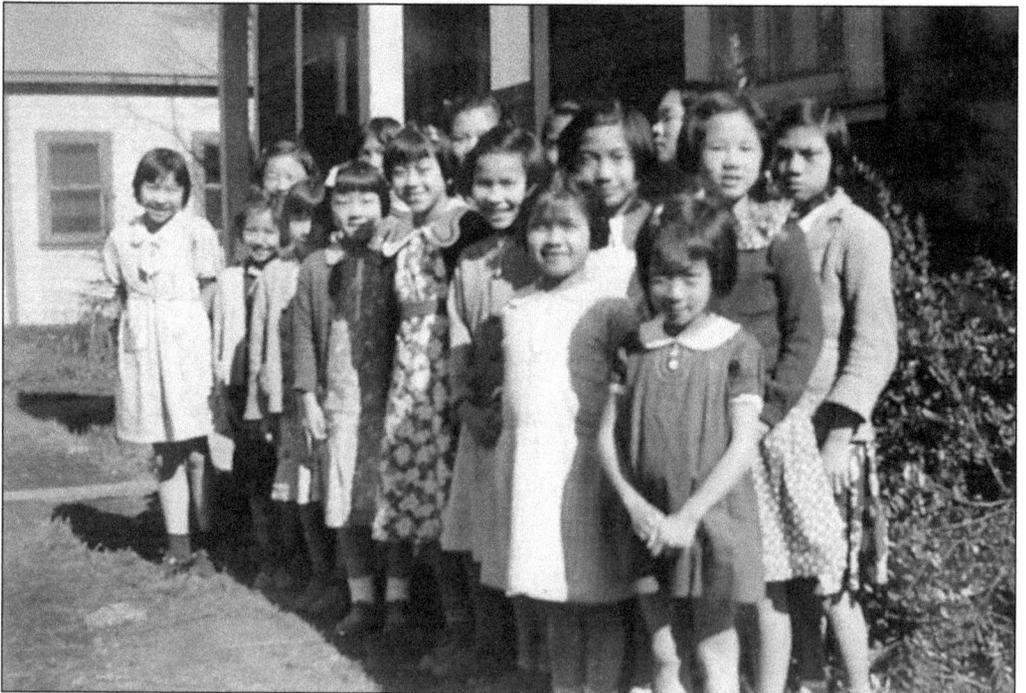

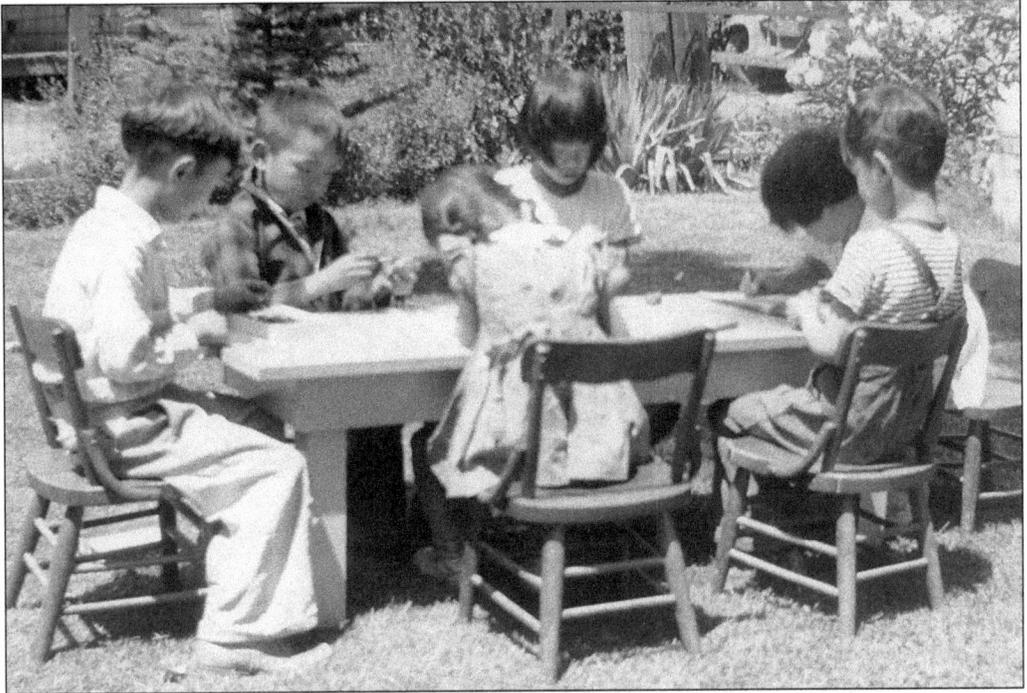

This group of children is taking advantage of the springlike weather during Sunday school at the Baptist Mission Center. Pictured in 1937 are, from left to right, Tommy Lee, Gene Chan, unidentified, Loretta Law, and two unidentified. (Courtesy Gene Chan.)

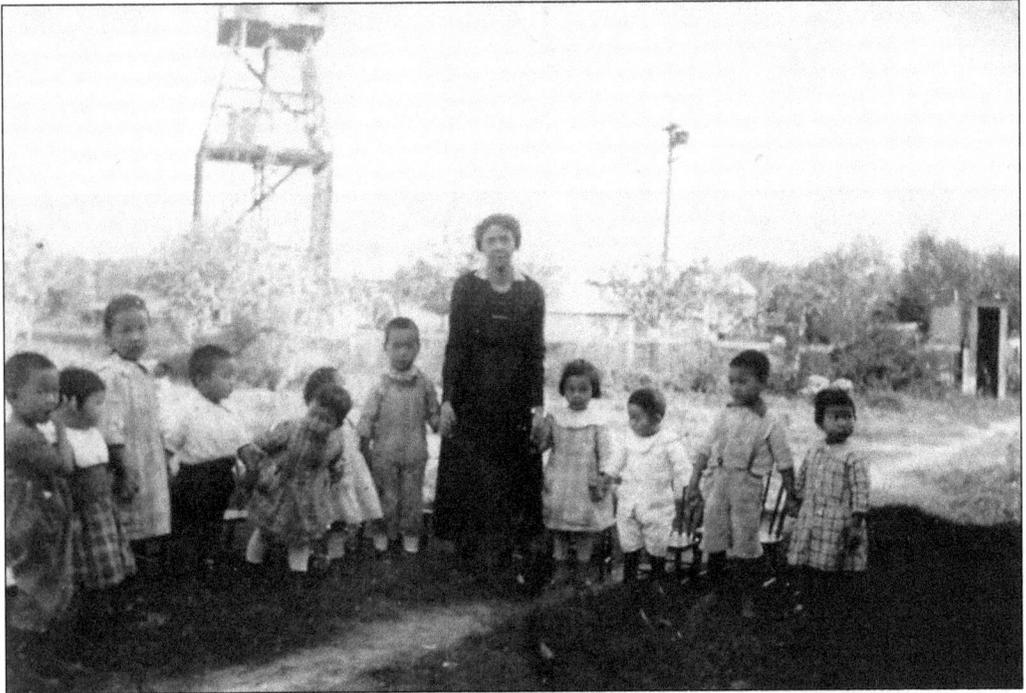

Missionaries held many church activities in the meadows behind the mission building. The water tower in the background provided water to Locke residents. (Courtesy Gene Chan.)

In the 1940s, Rev. Edward S. Yook assumed responsibility of the Locke's Chinese Baptist Christian Center. Here, he is shown with his wife and three of his children—Phyllis, Doris, and Janice—in front of the Baptist Mission Center. (Courtesy Gene Chan.)

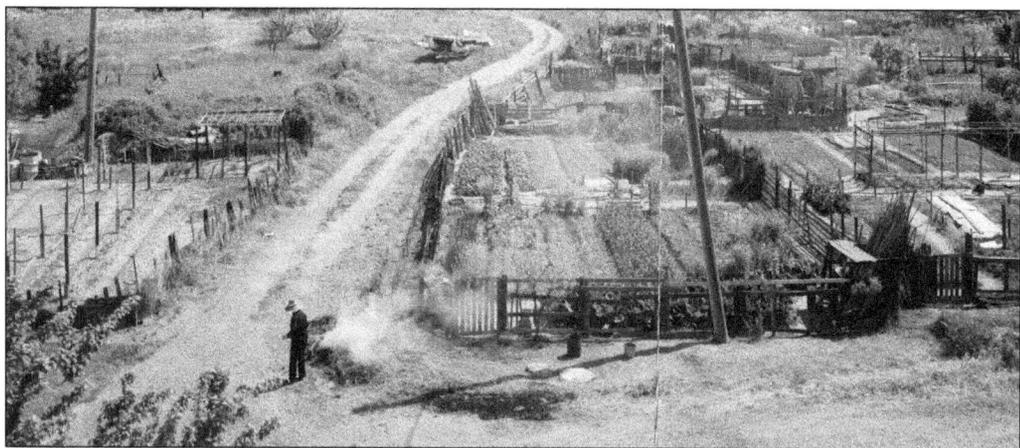

Pictured in 1984 is the nine-acre communal garden directly east of Locke, where residents grew much of their vegetables, many of them Chinese varieties common in Chinese cooking, including winter melons, bok choy, Chinese cabbage, bitter melon, snow peas, and loquats. Each of the residents was assigned his or her own small plot. (Courtesy NPS.)

念紀影撮軍

民族英雄

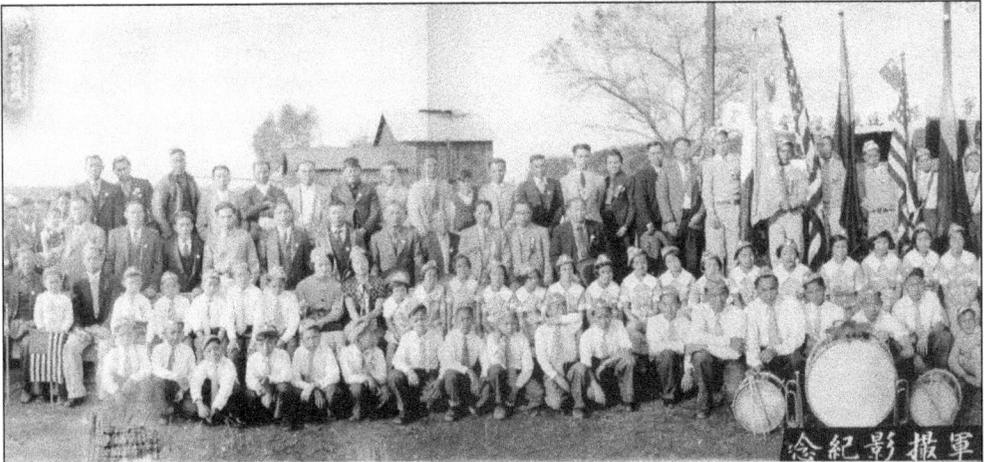

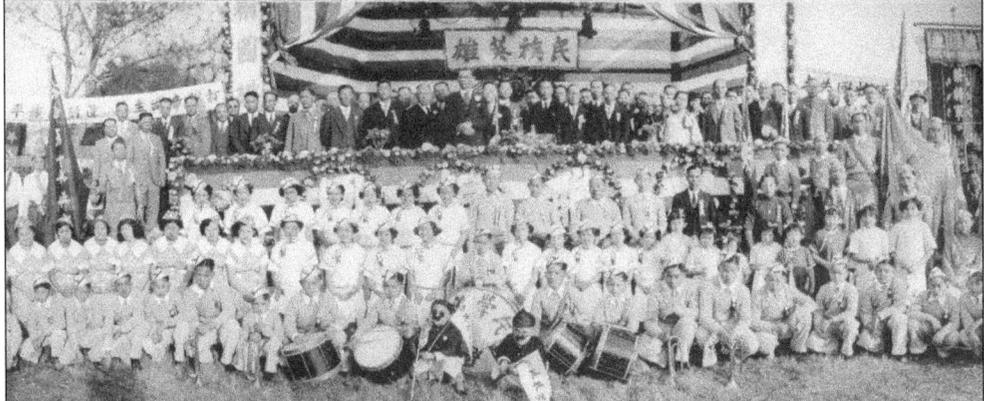

美國加省樂居江古魯埃蓋頓三聯合歡迎民族英雄蔡廷鍇將

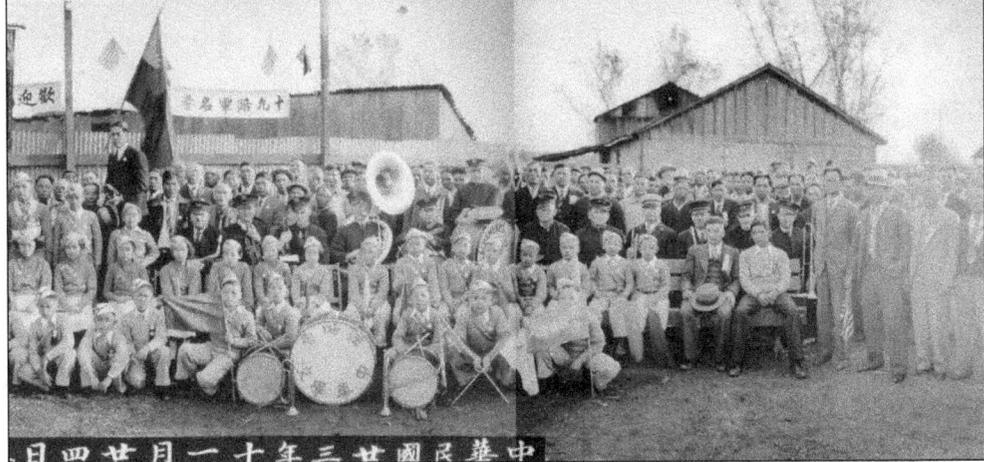

歡迎
十九路軍名譽

中華民國廿三年十一月廿四日

In 1934 Gen. Tsai Ting Kai, commander of the Republic of China's 19th Route Army, was on a goodwill tour through the delta to raise funds for China's war effort. General Kai helped lead the defense of Shanghai during the 1932 battle with the Japanese Army. A stand was constructed in the back of Locke in the meadows for this event. Though the event was held in Locke, all of the delta Chinese participated in the welcoming celebration. General Tsai is in the stand in the center photograph. (Courtesy Locke Foundation.)

Chin King, on the left, was one of the partners who established Yuen Chong grocery store in Locke. Kim King, on the right, was known as the "Slot Machine King," with slot machines in 50 locations up and down the Central Valley and the delta. (Courtesy Gene Chan.)

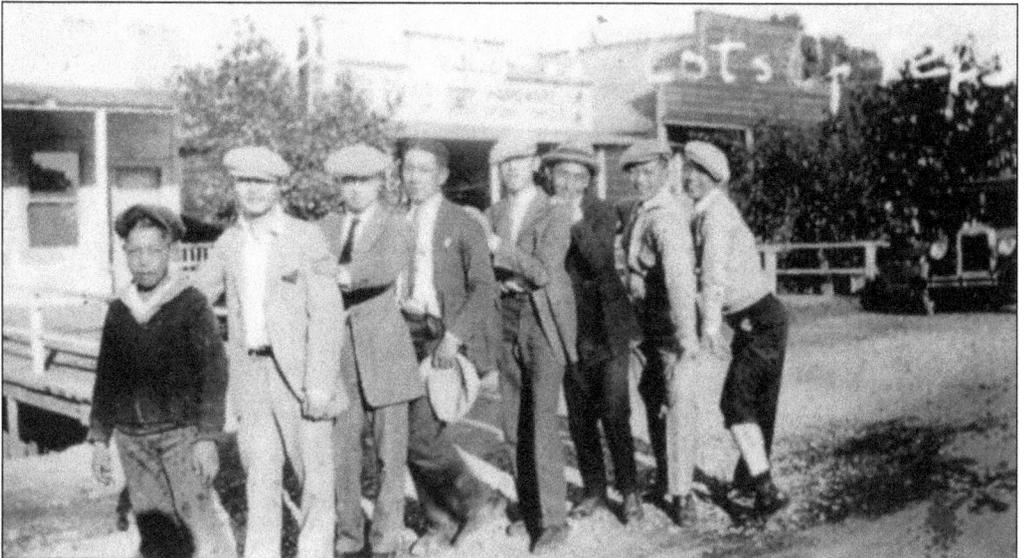

The single young men lined up to have their photograph taken on River Road in Locke in 1926. The three young men from the far left, going right, are George Law, Francis Chan, and Albert Law. In the background is the Wah Lee Dry Goods and Hardware Store. (Courtesy Gene Chan.)

Walter Chan was born in 1905 in
Chungshan, China. He came to America
in 1920 and settled in Locke in 1926 with
his wife, Carol Chan, and his family. Since
there was a railroad siding next to Locke,
he is demonstrating the correct method to
board a train. He worked at Yuen Chong
market until 1940 and then moved to
Sacramento. (Courtesy Don Chan.)

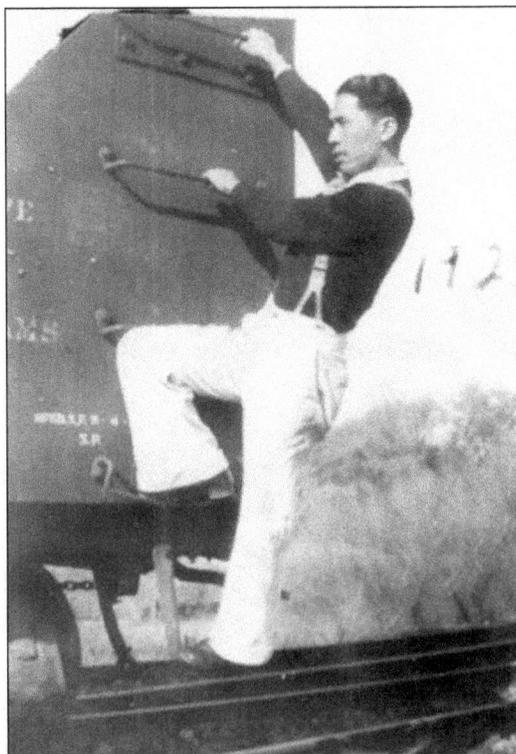

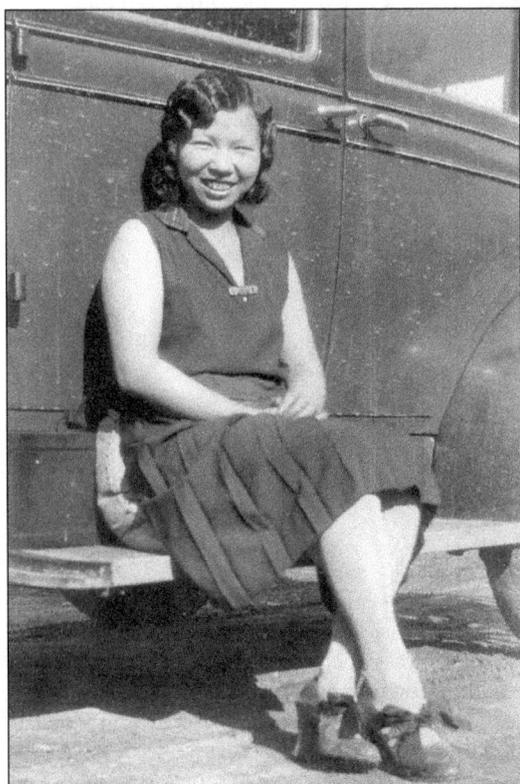

Pictured in 1932, Carol Chan, born in
China, was one of the first Chinese
women in the delta to drive an automobile
and almost never turned down any
request for transportation. Because of
her ability to read and write Chinese, she
was the Chinese secretary for the delta
women's league. (Courtesy Don Chan.)

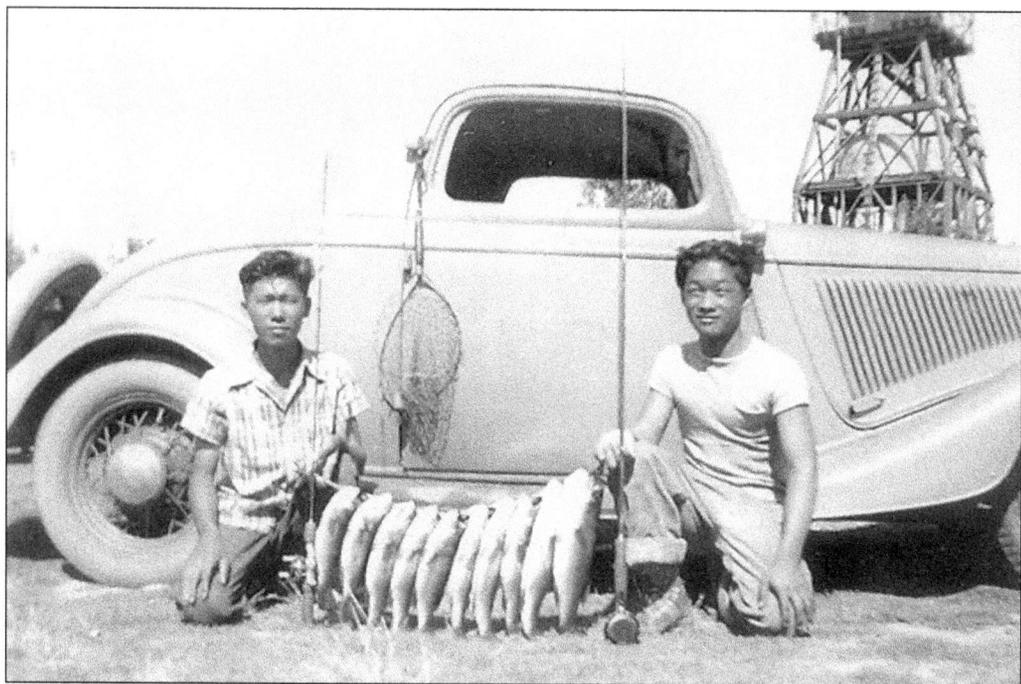

Because of the many sloughs in the delta, fishing was very popular. Chester (left) and Bill Chan had a very successful day in 1938 at Snodgrass Slough behind Locke posing in front of their 1932 Ford Model A. (Courtesy Don Chan.)

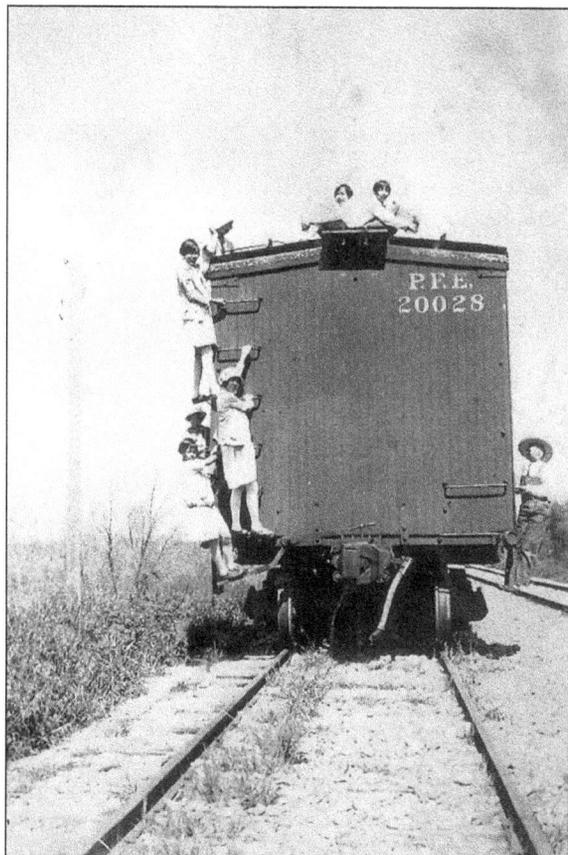

After Sunday service at the Baptist mission, girls in their best Sunday dress decided to catch a ride into town in the 1930s. This was the quickest and least-expensive mode of transportation available in Locke. (Courtesy Gene Chan.)

In the 1930s, two future engineers, Ronnie Law and Gene Chan, are designing plans for the future of Locke. In the background is Yuen Chong Market's delivery truck parked across from their garage on the service alley in Locke. (Courtesy Gene Chan.)

The Southern Pacific Railroad water tower, next to Locke, not only provided water for the locomotives but was also used several times to extinguish fires. The water tower provided a place for teenagers to hang out. From left to right are Lorraine Chun, Jeannie Chan, Nytee Chan, and Amy Chan. (Courtesy Gene Chan.)

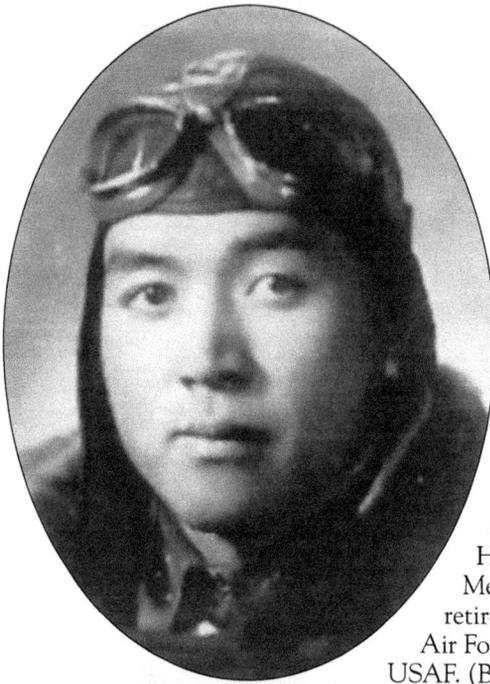

William Chow King was born and raised in Locke. After graduating from Sacramento City College, he volunteered to fly for the Chinese Air Force in World War II. After graduating from the Chinese Air Force Academy in February 1941, and under General Chennault, King was assigned to the Chinese American Composite Wing. This group was part of the 14th Air Force of the United States. He was a highly decorated Flying Tiger pilot. Among his medals were the Distinguish Flying Cross from the United States and a Unit Citation from Pres. Harry Truman. He also earned the Order of the Book of Nature Medal from the Taiwan Nationalist Chinese Party. He retired as captain of the CACW (provisional) Chinese Air Force, X170 26th Squadron 5th Fighter Group, 14th USAF. (Both, courtesy Gene Chan.)

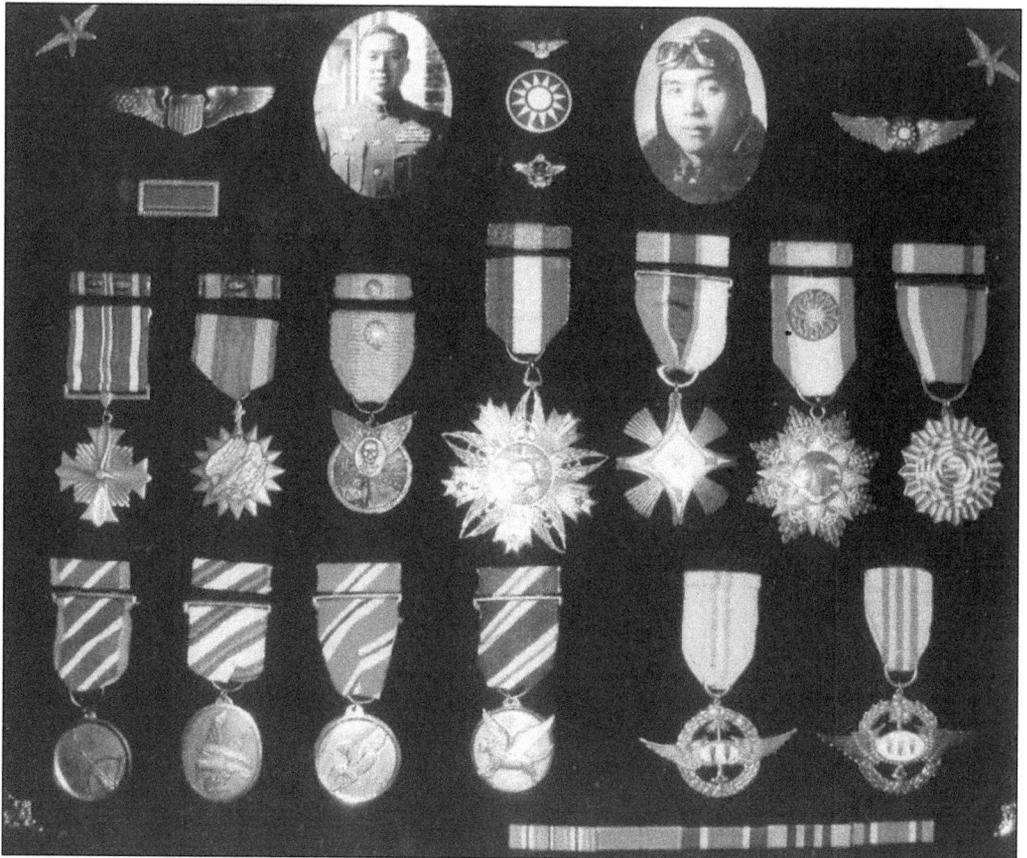

Ruth Chan was born in Walnut Grove. In the early 1930s, her family moved to Locke and opened the Happy Café at 13964 Main Street. She joined the Army Air Forces during World War II and was stationed at Moody Field in Georgia. After being discharged, she married Harry Jang and settled in Sacramento. (Courtesy Ruth Chan Jang.)

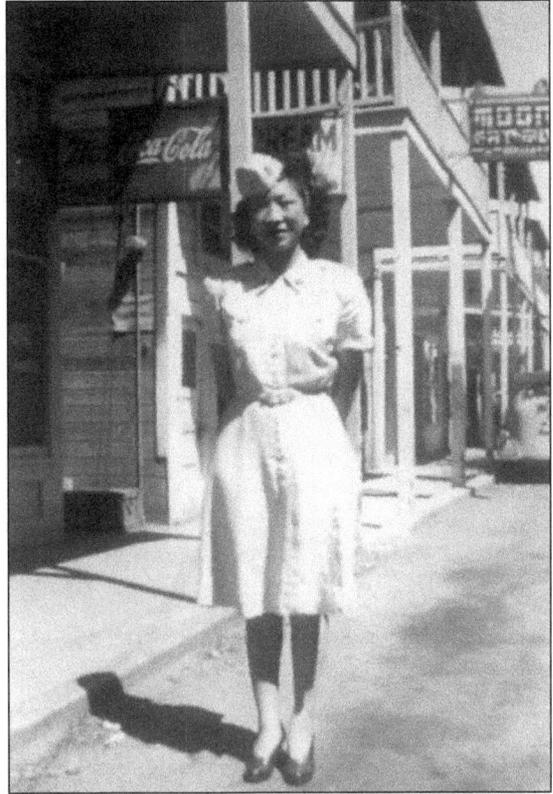

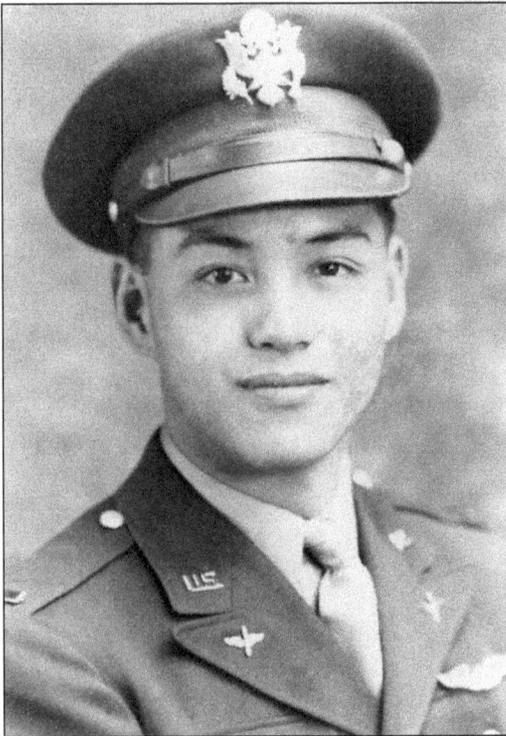

Harry Jang was raised in Locke. He joined the Army Air Forces and during World War II and was a navigator in the 367th Bomb Squadron, flying in a B-17 (Flying Fortress) over Germany. After the war, he married Ruth Chan in 1947. (Courtesy Ruth Chan Jang.)

Penny (left) and Linky Lee, pictured in 1946, were born in Locke. They are getting ready to lead the parade from Locke to Walnut Grove to celebrate the end of World War II. They are the daughters of Eugene and Bobbie Lee. (Courtesy Locke Foundation.)

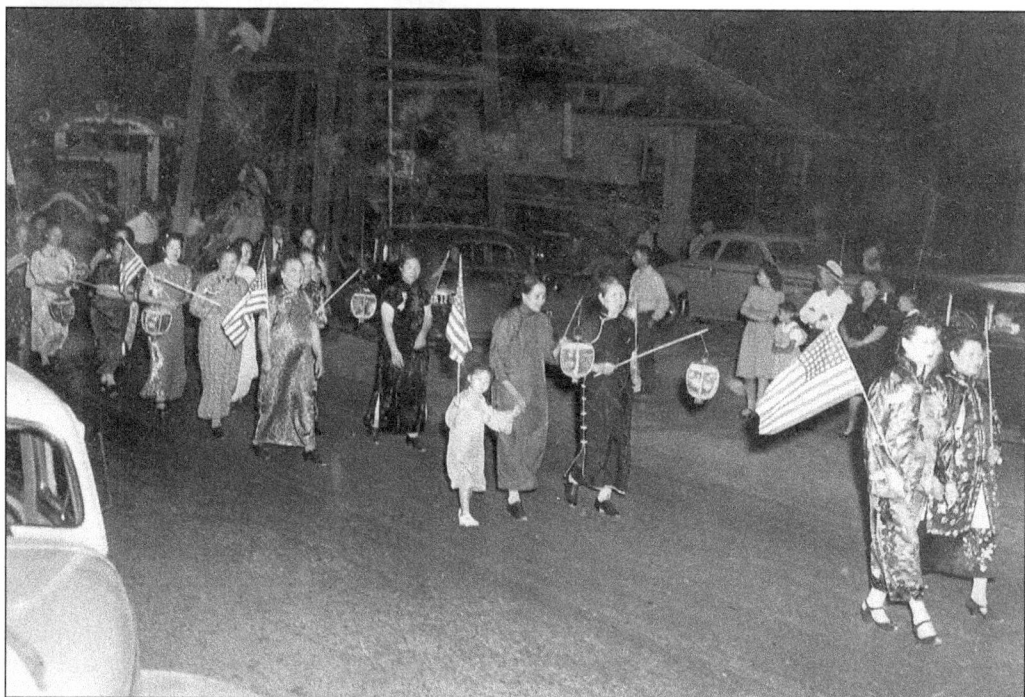

To celebrate the end of World War II, a parade started on Main Street in Locke and continued down River Road to Walnut Grove. All the residents of the town came out to participate in the celebration, pictured in 1946. (Courtesy Locke Foundation.)

Nytee Chan grew up in Locke, graduated from the University of California, and received the first of several teaching credentials from California State University at Sacramento. She was the first public school teacher from Locke. In 1965, she was one of 13 selected to implement the Head Start program (part of Pres. Lyndon Johnson's War on Poverty) in Sacramento's schools. After 30 years as a teacher, she retired in 1989. (Courtesy Nytee Young.)

Edna Jang (left), Margaret Chan (center), and Eva Hing are pictured in the 1930s on a lazy afternoon in front of the Happy Café on River Road. (Courtesy Nytee Chan Young.)

The Baptist Mission Church sponsored the Chinese boys' basketball team, which played against other Chinese teams in the surrounding towns. The team practiced on packed dirt, and the basketball backboard was attached to the town's water tower. The 1937 photograph above shows a practice game between Locke's Chinese team and Courtland's Chinese team. Below, also in 1937, are the Locke team players, from left to right, (first row) Wally Owyang, Henry Choy, On Lee, Ernest Chan, Walter Owyang, and Joe Chun; (second row) Ping Lee, Richard Chan, Harry Jang, William Jang, and George Jang. (Both, courtesy Ping Lee.)

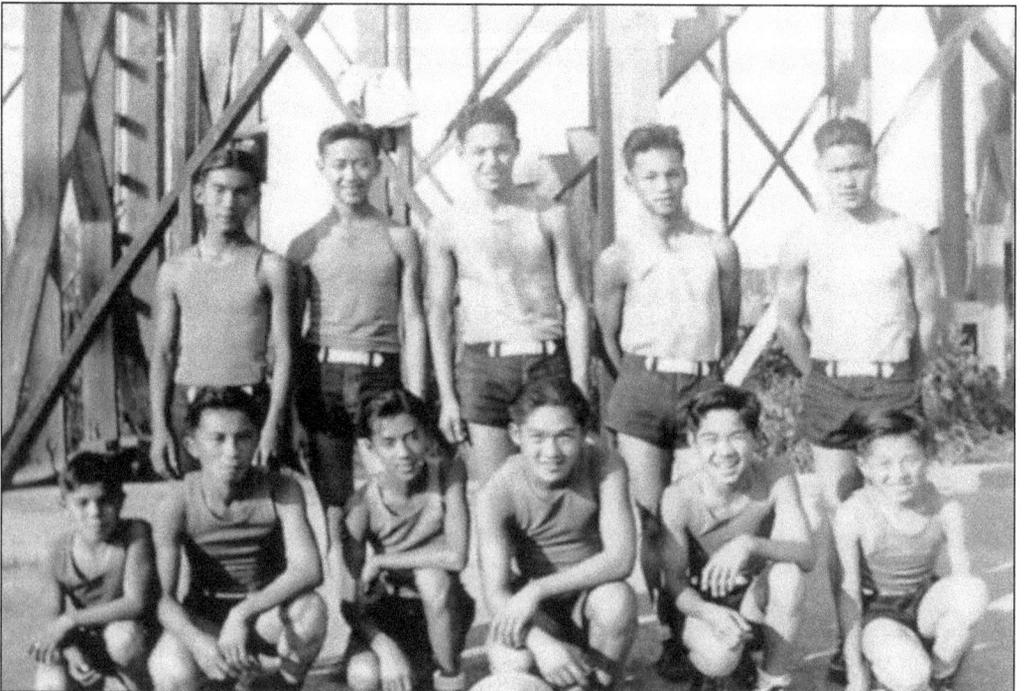

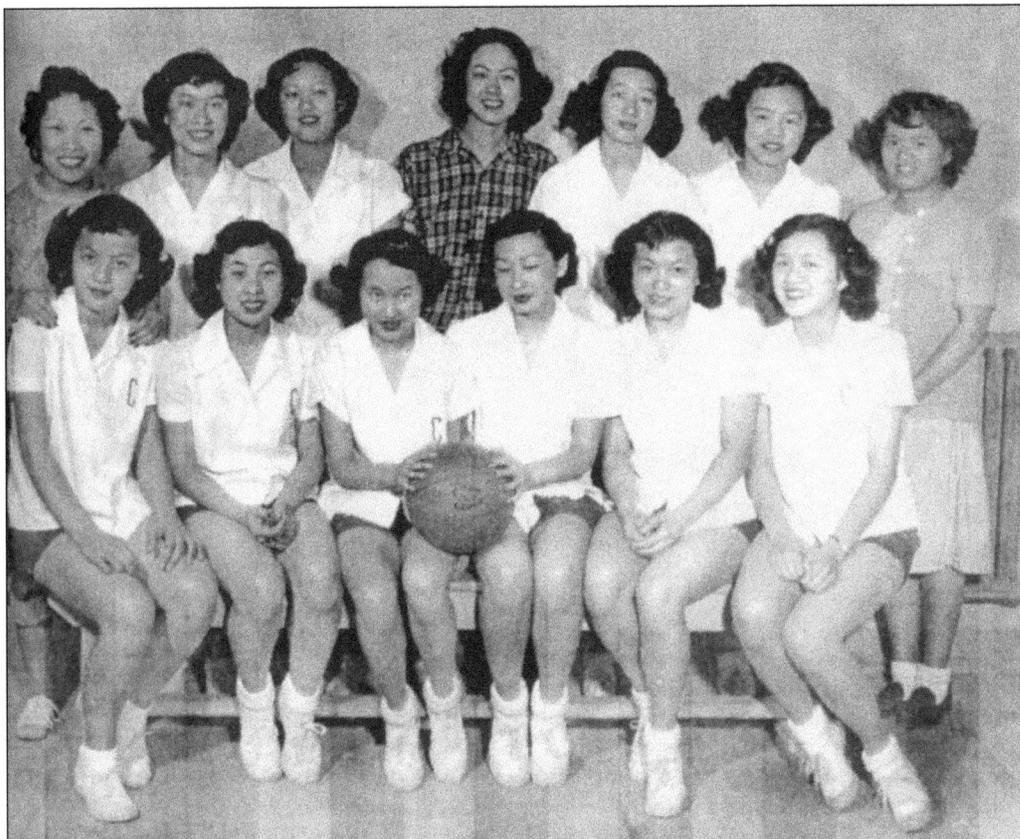

The Locke Chargettes were sponsored by the Baptist Mission Church and played in a church league. In 1949, the team won the league championship game, played at Lincoln Junior High School in Sacramento against a much larger team. The photograph below shows Barbara Chan accepting the trophy for the championship game. Pictured above, from left to right, are (first row) Janet Jang, Margaret Sen, Barbara Chan, Yvonne King, Jean Suen, and Alice Chan; (second row) Jenny Chan, Eva Chun, Virginia Owyang, Ruby Chan, Elaine Lee, Evelyn Mar, and Alice Chan. (Both, courtesy Gene Chan.)

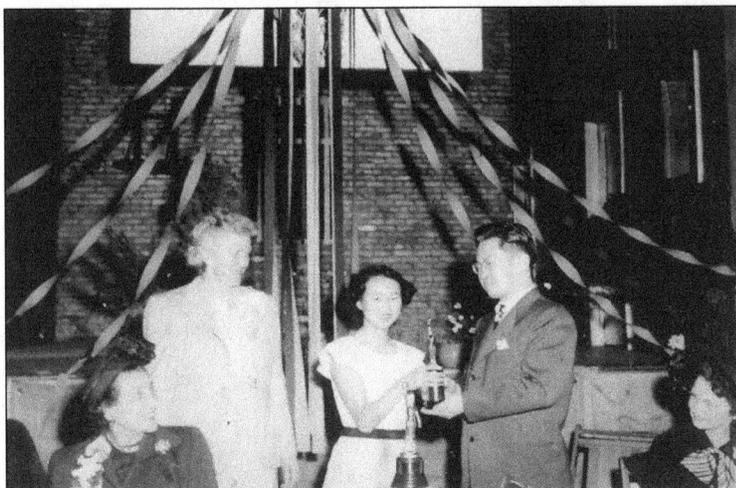

Connie Tom King is shown with her husband, Tommy King. For many decades, she has been the inspiration and driving force behind the revitalization of Locke. When the town was built, Chinese could not own property due to the state's Alien Land Law. After the law was ruled unconstitutional, she led the effort to overcome the many obstacles for the individual homeowners to purchase the land. After 55 years, she was finally successful in 2004. (Courtesy Locke Foundation.)

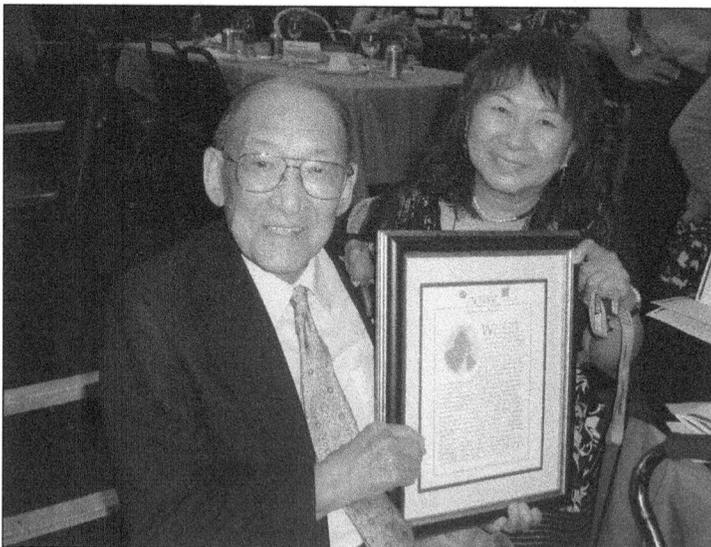

Ping Kan Lee was born in Locke in 1917 and graduated from the University of California in 1941. After returning to Locke in 1951, he pursued the goal of preserving the history and culture of Locke. For the following 28 years, he was the unofficial mayor of Locke.

Here, Ping is showing Elizabeth Wong the Hall of Fame award he received in 2008 from the Chinese American Council of Sacramento.

# Five

# WALNUT GROVE'S CHINATOWN

The town of Walnut Grove was settled in 1850 and is the only town in the delta on both sides of the Sacramento River. The town's name was derived from the abundance of walnut trees in the area. It is estimated that Walnut Grove's Chinatown was established as early as 1875. The Chinese that settled here were from both the Sze Yup and Chungshan districts. Similar to the other Chinatowns in the delta, the first Walnut Grove Chinatown was built on stilts overhanging the Sacramento River. After several fires at that location, the Chinese rebuilt the town on the land side of the levee. Chinatown had two more fires at the new location; the most devastating one was in 1915, destroying 94 houses and numerous businesses. Prior to this fire, the town abounded with activity. This Chinatown was at one time the largest in the delta, with an active membership of 400 members in the Bing Kong Tong. After the 1915 fire, under the leadership of Lee Bing, the Chungshan people decided to build one mile north to the property owned by George Locke instead of rebuilding in Walnut Grove. The Chinatown in Walnut Grove was rebuilt by the Sze Yup people. By 1929, the Chinese population in Walnut Grove was 800 and during harvest season, increased to over a 1,000. The Chinatown burned down again in 1937. The burned section of Chinatown included grocery stores, gambling halls, lodging houses, and general merchandise stores. The Chinese planned to rebuild the Chinatown; however, the landowners requested an increase in rent. The Chinese thought the rent was too high, so many of them left Walnut Grove. Today, the only building remaining that has Chinese architectural elements is the Bing Kong Tong building facing River Road. Walnut Grove's Chinatown no longer exists.

The sign above marks the entrance to Walnut Grove. The first Walnut Grove Chinatown similar to the other Chinatowns in the delta was built on stilts overhanging the Sacramento River. After several fires at this location, the Chinese rebuilt the town on the land side of the levee, pictured below in 1910. Chinatown had two more fires at the new location; the most devastating one was in 1915 and destroyed 94 houses and numerous businesses. After rebuilding, the Chinatown burned down again in 1937. Today, the only building with Chinese architectural elements in Walnut Grove is the Bing Kong Tong building. (Above, courtesy Lawrence Tom; below, courtesy Locke Foundation.)

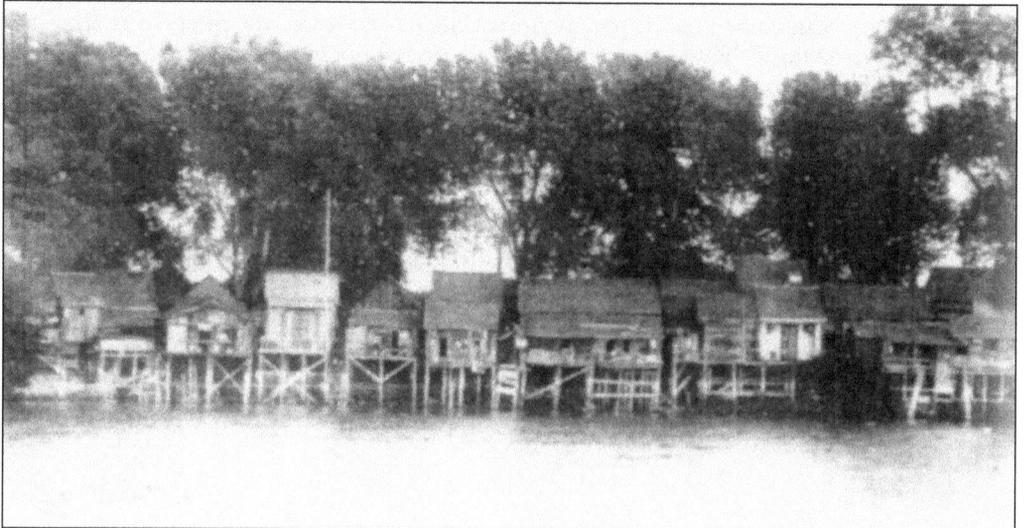

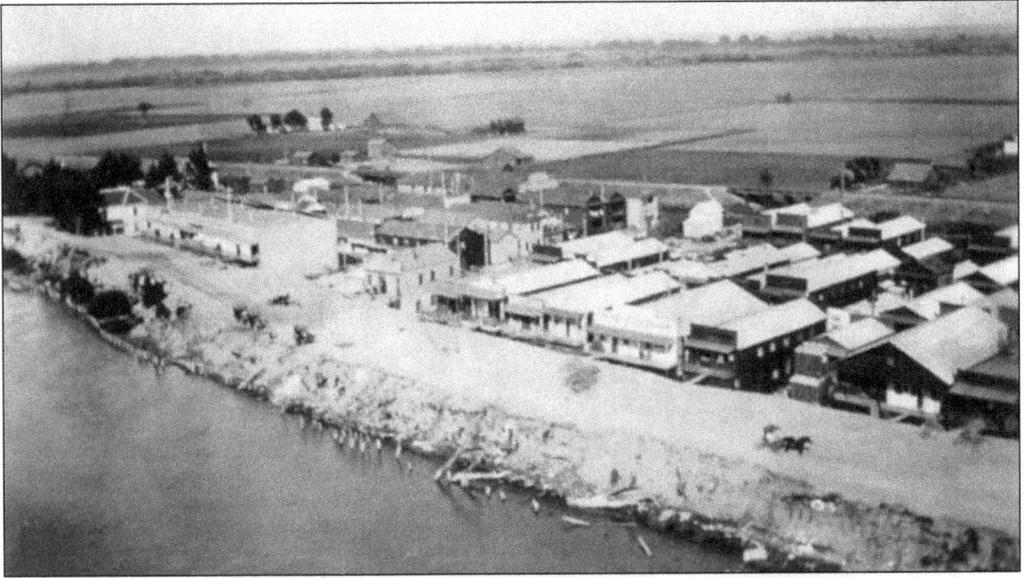

This is an aerial view of Walnut Grove's Chinatown (to the right) and Japantown (to the left) in the early 1915. The road on top of the levee had not been paved. The automobile and the horse and buggy shared the road as shown in the photograph. (Courtesy SRDHS.)

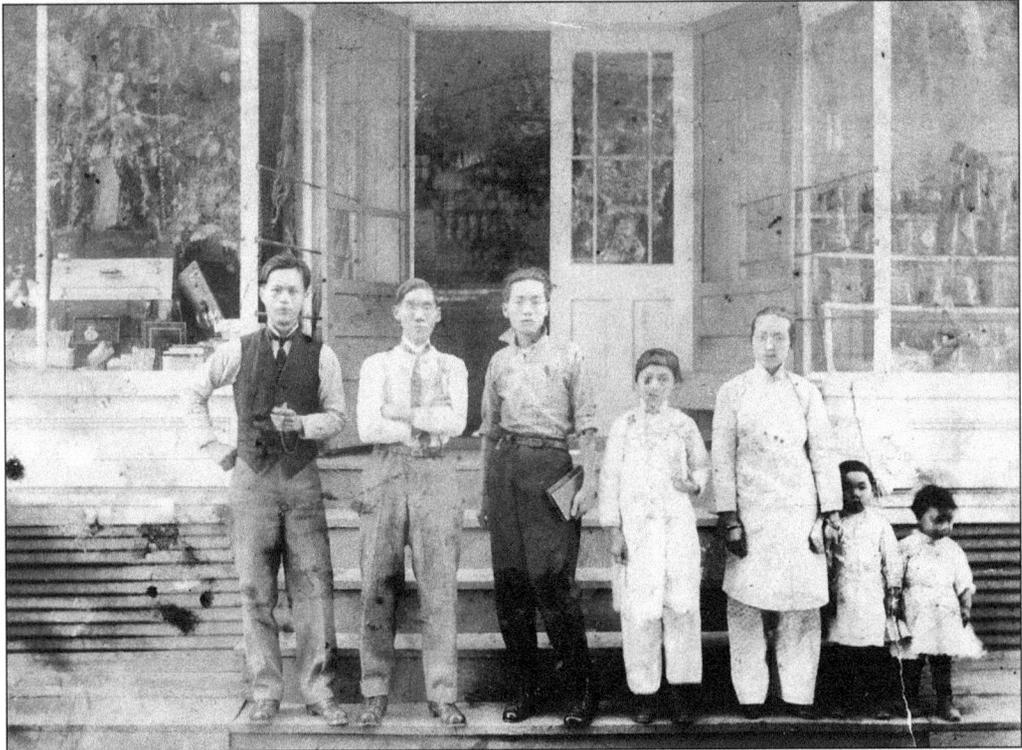

The Hing Lee Company, a general store, was owned by Lee Bing in Walnut Grove's Chinatown. The store was both a dry goods store and a drugstore. Pictured before the 1915 fire in Walnut Grove, the people are, from left to right, unidentified, Lee Bing, two unidentified, Lum Shee, Lee Bing's wife, and Dorothy and Connie King, daughters of Chin King. (Courtesy Ping Lee.)

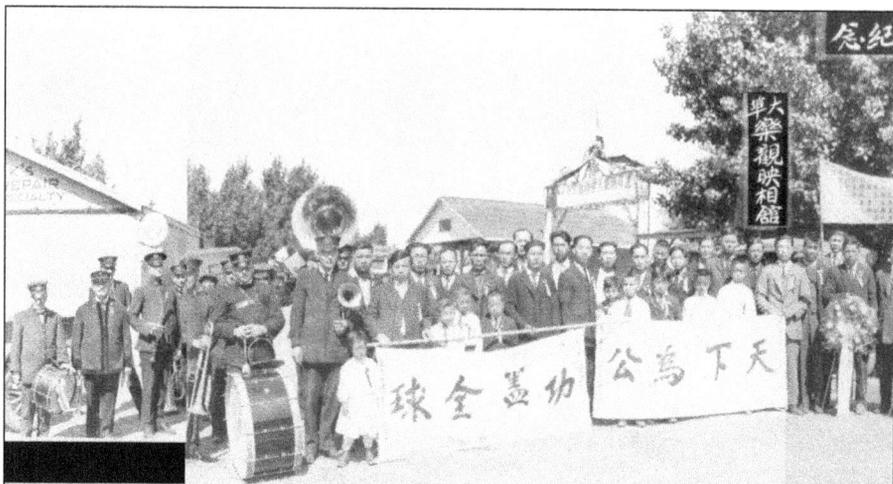

紀念

大樂觀映相館

功蓋全球　天下為公

中華民國十四年四月十二日

沽埠中華會館國民黨分部邑華安學校聯合追悼孫中山先生大會撮影

江米分時岭　團民國

追悼孫公中山
In Memoriam for Sun...

注古

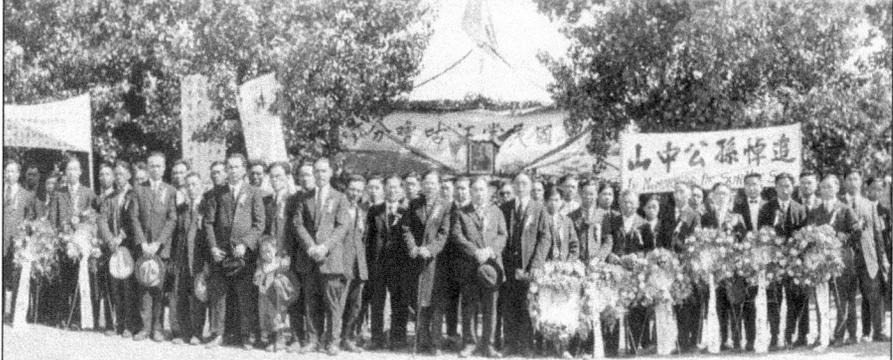

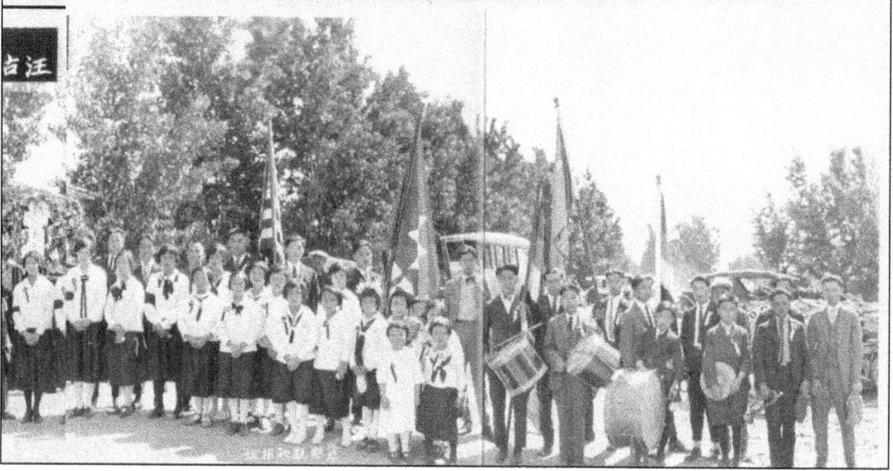

The Chinese in the delta were strong supporters of Dr. Sun Yat-sen and his cause, a democratic revolution in China. He had visited Walnut Grove in the past to gain support for his cause. After his passing, an elaborate memorial service in Walnut Grove was held for him on April 12, 1925. (Courtesy Arthur Mark.)

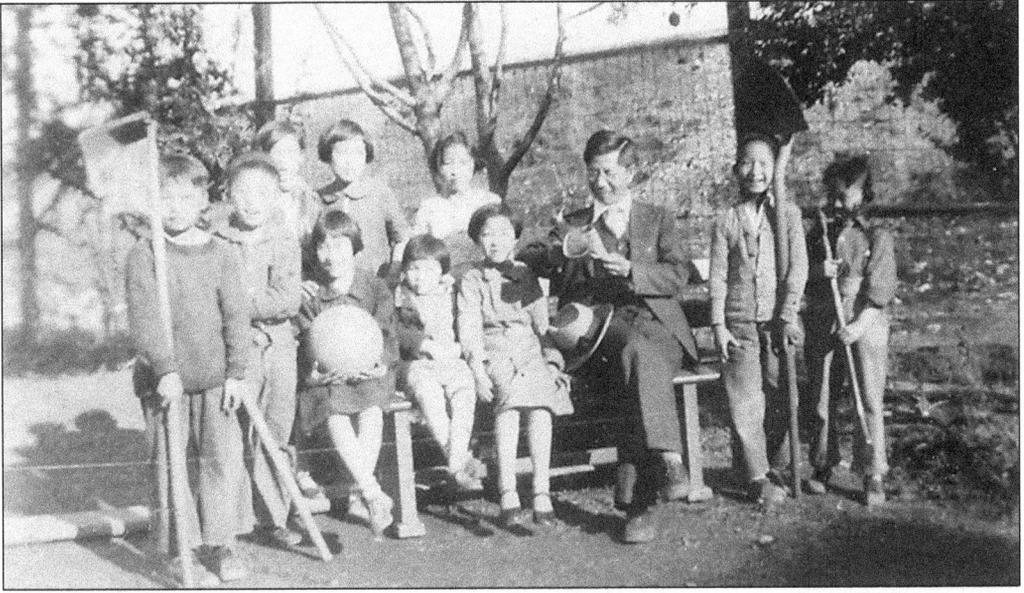

Chinese schools were an important part of the Chinese communities in the delta Chinatowns. Wing Lee was the teacher at the Walnut Grove Chinese School in 1933 and is shown here with some of his students. (Courtesy Walter Lee collection.)

The bachelorettes of Walnut Grove are pictured in 1934. They are, from left to right, Minnie Lee, Mary Ann Chan, Marie Lee, Lillian Lee, Bessie Joe, Katherine Mar, and Evelyn Lee. (Courtesy Walter Lee collection.)

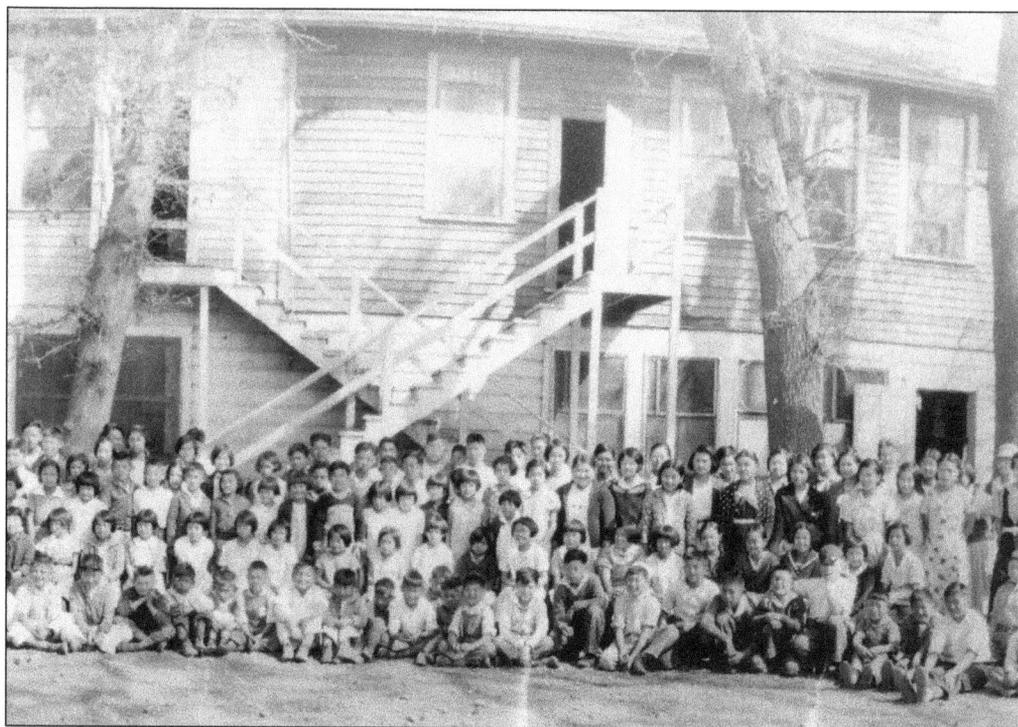

Walnut Grove, similar to the other Sacramento delta towns, had segregated schools—one for whites, one for migratory students, and one for Asians. The enrollment in each school in 1918 was 62 students at the white school, 29 attended the migratory school, and 222 attended the Oriental school. This is the total student body at the Oriental school in Walnut Grove in 1934. Segregated schools continued in Walnut Grove until 1942, after the Japanese were relocated to internment camps in 1942. (Both, courtesy SRDHS.)

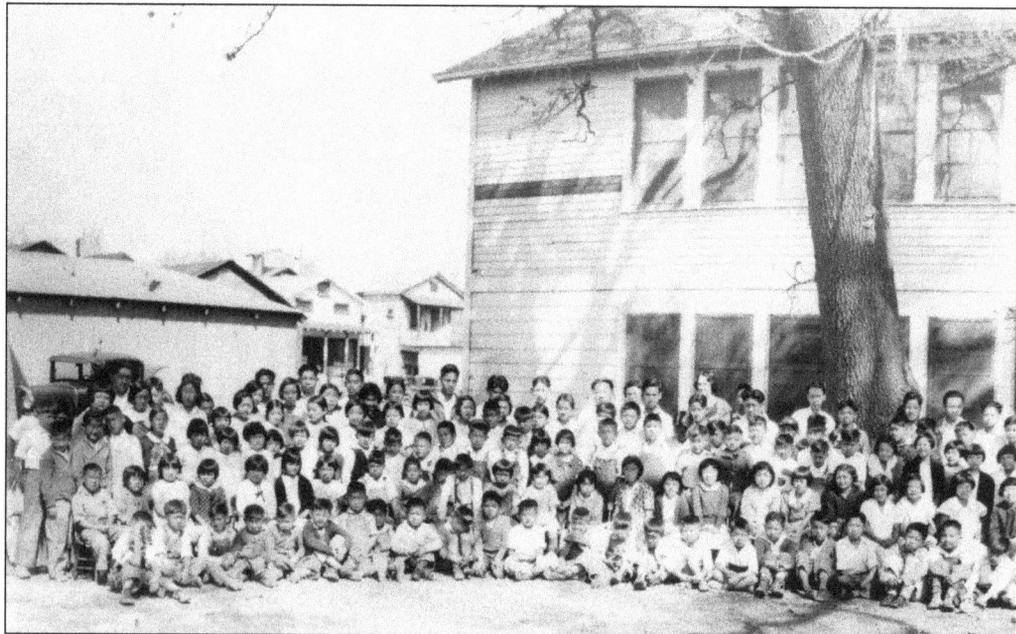

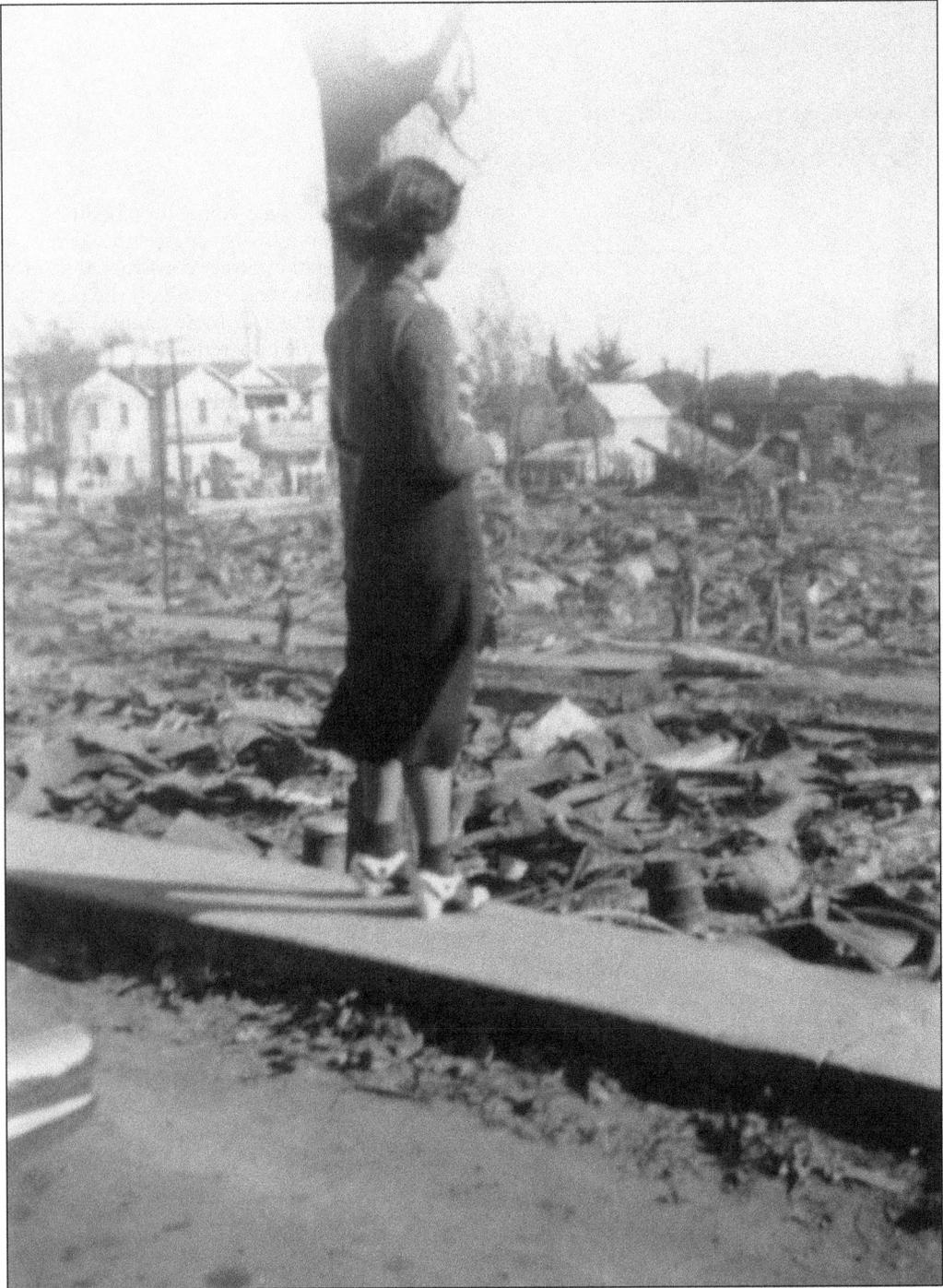

Before the 1937 fire, Chinatown had many groceries, six gambling halls, numerous lodging houses, general merchandise stores, and barbershops. The fire on November 9, 1937, lasting four hours, destroyed 80 buildings (all of the businesses and homes in Chinatown), leaving 500 homeless and five dead. Pictured after the fire that morning, one of the residents of Walnut Grove cannot quite grasp what has happened to her home and possessions. (Courtesy Walter Lee collection.)

The Bing Kong Tong building was a two-story structure on Market Street constructed shortly after the 1937 fire on the previous site of a Chinese temple. This is the only remaining building in Walnut Grove with Chinese architectural elements. The second floor (below) faced River Road and was the fraternal hall, while the ground floor was a "Chop Suey" house operated by the Moon family. Bing Kong Tong was established to oversee and regulate businesses, to assist the indigent in returning to China, or to send the remains of the deceased to their ancestral village. It also helped members repay debts and mediate quarrels. The Walnut Grove Bing Kong Tong branch had 400 members at the height of its influence.

# Six

# ISLETON'S CHINATOWN

The town of Isleton was founded by Josiah Pool in 1874. Though Chinese have been in the delta since the 1860s, the Chinatown in Isleton was not established until 1878. It was located in the vicinity of Delta Avenue, west of the business district. The Chinatown grew rapidly (in the 1880 census, Isleton had 1,680 residents of which 880 were Chinese) and was built completely of wood with wooden sidewalks. A fire in 1915 completely destroyed the 40 buildings in Chinatown. Since many of the Chinese worked at the canneries on the east side of the business district, Yee Toy, a Chinese community leader in Isleton, negotiated with the landowner, James Gardiner, to lease the land to the Chinese on Main Street between E and F Streets, closer to the canneries. The California Alien Land Law of 1913 did not allow the Chinese to own land. This location on Main Street became the present Chinatown in Isleton. Immediately adjacent to Chinatown was Japantown, across F Street to the east.

The new Chinatown grew rapidly due to the three canneries in Isleton, with a workforce that was over 90-percent Asian. Chinatown became a very lively place during the harvest and packing season. For the farm laborers, there were restaurants, saloons, gambling halls, and brothels for recreation and relaxation, in addition to stores for supplies. In 1926, Chinatown and the adjacent Japantown were destroyed by fire. It was reported that 110 buildings were destroyed, affecting 1,500 people. After the fire, the Chinese and Japanese rebuilt their town in the same location. However, similar to the other small Chinatowns in the Sacramento River delta, the next generation of Chinese started leaving in the 1930s and their departure accelerated during the 1940s. Today, there are only a small number of Chinese remaining in Isleton. In 1991, the Isleton Chinese Commercial District was listed in the National Register of Historic Places.

Location of
White School

Location of
Migratory School

N

Approx. Scale

0

100 FT.

Oriental
School

E Street

UNION STREET

Ice Plant

MAIN STREET

SACRAMENTO

LEVEE ROAD

RIVER

2
4
6
8
10
12
14
16
18
20
22
24
26
28
30
32   32 1/2
34
36

1
3
5
7
9
11
13
15
17
19
21
23
25
27
29
31
33
35

Cigar shop/pool
Paul's barbershop

National
Cafe

Charley Sing's Rest
Lee's Bros

National Grocery
Chinese School

New Life
Grocery

Pool Hall
Pineapple Rest.

Kum Kee Grocery

Yet Sing Cafe

Chan Kee Store

Wang-Bun Gambling

Choon-Daw Gambling

U-Like Grocery
Barber Shop

Luna Merchandise
Dry Goods Store

Barbershop
Pool Hall

Wing Hing Lee

Hop Fat Grocery

Quong-Wo-Sing

Kong-Yick Co

Bing Kong Tong
2nd Chinese School 1933-1950

Mee-Joe Gambling
vacant lot now

New Asia Gambling
Isleton Museum Currently

Mee-Wah Gambling

F Street

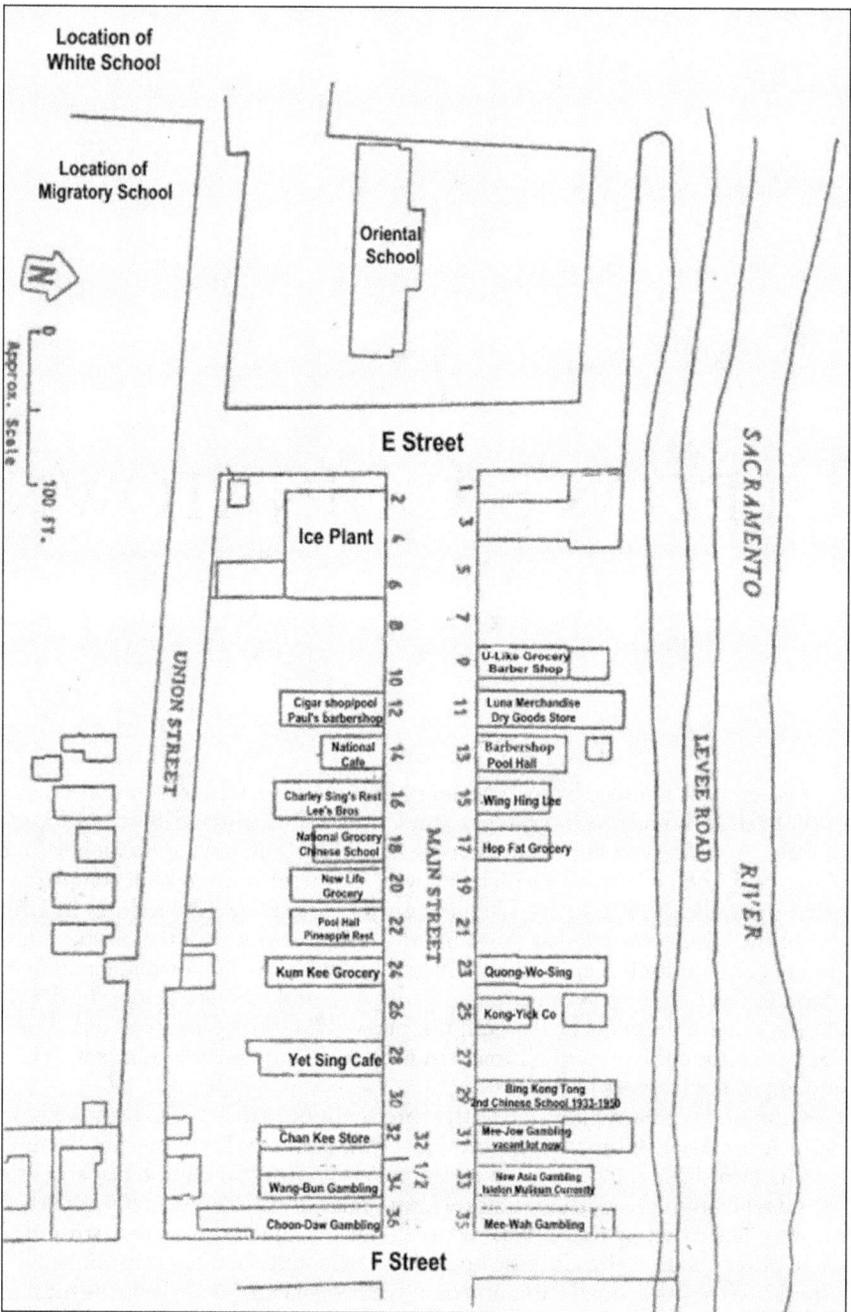

This is a map of the second Chinatown in Isleton. It was built in 1915 after a fire destroyed the first Chinatown. The second Chinatown was closer to the canneries, and the location made it more convenient for the many Chinese who worked there. In 1926, another fire completely destroyed the second Chinatown, but it was quickly rebuilt at the same location. This map shows some of the businesses at each of the locations during the time period 1920 to 1950—except for the Isleton museum at 33 Main Street, which moved there in March 2010. (Courtesy IBAHS.)

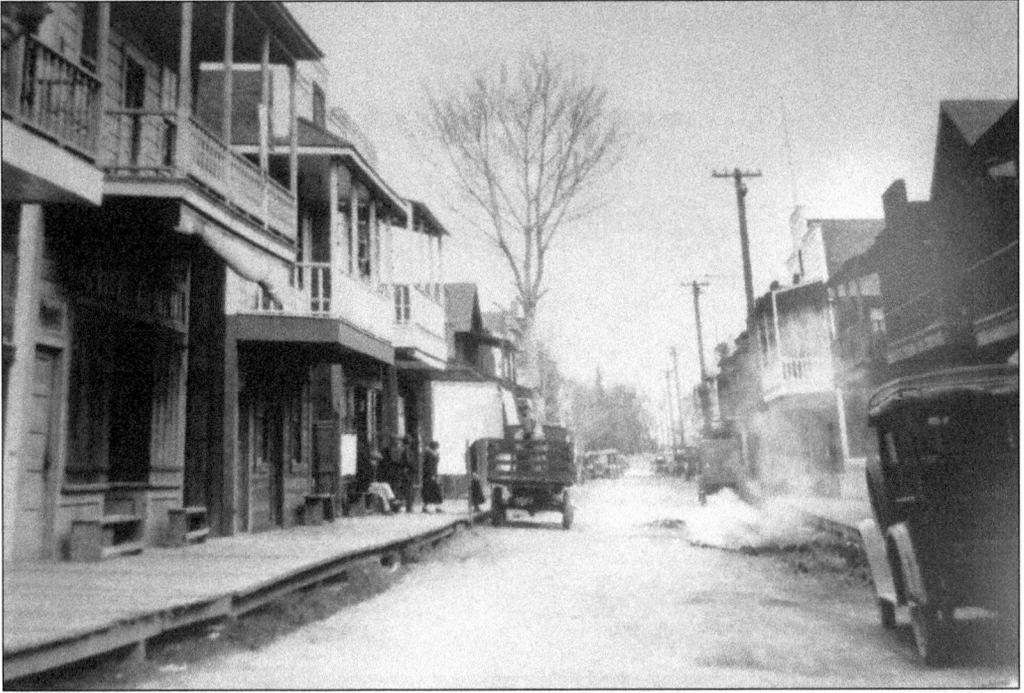

Bessie Toy (pictured next to the wagon in 1916) was the youngest daughter of Yee Toy, a Chinatown community leader. He had inherited the store Quong Wo Sing from his father, who had settled in the first Chinatown in the 1880s. Bessie and her husband, Chinn Gee, operated the dry goods store and expanded to sell fishing and hunting equipment. Six generations of Toys have lived in Isleton. (Courtesy IBAHS.)

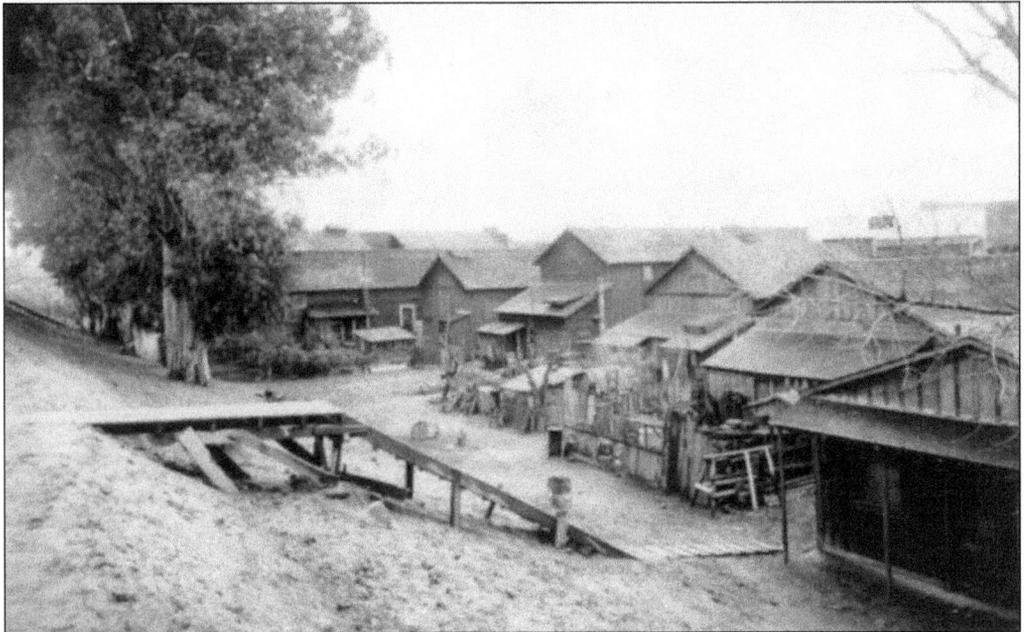

This is the levee view of the backs of the buildings on Main Street of Chinatown prior to the 1926 fire. (Courtesy IBAHS.)

The second fire occurred in 1926, destroying 110 buildings on Main Street. It broke out in a house next to the Chinese language school building at 18 Main Street. It was reported that 1,500 people lost their homes and belongings in the fire, which destroyed both Chinatown and Japantown, an area of six square blocks. The photograph is looking east on Main Street with the canneries shown in the background. (Courtesy IBAHS.)

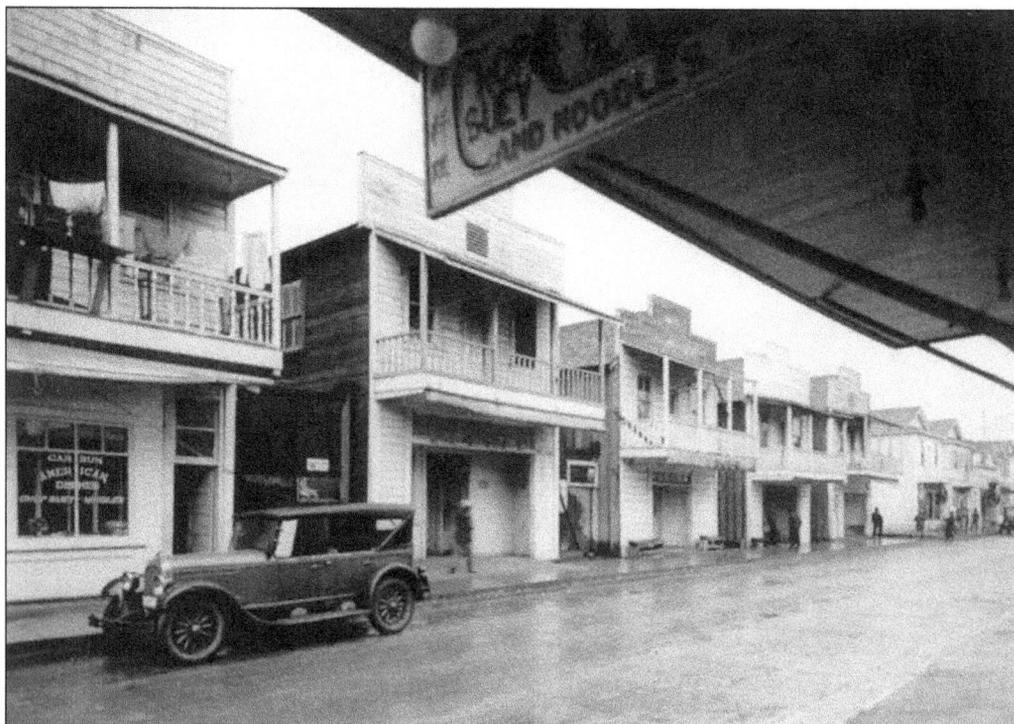

Chinese American businesses were confined to the area on Main Street west of F Street. The Bing Kong Tong building is the second one from the left. To the right of the building are three gambling halls whose clientele included not only Chinese workers but Filipinos, Japanese, East Indians, and Caucasians. State law forced the closing of these gambling establishments in the 1950s. (Courtesy IBAHS.)

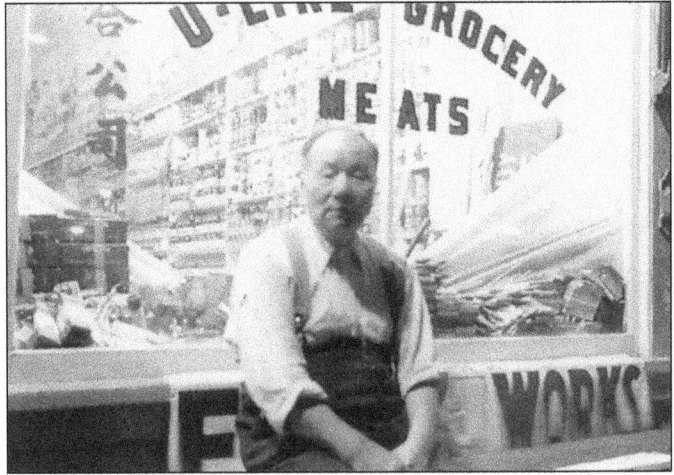

The U-Like Grocery was located at 9 Main Street. The owner, Lee Sar Mon (pictured), had moved his family from Walnut Grove after a fire there in 1937 and established the grocery. After he retired, his three sons—Alfred, William, and Walter—operated the business. It was a busy store serving not only the residents of Chinatown but also the entire Isleton community. The store closed in 1976. (Courtesy Walter Lee collection.)

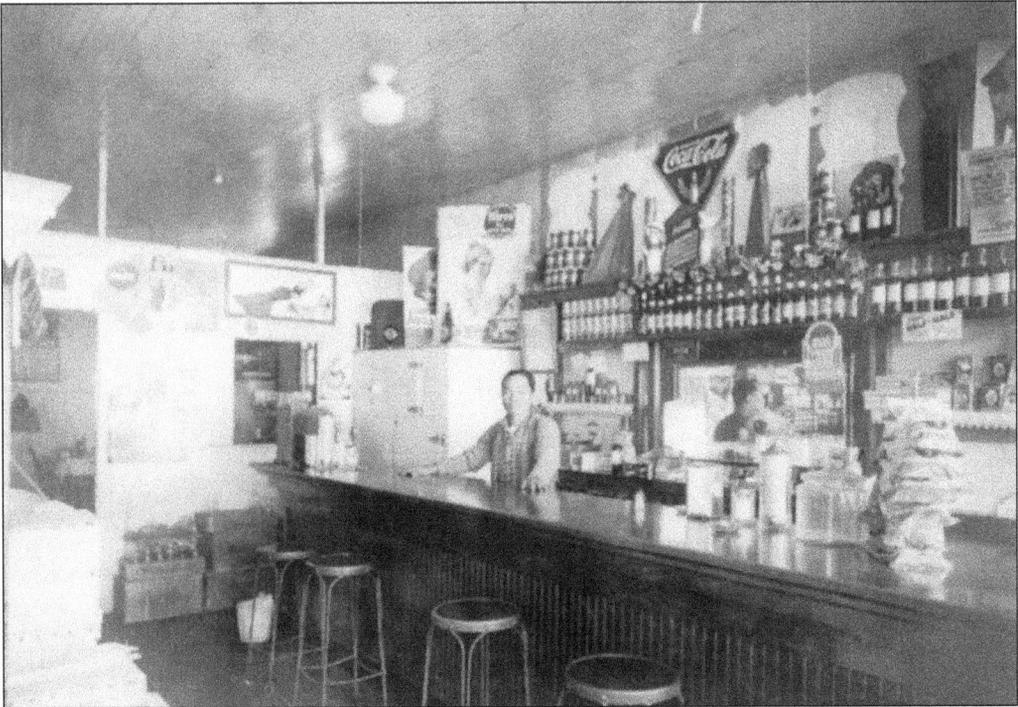

Marion and Sing Wong purchased 14 Main Street in 1943 for their National Café. The Wongs previously owned the National Grocery at 18 Main Street before moving to this location. Sing Wong is standing behind the counter. National Café closed after the 1972 Isleton flood. (Courtesy Marion Owyang Wong collection.)

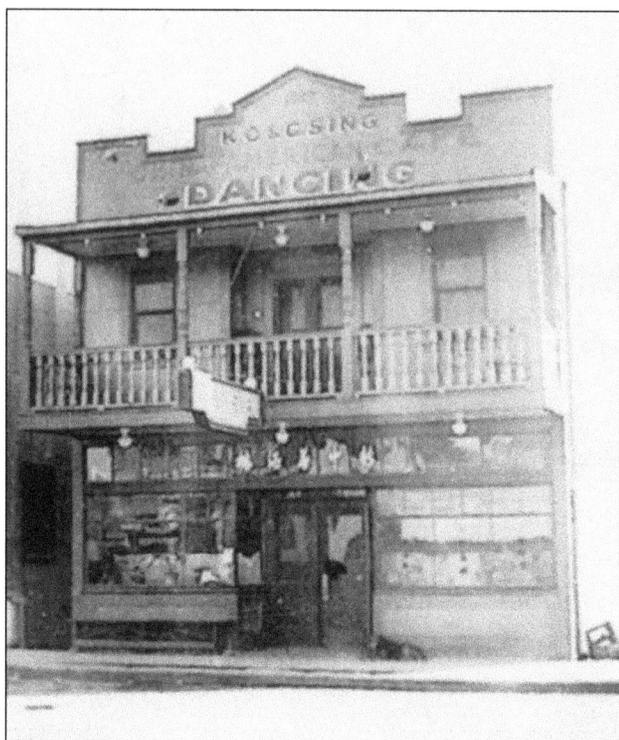

Charlie Sing Owyang opened a restaurant at 16 Main Street in 1926. Above the restaurant was a jukebox and dance floor. It was the busiest and the noisiest building in Chinatown in the early days. (Courtesy Lucille Chan Searle.)

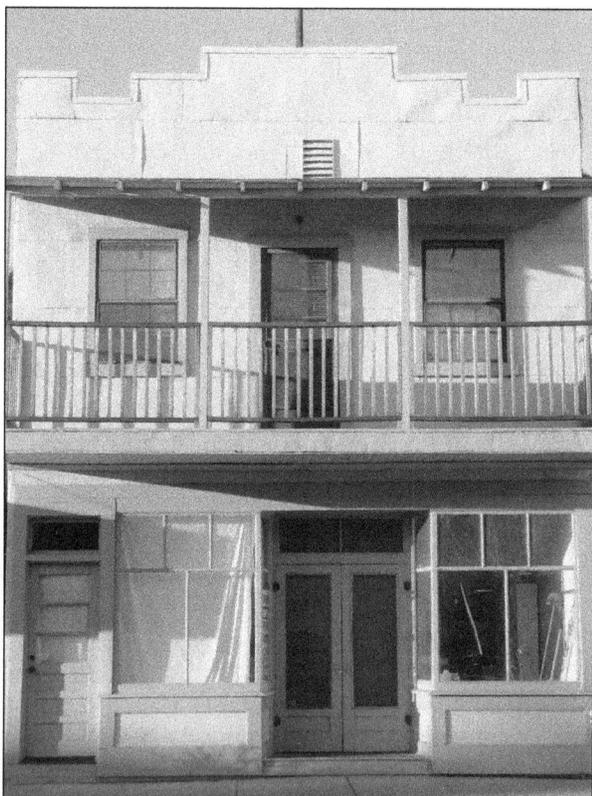

17 Main Street was the site of Hop Fat, selling Chinese goods. Yee Toy constructed this building for his daughter Suey "Lucille" Toy. Two additional buildings on Main Street were erected for his other two daughters, Bessie and Marion. The basement of this building was the temporary meeting place of the Bing Kong Tong while its permanent building at 29 Main Street was being constructed. (Courtesy IBAHS.)

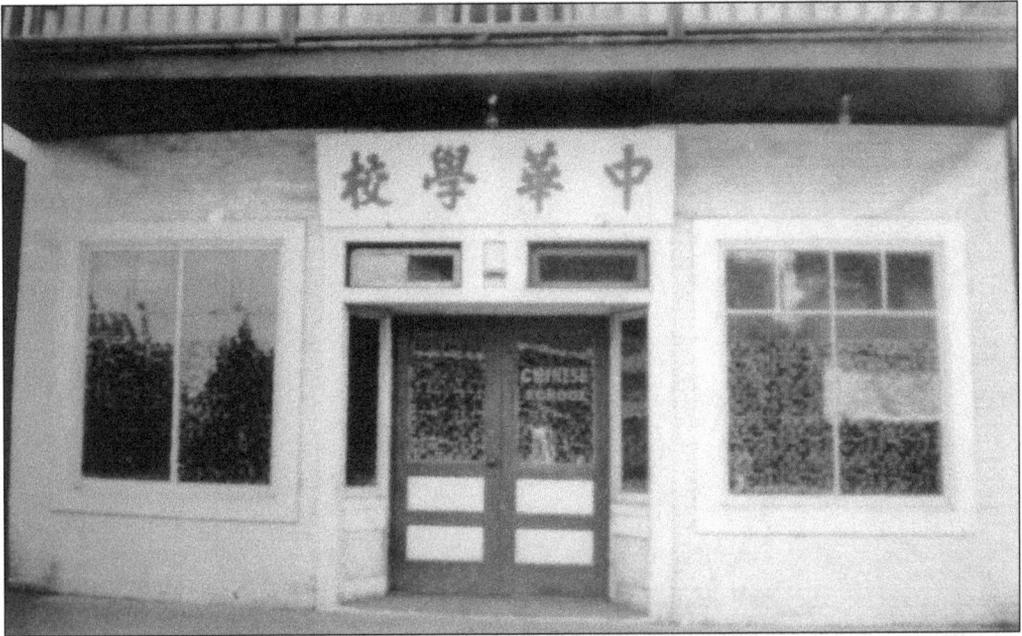

18 Main Street served as the first Chinese language school in Isleton until 1933. The building also served as a Sunday school when missionaries Faith Joys and Florence Benson visited from Locke. Due to a lack of space, the school moved to the Bing Kong Tong building at 29 Main Street. This building became the National Grocery Store until 1943. (Courtesy Hong Kong Chow family.)

23 Main Street was the Quong Wo Sing Store, a general store owned by Yee Toy, a community leader and the president of the Bing Kong Tong for many years. He also operated several gambling establishments on Main Street. (Courtesy Roger Chin.)

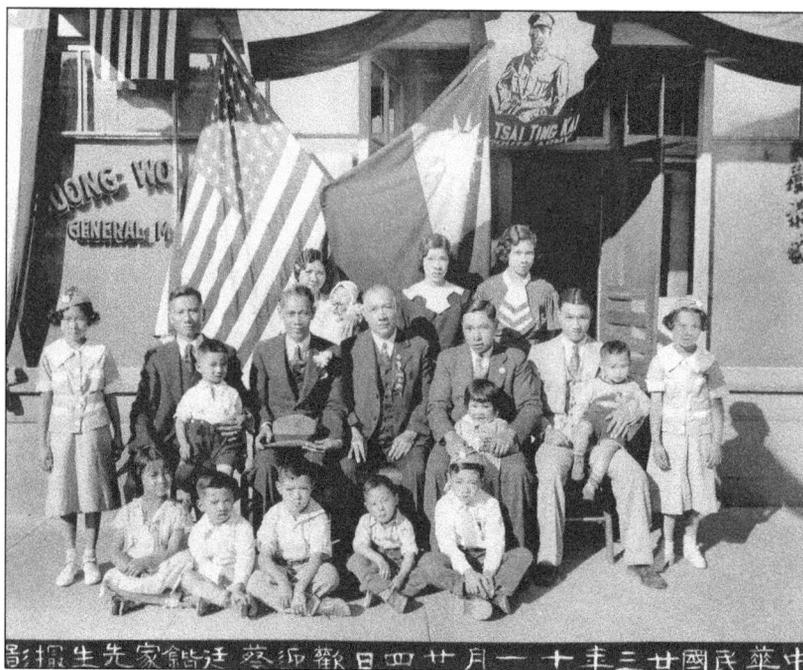

Yee Toy (second row, fourth from left) and family are shown with Gen. Tsai Ting-Kai, fourth from the right in front of the Quong Wo Sing store on 23 Main Street in 1934. He was visiting America to raise funds for the war against Japan. He stayed for several days at Yee Toy's store on 23 Main Street. (Courtesy Elsie Owyoung Yun.)

影撮生先鍇廷蔡師尊歡日四廿月一十年三廿國民華中

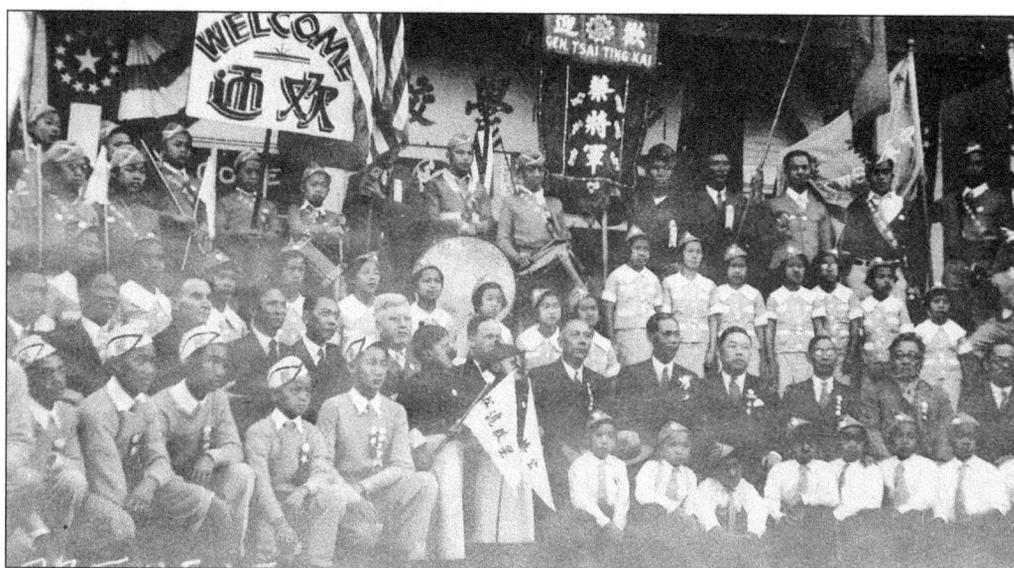

Isleton's Chinatown celebrated the visit of Gen. Tsai Ting Kai. The children of the Chinese language schools in Courtland, Walnut Grove, and Isleton participated in a parade. All the Chinese in town and the surrounding farms came out to welcome and support this Chinese hero. General Tsai is seated second row, fifth from the right. (Courtesy Elsie Owyoung Yun.)

24 Main Street was the site of Kum Kee Grocery. In addition to the main store, a commissary was opened at the E&A (Escher, Barsoom, and Alexander) cannery to serve the cannery workers. Sandwiches (15¢ each) and homemade stew were on the menu. Pictured in front of the store is Hon Sun Lum, one of the partners, in 1935. (Courtesy Hong Kong Chow family.)

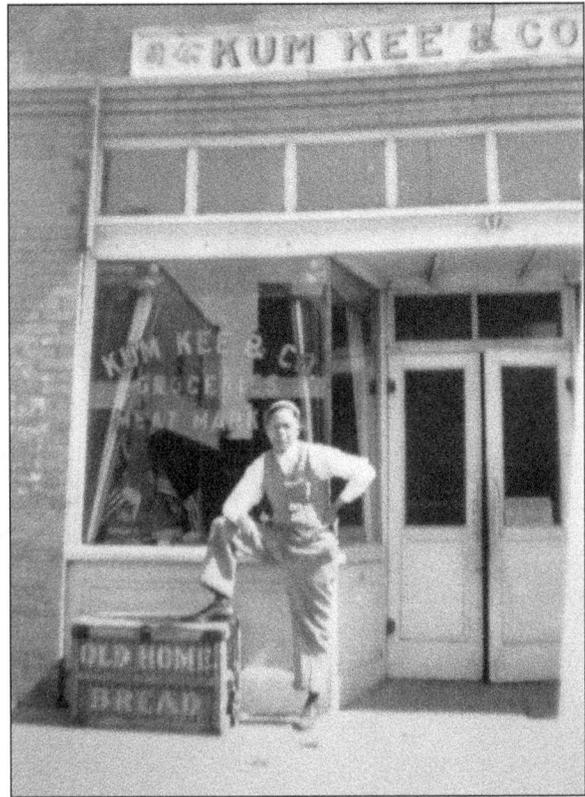

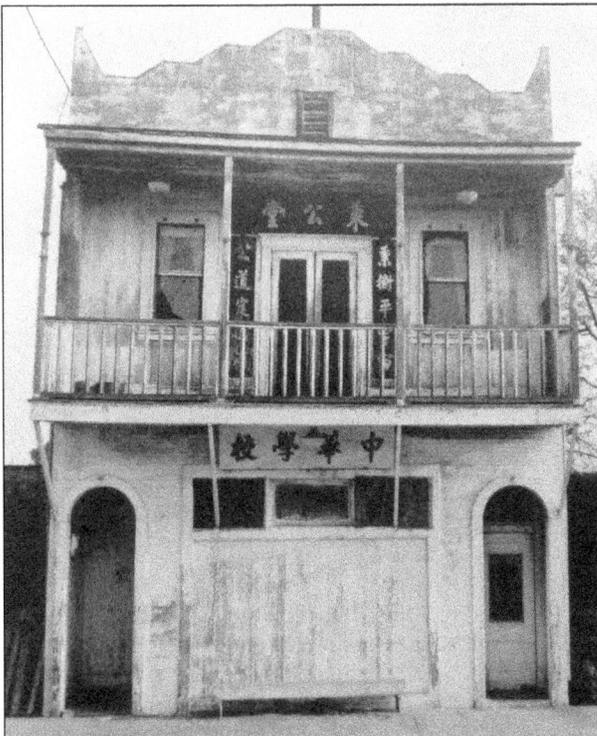

29 Main Street was the Bing Kung Tong building. The Bing Kong Tong branch was established in Isleton during the 1890s and was a focal point of the Chinese American community, providing social, religious, employment support to fellow countrymen and settling internal frictions and disagreement with its members or with members of a rival tong. The building was later used as the Chinese school until 1950. (Courtesy IBAHS.)

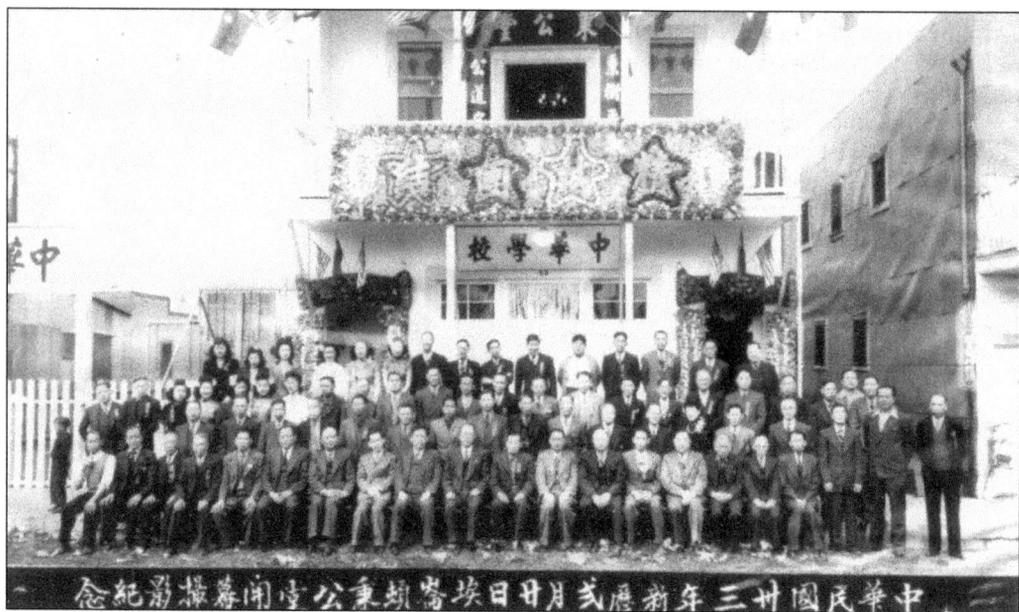

These are the members of the Bing Kong Tong in front of their building at 29 Main Street in 1944. (Courtesy IBAHS.)

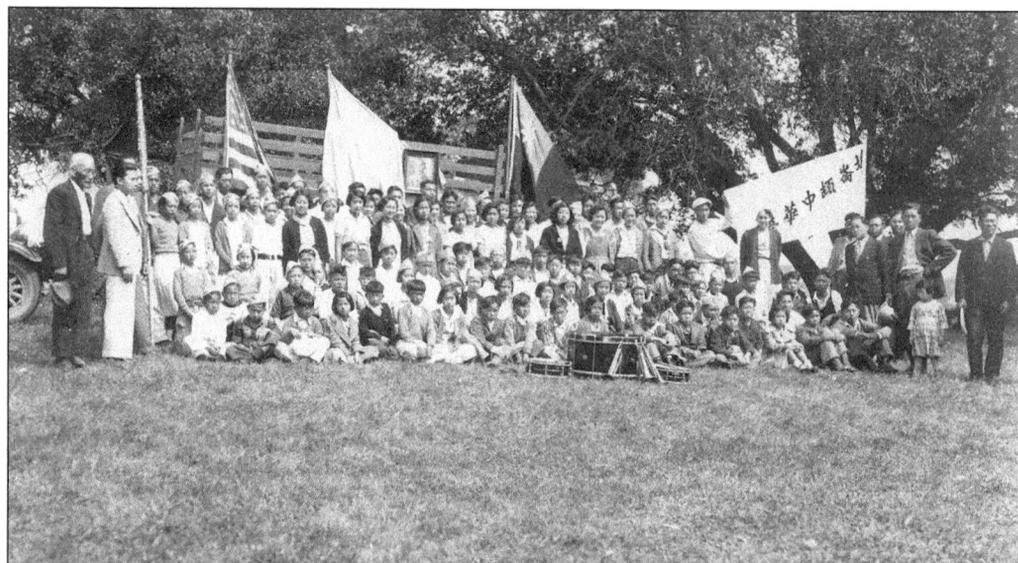

The annual Sacramento River Delta Chinese Interschool Picnic was held in Ione in the spring of 1934. The children from all the Chinese schools in the delta were invited to attend. (Courtesy Walter Lee collection.)

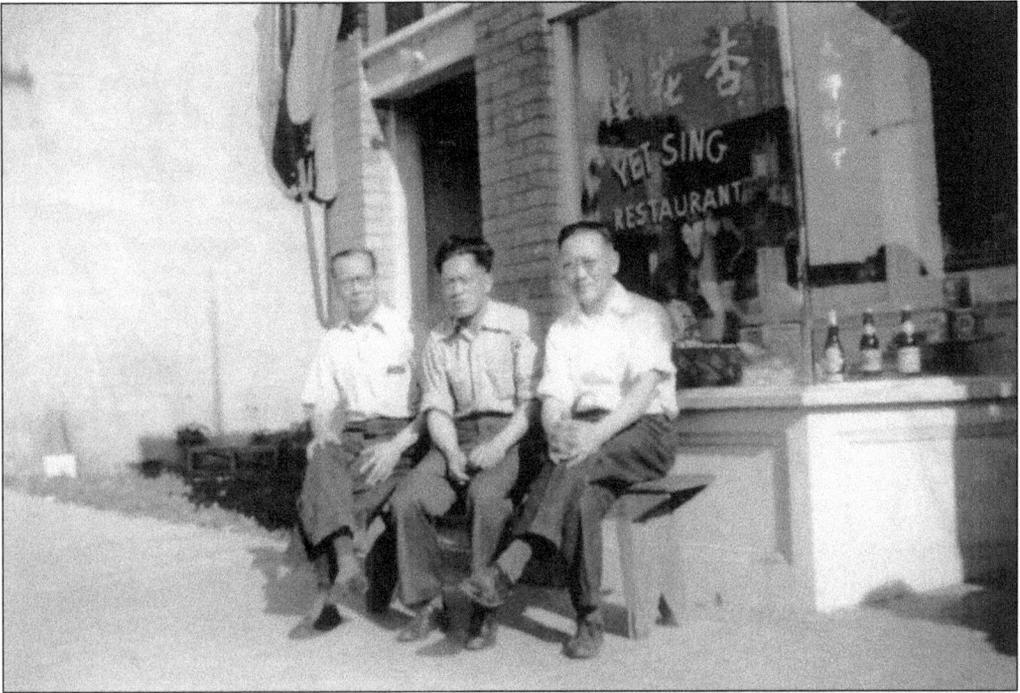

In 1923, Wong Lin Dong (left) opened the Yet Sing Restaurant above Charley's Bar at 16 Main Street. After the 1926 fire, the restaurant was moved to 28 Main Street. He, with his wife Hall Shee and seven children, ran the restaurant often preparing banquets for weddings and association dinners served at the Bing Konh Tong across the street. In 1956 the restaurant was sold.. (Courtesy Woong family collection.)

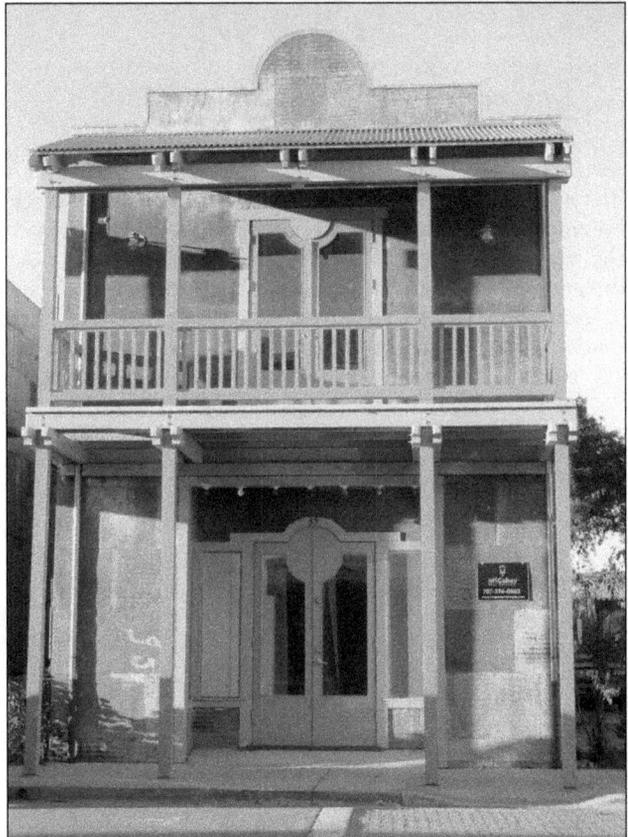

35 Main Street was a former gambling hall call Mee-Wah. It was owned by Yee Toy. He had two other gambling establishments on Main Street. All the gambling halls were closed in 1950s. (Courtesy IBAHS.)

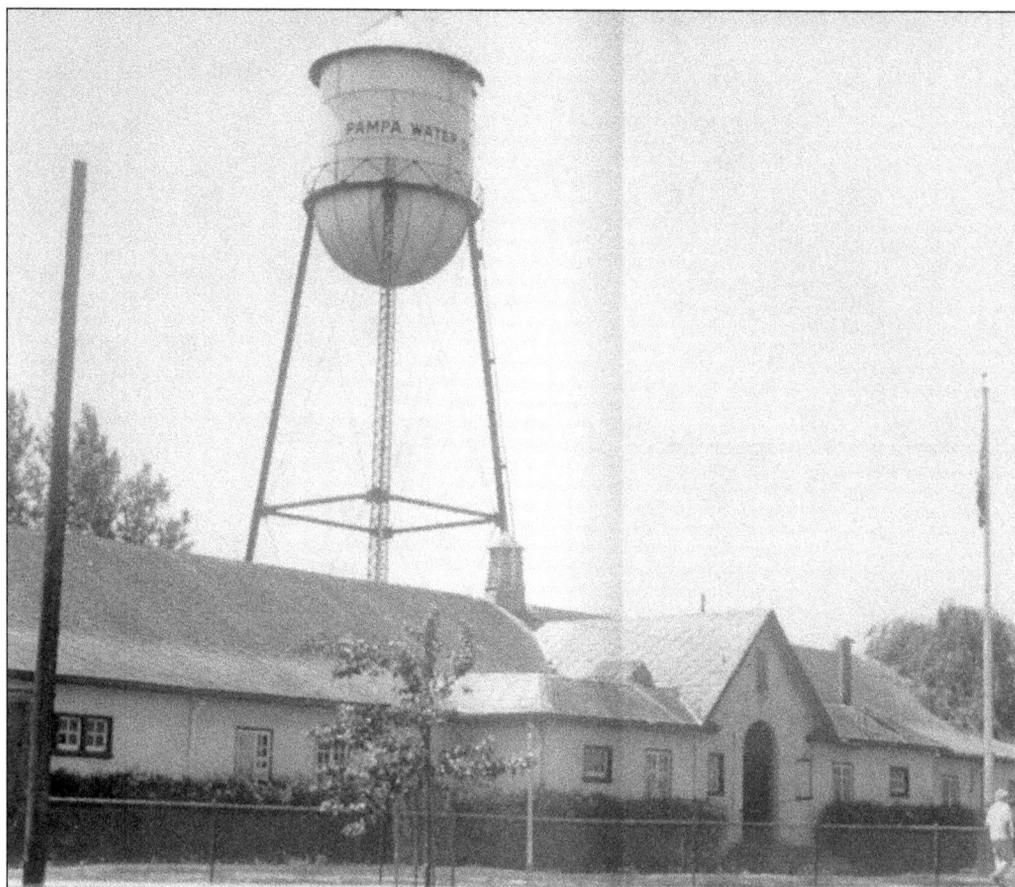

Isleton had segregated schools until 1942. There was the school for Asians (Chinese, Japanese, and Filipinos) and a migratory school for workers who arrived during the harvest season. In Isleton, the segregation started in 1909, and all Asian names disappeared from rosters of the previously integrated classrooms in January 1910. After World War II started and the Japanese were sent to internment camps, the schools were desegregated. The photograph above shows the Oriental school, which Asian children attended. Due to the large number of Asian students, some of them also attended the migratory school, shown in the photograph below. (Both, courtesy IBAHS.)

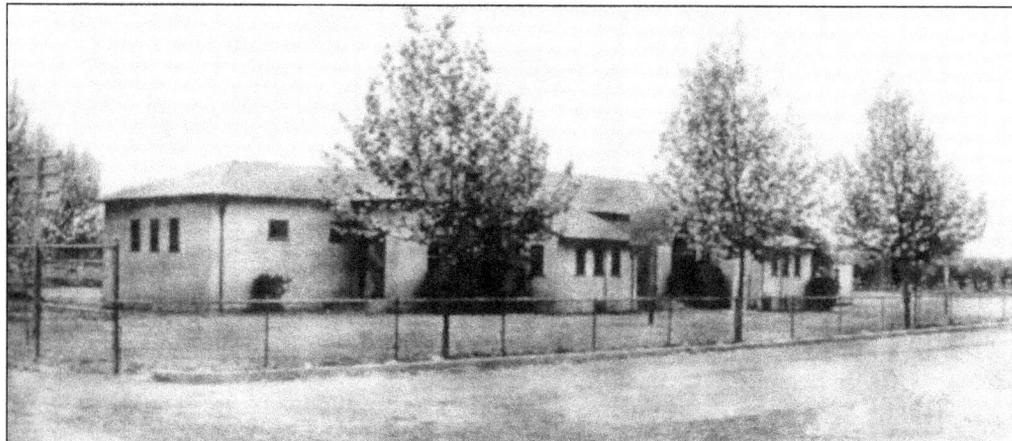

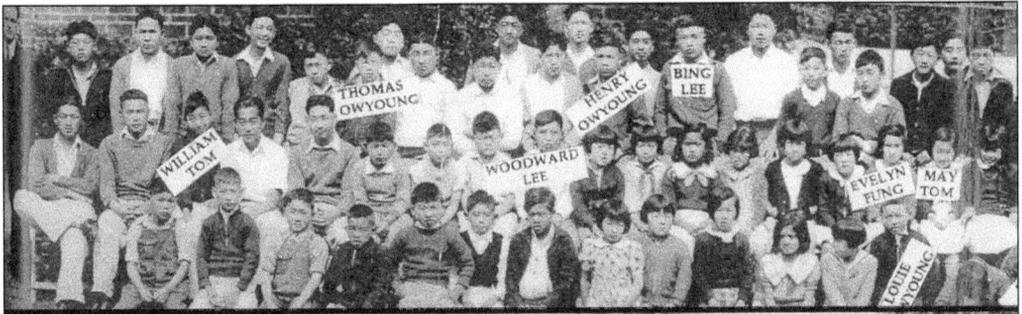

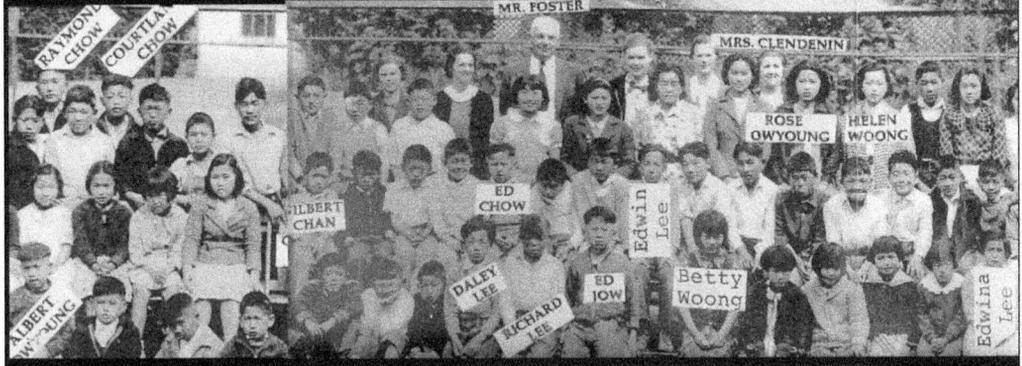

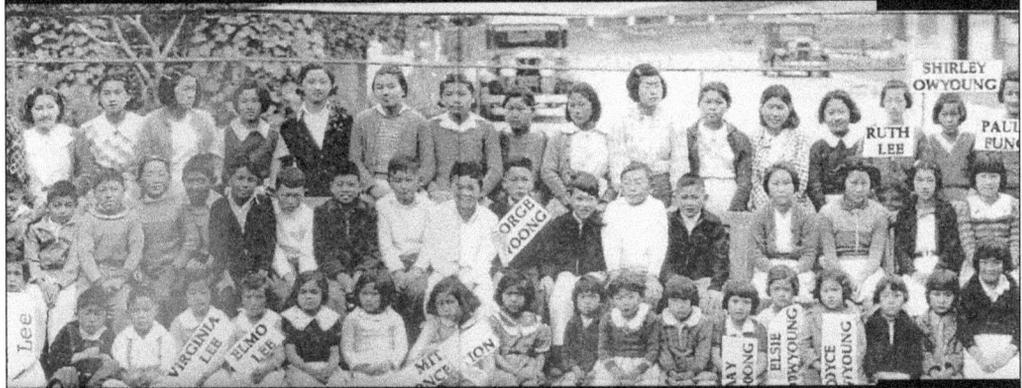

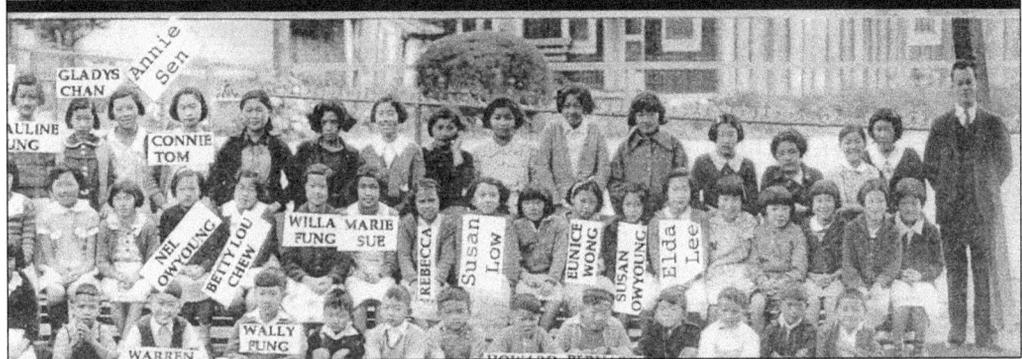

The students and teachers are pictured in April 1937 at the Oriental school. A Mr. Foster was the principal of all three schools, the migratory school, the Oriental school, and the white school. He is in the middle of the back row of the middle photograph. (Courtesy Elsie Owyoung Yun.)

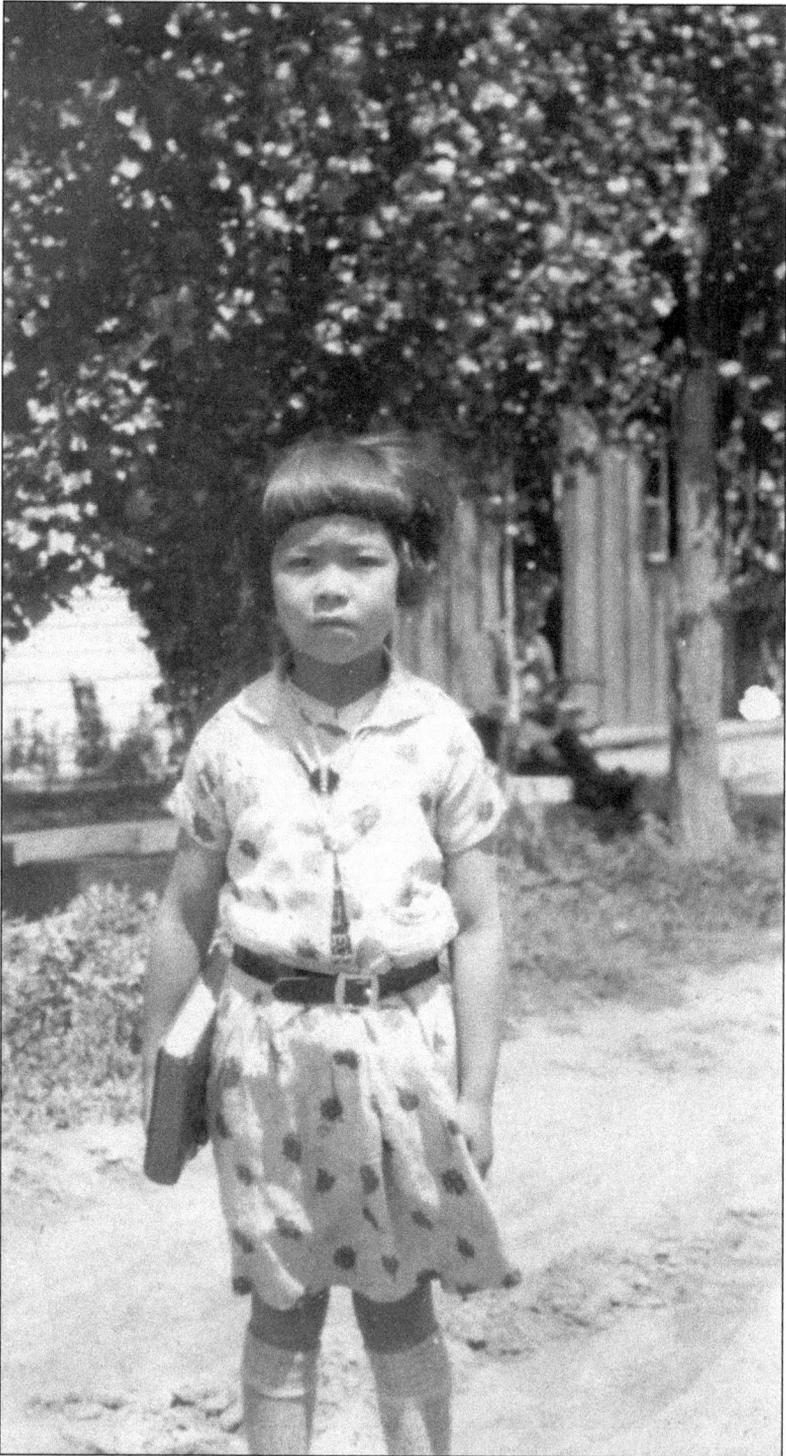

Shirley Owyoung waits for the school bus in 1931. In the late 1940s, Shirley was hired in Isleton as the first Chinese American teller for Bank of America. She was also the first woman promoted to the rank of officer at Bank of America. (Courtesy Elsie Owyoung Yun.)

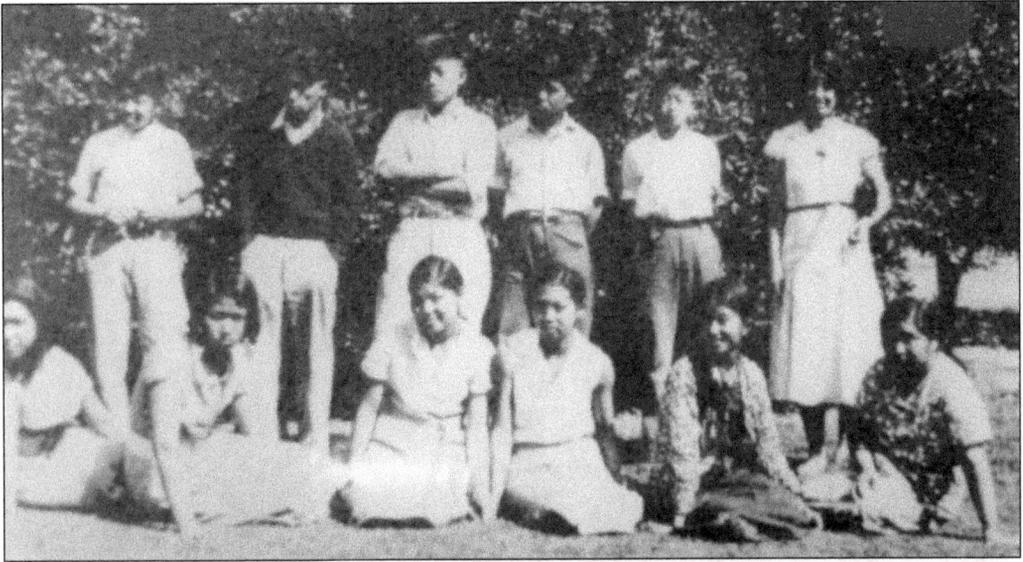

These are the students in the Isleton Oriental school's eighth grade in 1928. Marion Owyang (first row, far left) was a long time resident of Isleton. She and her husband, Sing Wong, initially owed the National Grocery and later the National Cafe on Main Street. She was considered the matriarch in Isleton's Chinatown and was honored in 1995 as the grand marshal at the Chinese New Year's celebration. (Courtesy IBAHS.)

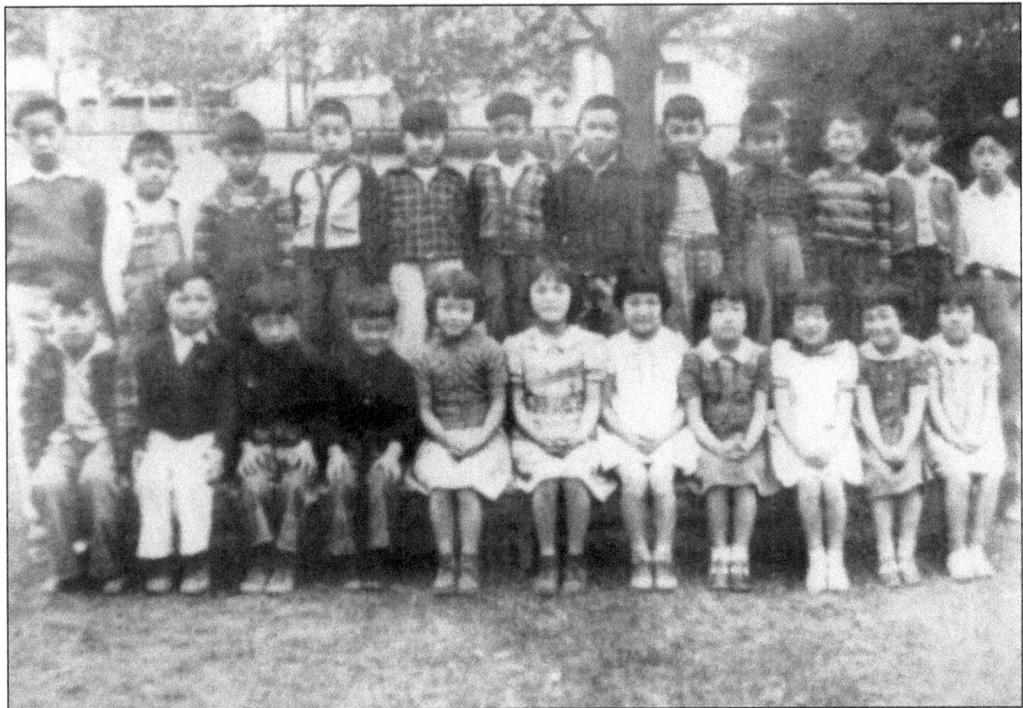

These are the primary grade classes at the segregated Isleton's Oriental school in 1941. After the Japanese were relocated to internment camps, segregation of the schools ended at the close of the 1942 school year. Bernice Woong (first row, sixth from the left) was selected as Miss Chinatown in the Chinese New Year celebration in San Francisco in 1954. (Courtesy IBAHS.)

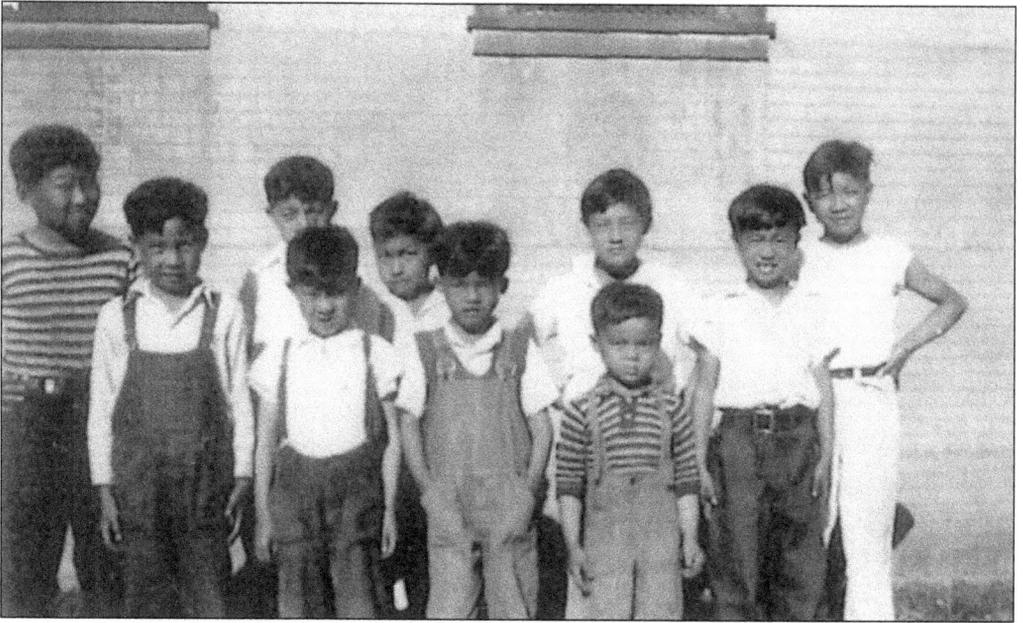

The Isleton's Boys' Club was sponsored by the Baptist mission group from Locke. These are the members of the boy's club in 1941. They are, from left to right, (first row) Dot Kim Choy, Alfred Owyoung, unidentified, Vincent Owyoung, and Richard Jang; (second row) Bernard Wong, Albert Owyoung, Howard Chow, unidentified, and Louis Owyoung. (Courtesy SRDHS.)

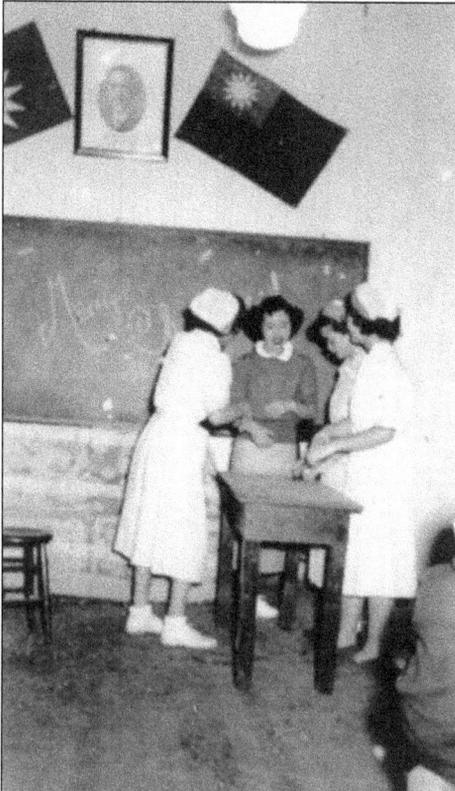

In 1942, a girls' group in Isleton put on a skit during Christmas, speaking Chinese and imitating their mothers during a typical workday at the cannery. The mothers loved it, and considered it the best gift they could have received from their daughters. Pictured, from left to right, are Joyce Owyoung, Evelyn Fung, Vernie Owyoung, and Elsie Owyoung. (Courtesy Elsie Owyoung Yun.)

Vernie Owyoung was born and raised in Isleton. She was very active in the Future Homemakers of America (FHA) organization. At the FHA state convention, she was elected as the state FHA project chairman. At the first FHA Western Leadership Training Conference in 1951, Vernie was the state vice president of projects and represented 5,783 California FHA members from 157 schools in the state of California. (Courtesy Elsie Owyoung Yun.)

Kathy Lum was born in Isleton. She attended the College of Pacific (now the University of the Pacific) and was in the first pharmacy class. In 1959, she was the first and only woman to graduate from the school of pharmacy. She started her working career at St. Joseph's Medical Center in Stockton and retired after 40 years as director of the pharmacy at the medical center. (Courtesy Kathy Lum Owyoung.)

Marion Owyang Wong was born in Clarksburg and was a resident of Isleton for over 80 years. In addition to helping her husband in his business and working at the local canneries, she helped many Chinese immigrants in Isleton. She was honored at the Chinese New Year's celebration in 1995 as grand marshal for her many years of service within the Chinese community. (Courtesy Marion Owyang Wong collection.)

The descendants of the Hong Kong Chow family had a reunion in Isleton in 2011. Hong Kong Chow came to America in 1899 and was a tenant farmer. In 1934, he settled in Isleton with his family. The reunion was in memory of Mary Chow Wong, his eldest daughter, who had recently passed away. Mary was forced to quit high school to help support the family by working in the local canneries. (Courtesy Lawrence Tom.)

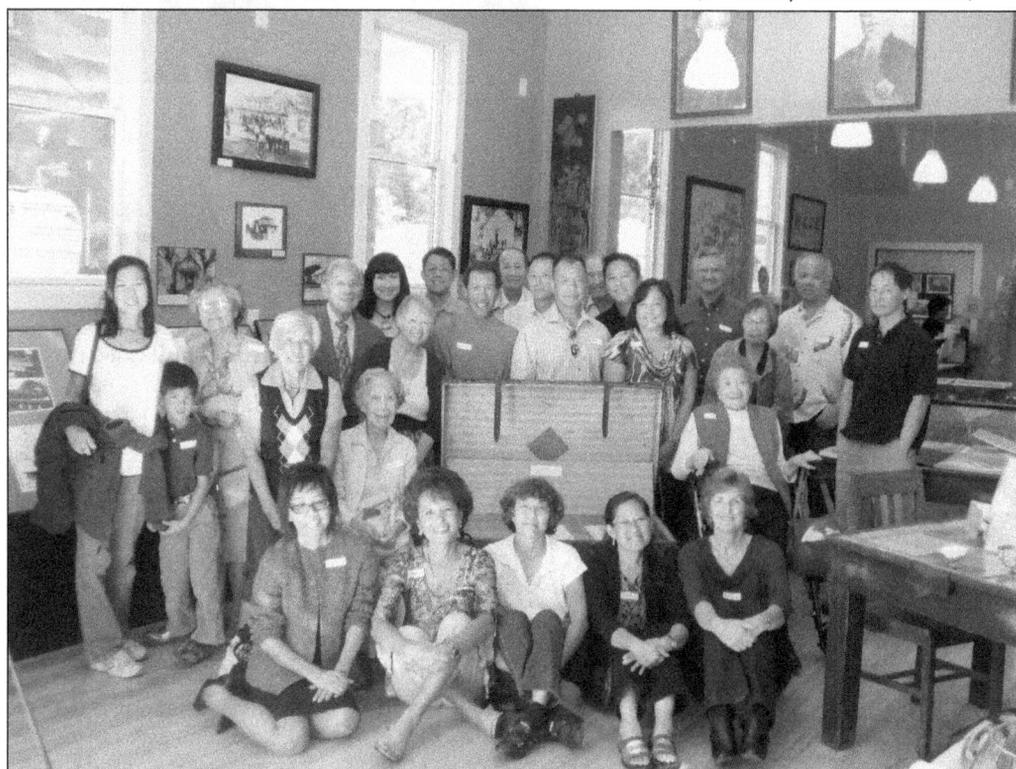

# Seven

# CHINESE DELTA PIONEERS IN AGRICULTURE

The Chinese started settling in the Sacramento River delta soon after the Gold Rush, and their numbers accelerated after the transcontinental railroad construction ended. The Chinese were an important factor in construction of the early levee system to reclaim the land for agriculture. They were very innovative. One of their inventions was the development of a tule shoe, a showshoe-type horseshoe that worked in the marshy soil. Prior to the influx of Chinese, the levees built by early workers were periodically destroyed by flooding. After the construction of the levees, the Chinese remained as either farm laborer or tenant farmers. It is estimated by some historians that by the latter part of the 1800s, 90 percent of the farm laborers were Chinese.

A well-known Chinese pioneer in agriculture was Thomas Foon Chew, who owned the Bayside Canning Company in Isleton and Alviso. The company became the third-largest canning company in the United States after Del Monte and Libby. Chew became known as the "Asparagus King." In 1926, the smart and resourceful Chong brothers invented the asparagus plow. The brothers, along with partner Tony Miller, were awarded 10 US patents for the design of the blades and the machinery for the plow. A US patent awarded to a Chinese person was very unusual at that time. Some notable farmers were Lincoln Chan and Kern Chew from Courtland. Lincoln's father, Chong Chan, established himself in the pear business in 1925 after being successful with the grocery business in Courtland. After taking over his father's pear operation in 1939, Lincoln expanded the business and later became known as the "Pear King." Kern Chew and his brother Chester entered the farming business after World War II. They were well known as being aggressive and innovative farmers and were once among the 10 largest private sugar beet producers in the world. These and other Chinese pioneers from the delta made significant contributions to the agricultural industry in California.

The Chong brothers were born in California. They moved to the delta in 1911–1912 and quickly established themselves in farming. They started by leasing a 563-acre ranch. In 1923, the four younger brothers decided to venture out and leased more acreage. They later became known as the largest open-land farmers in the delta. The brothers, from left to right, are Jue, Sam, Bing, and Look Chong. (Courtesy Ron Chong.)

U.S. Patent 1,903,124 : front , claims
Filed May 17, 1932, serial no. 611,840
Granted March 28, 1933
Tony S. Miller, Look L. Chong, Jue L. Chong, and Sam L. Chong of Isleton, California
Rotary Ground Working Implement
Current U.S. Class: 172/79 37/189 37/906 172/68 172/74 172/112 172/125 172/430 172/438 172/508

Jue Chong achieved his greatest success in 1926 by inventing the first reliable asparagus plow. He formed a partnership with Tony Miller to secure a US patent. He and his younger brothers, Sam and Look, would eventually be awarded 10 US patents for design of the blades and the plow machinery. This is their sixth US patent, no. 1,903,124. (Courtesy Ron Chong.)

California Fruit Grower

A PUBLICATION OF BLUE ANCHOR, INC. • THE VOICE OF CALIFORNIA'S FRESH FRUIT INDUSTRY • SUMMER 1988

THE LEGEND
—OF THE—
RIVER PEAR

▶ SPECIAL REPORT:
Living With SO$_2$
Regulations

Lincoln Chan was born in San Francisco and was raised in Courtland. In 1938, he started farming. He purchased his first pear ranch in 1942 and grew more pears than anyone else in the delta. His 1,000 acres of pears extend north as far as Sacramento International Airport and to Walnut Grove in the south. His harvest was so large that he became known as the "Pear King." (Courtesy Sonya Chan.)

Lum Bunn Fong was born in the 1893 and settled in Courtland in 1911. He started working as a farm laborer and later formed a partnership to lease some acreage near Courtland. In 1939, he purchased 196 acres and became one of the larger Chinese landowners in the delta. In 1941, he added 201 acres to his holdings. In addition, he also rented 100 acres. His land-management abilities were unsurpassed, resulting in a tremendous yield of fruits and vegetables. (Left, courtesy George Fong; below, courtesy Ping Lee.)

Kern Chew was born and raised in Courtland. Kern joined the Army during World War II and fought in the battles of Leyte, Okinawa, and Saipan. After the war, along with his brother Chester, Kern entered into the farming business. Pictured in 1968, they were once one of the 10 largest private sugar beet producers in the world and were well known for being aggressive and innovative farmers. (Courtesy Kern Chew.)

Bayside Cannery was founded by Sai Yen Chew in 1906. After his death, the operation was taken over by his son Thomas Foon Chew. In 1920, at the Isleton canning operation, Thomas developed a method for canning asparagus. By 1931, Thomas built the business into the third-largest cannery in the world, after Libby and Del Monte, and became known as the "Asparagus King." (Courtesy IBAHS.)

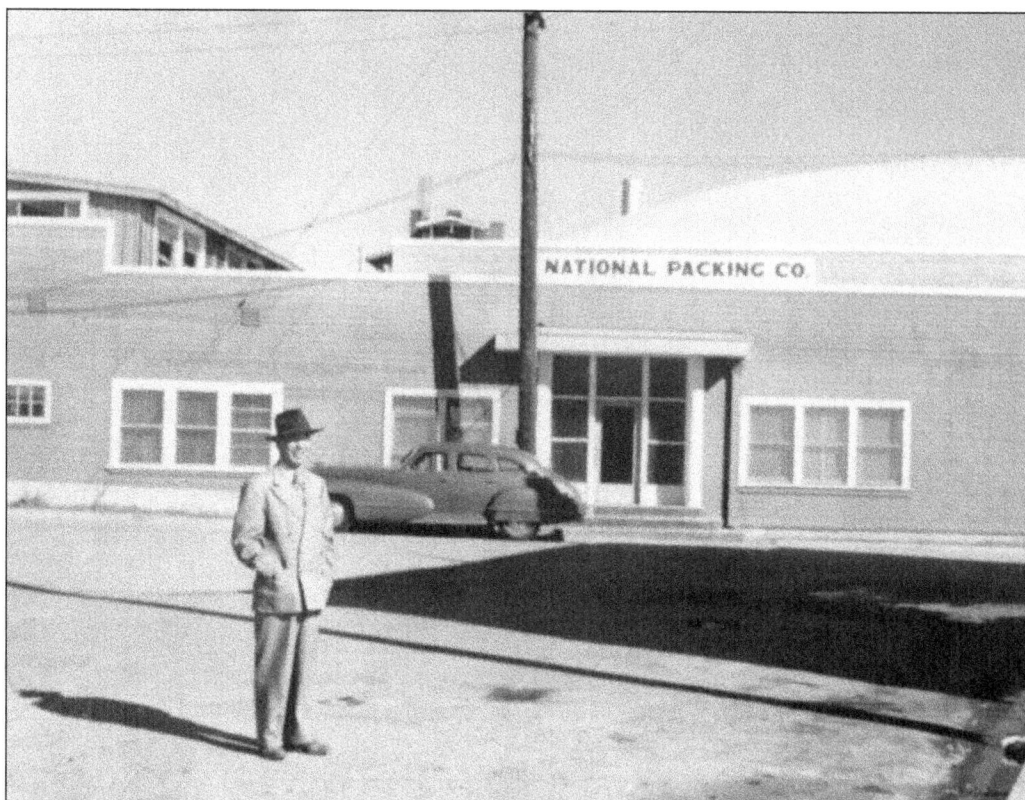

The National Packing Company in Isleton was the only packing company known to have been solely owned and operated by the Chinese in the United States. It started as the Isleton Packing Company, but the name changed along with changes in Chinese ownership. It had its own label, but also canned for other labels such as Del Monte, Lucky Stores, Lady Lee, and a Canadian company called Club 8. Lee Wing, the owner, is shown in front of the National Packing Company in the 1940s. The company and the building no longer exist. (Both, courtesy IBAHS.)

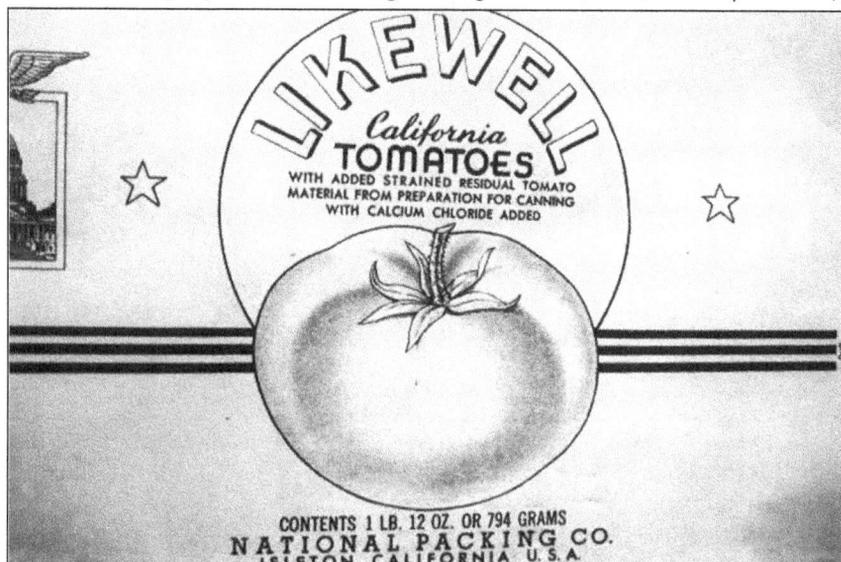

*Eight*

# PRESERVING THE PAST
# FOR THE FUTURE

The Chinese started leaving the Sacramento River delta in the 1930s. After World War II, the exodus from of the delta accelerated because those in the generation that served in the military continued their educations at universities and colleges under the GI Bill. Afterwards, they settled in metropolitan area because of the job opportunities there. By the 1970s, many Chinese had already left the delta.

Two towns, Locke and Isleton, have preserved the contributions of the Chinese in the delta by establishing several museums and a restored State Historical Landmark building as part of the California State Parks system. In these two towns, Chinese celebrations are still taking place to preserve Chinese tradition and culture so that it will not be forgotten. In the town of Isleton, the Bing Kong Tong building, constructed in 1927, is scheduled for restoration with monies from the California Heritage Fund. The building will be used to house and preserve many Chinese artifacts, in addition to being a community center. The town of Locke was placed in the National Register of Historic Places in 1971 and was designated a National Historic Landmark in 1990. It is also a California State Historical Landmark (No. 87), listed in May 1971.

In Locke, a memorial park was dedicated on October 2006, honoring the Chinese pioneers of California who helped build the transcontinental railroad, construct the levees of the delta, develop agriculture, and build the town of Locke. The boardinghouse was restored and dedicated on October 2008, with a ribbon-cutting by several of the longtime residents of Locke. The project was a joint effort between California State Parks and the Locke Foundation. The mission of the Locke Foundation is to educate the public about Locke's history and legacy. The boardinghouse serves as the headquarters for the Locke Foundation and is a museum and learning center. All of these ongoing efforts are for the following generations to gain an appreciation and understanding of the struggles and achievements of the Chinese pioneers in the Sacramento River delta so that they will not be forgotten.

On October 11, 2008, the Locke Boarding House, located at 13915 Main Street, was dedicated with a ribbon-cutting by Connie King and Ping Lee, two longtime residents of Locke. It was another chapter in the continuing preservation of the buildings and the history of Locke. The boardinghouse was operated by the Kuramotos starting in 1921. At the beginning of World War II, the family was relocated to an internment camp and never returned. The boardinghouse is now a museum and learning center for the public to understand and appreciate the historical significance of Locke. It is operated by California State Parks and the Locke Foundation.

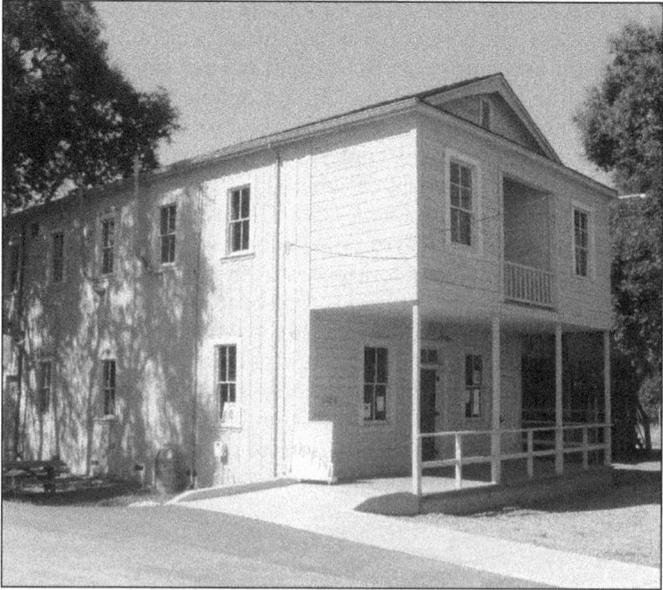

The Kuomingtang Building at 13920 Main Street was restored in 1954 with funding from the Joe Shoong Foundation for use as a Chinese school. The school was named Joe Shoong School after the founder of the National Dollar Stores. It closed in the 1980s due to a lack of students and is now a museum. The two monuments to Dr. Sun Yat-sen (right) and Confucius were dedicated at the front entrance on May 14, 2011.

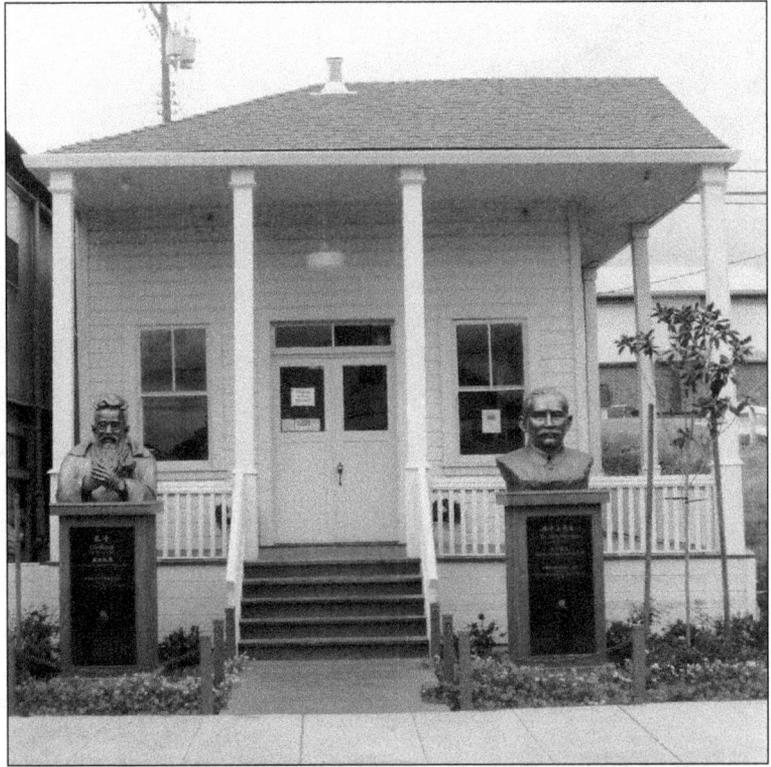

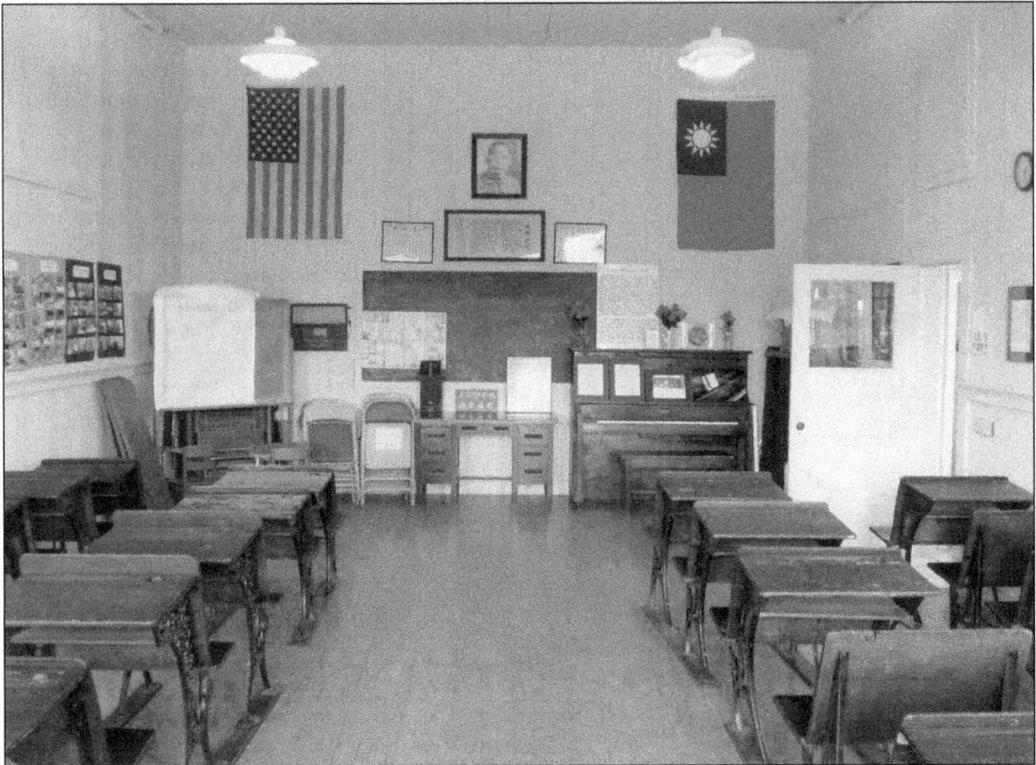

紀念福尼亞州華裔先民以勤勞的加利

堅毅不移前赴後繼拔山關疆精神

修築了薩克拉門托三掘金三角洲堤堰

建設了中谷地區及農業

發展了樂居鎮

興立了一九四八年以來為拓建

自加州前景努力好暨樂居鎮居民

加州馬月好暨樂居鎮居民謹立

公元二零零七年十月十三日

Locke Memorial Park was dedicated on October 8, 2006. The park serves as a memorial to the Chinese pioneers of California who helped build the transcontinental railroad, constructed the levees of the Sacramento San Joaquin delta, developed agriculture in the Central Valley, and built the town of Locke. The photograph to the left shows the monument with the Chinese inscriptions immediately inside the Locke Memorial Park.

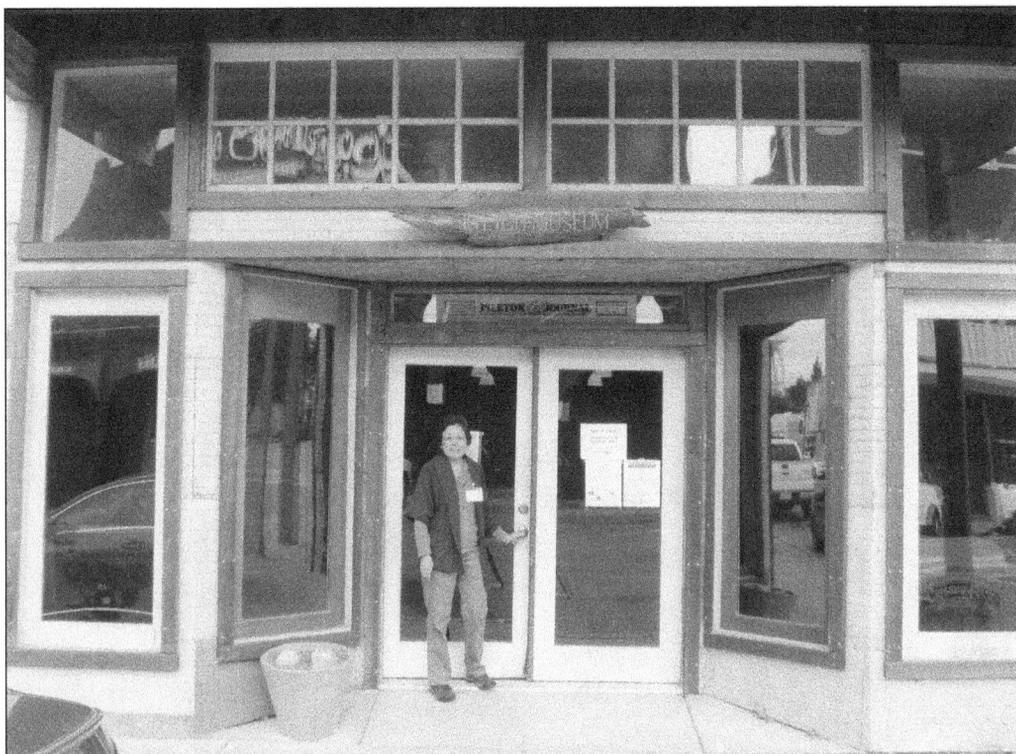

The Isleton Museum was established in 1992. Among its exhibits are many of the artifacts and photographs from early Isleton's Chinatown. Sharon Fong is shown welcoming visitors to the museum at 33 Main Street. She was born and raised in Isleton and is an officer of the Brannan-Andrus Historical Society and the tour director for the Isleton Museum.

Under the leadership and direction of Peter Leung, Ka Shi Chan, a Chinese artist, was selected to draw the images on each panel of the Chinese Laborers Memorial Pavilion in Isleton. The images pay tribute to Chinese laborers who worked on the levees and farmland. In recognition of their efforts, their names are inscribed on the front panel. The pavilion was dedicated in 1993.

Visit us at
arcadiapublishing.com

www.ingramcontent.com/pod-product-compliance
Lightning Source LLC
Chambersburg PA
CBHW050649110426
42813CB00007B/1956